creative DARKROOM TECHNIQUES

Library of Congress Catalog Number 73-87110

Standard Book Number: 0-87985-075-2

© Eastman Kodak Company, 1973 First Edition

ANOTHER IDEA BOOK FROM KODAK

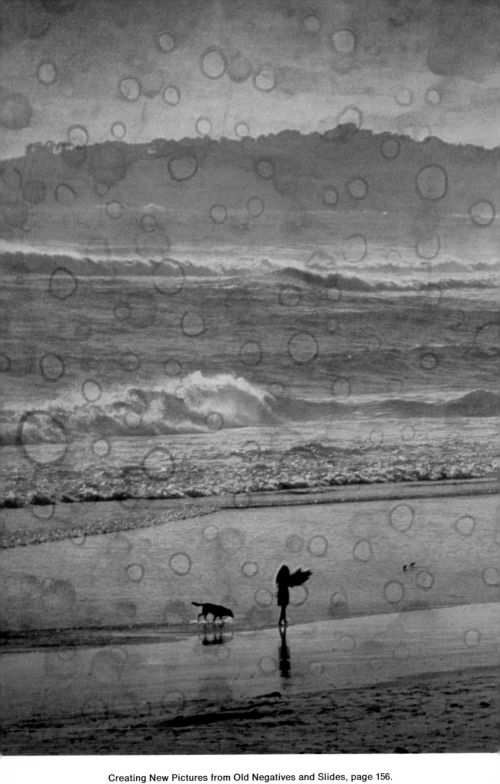

Creating New Pictures from Old Negatives and Slides, page 156.

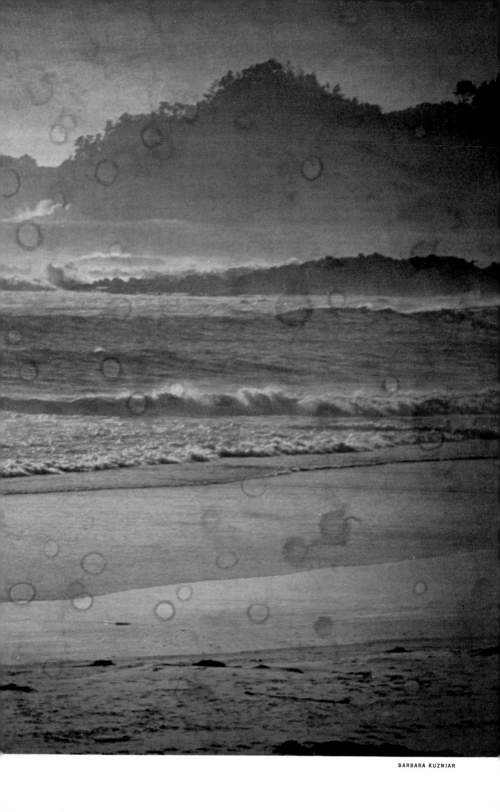

CONTENTS

THE PROCESSES COVERED IN THIS BOOK:

INTRODUCTION

This book is for people who have mastered the basic darkroom techniques, such as processing film and making high-quality prints. It will introduce you to new photographic techniques and stimulate your creativity in the darkroom. *Creative Darkroom Techniques* will help you make better prints from negatives you already have, and show you how to create new pictures from those negatives. You can combine the techniques presented here in any way your imagination directs for a continuing variety of new pictures. The possibilities are limitless.

You'll learn several ways of reducing contrast in your prints, and how to improve the composition and appearance of your pictures by vignetting, diffusion, and distortion techniques.

You can create pictures in your darkroom without using a negative. One chapter explains the art of making photograms, making paper negatives, and printing slides.

Have you ever reversed the system and made a color print from a black-and-white negative or a black-and-white print from a color negative? It's possible to add color to the black-and-white prints you've already made and to print black-and-white negatives on color paper. You can also create new pictures by using black-and-white and color negatives together!

High-contrast films offer you another creative outlet in the darkroom. One chapter of this book is devoted to the many ways that you can use high-contrast films to make old pictures better or to make old pictures into new ones.

A technique that has regained popularity recently, is the Sabattier Effect, commonly called "solarization." By re-exposing films or papers during development, you can produce both a negative and a positive image in your pictures. Learn how to produce these striking and unusual pictures in both black-and-white and color by reading the chapter on the Sabattier Effect.

In the chapter on reticulation, you'll find out how to produce a built-in texture screen in your negatives. There's also a section on how to freeze negatives and slides to create frost patterns. Far out? Yes, but who knows what exciting new pictures you may be able to create!

By using posterization, you can give your photographs a poster-like appearance which can give dramatic emphasis to some pictures. The chapter on posterization will tell you how to posterize your existing negatives and slides, and it also includes an easy way to make multiple exposures with a camera that won't double expose!

Gum bichromate printing is another old technique which is becoming popular again. You'll learn how to make your own photographic paper which is developed in water! With gum bichromate, you can print in black-and-white or color, and you can combine several images on the same paper.

Photo silk screen printing, a combination of photography and graphic arts, offers an additional area of expression for the photographer. Using this process, you can make inexpensive multiple copies of the pictures you produce.

Expose yourself to *Creative Darkroom Techniques* and you'll find there's no end to the creative outlets your darkroom can provide. You'll be proud of the exciting new photographs that this book will help you produce.

Posterization, page 230.

Creating High-Contrast Pictures, page 140. Combination Printing, page 72.

Printing Without Negatives, page 90.
Combining Black-and-White and Color, page 104.

ACKNOWLEDGEMENTS

We would like to thank the many people who contributed ideas and information for this book. Members of the Photographic Society of America shared the photographic techniques that they have tried and found successful, and many Kodak people offered their technical expertise. Professor James E. McMillion, Jr., of the Rochester Institute of Technology was a great help in introducing us to students who are experimenting with new techniques and in gathering student pictures for use in this book. This book could not have evolved without the voluntary assistance of many photo hobbyists interested in helping others to get more enjoyment from their hobby.

WE WANT TO HELP YOU MAKE GOOD PICTURES

This book explores many different photographic techniques—old and new—which you can use to get good pictures. If you have any questions about the techniques described here or about any phase of photography, write to us. We have the answers. Our staff of photographic specialists is available to answer your questions and help you make good pictures.

Kodak products are available through photo dealers; they are not available directly from Kodak. If you can't find the products mentioned in this book, we have a list of mail-order houses located throughout the United States, so that people who live in remote areas can obtain the materials they need.

Send your questions to Eastman Kodak Company, Photo Information, Department 841, Rochester, New York 14650. You'll get the answers.

Control Techniques

Techniques that will help you make exhibition-quality prints from hard-to-print negatives by controlling the contrast so that both the highlight and shadow areas will print with a full range of detail and tones. The techniques themselves do not show on the final print; they are used during or after the printing to improve the appearance of the picture.

PAUL D. YARROWS

This picture was taken with electronic flash, and the log reflected a lot of light. The resulting highlights were given extra exposure to darken them during the printing. Giving additional exposure to selected areas of a print, which is called printing in or burning in, can turn a good picture into a great one.

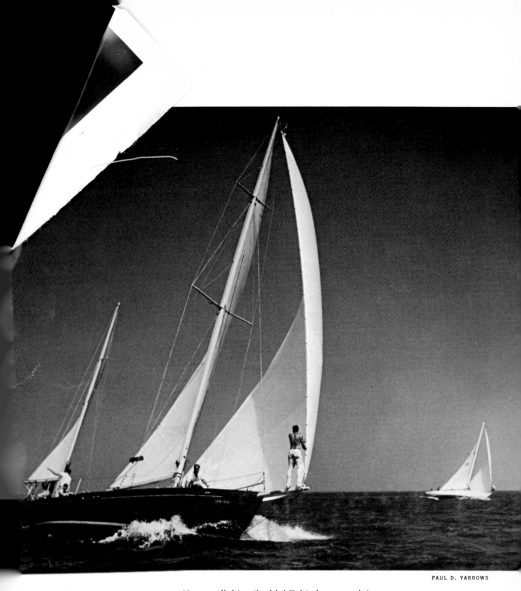

You can lighten the highlights in your prints with local reduction. These sails were brightened up by applying KODAK Farmer's Reducer, as described on page 36. Then print was toned blue to give it even more impact. Toning is explained on page 108.

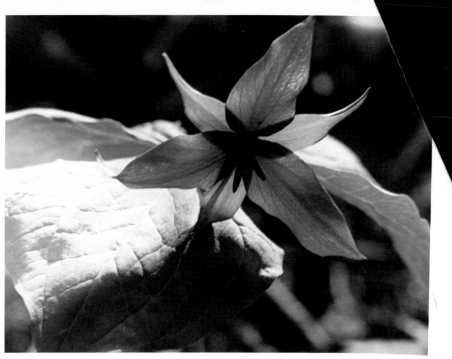

In the straight print above, the center of the flower is too dark, and highlight
on the leaf is too bright. The improved version below was made by
printing in the leaf for an additional fifteen seconds and dodging the center of the
flower for eight seconds during the initial exposure. Dodging and printing in
are easy to do. By using these techniques you can improve your prints
and make them look more professional.

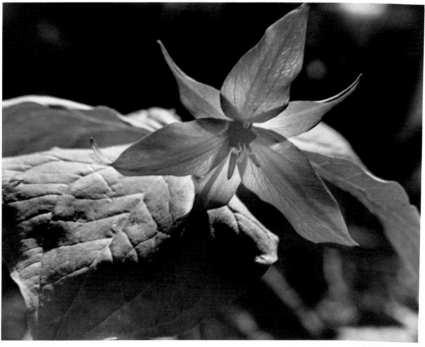

Have you ever accidentally underexposed a whole roll of black-and-white film? The picture above is a print made from an underexposed negative— pretty drab isn't it? The picture below was made from an underexposed negative on that same roll of film, and yet it's a good print. What's the difference? The negative used to print the picture below was intensified. You can salvage underexposed negatives with this process, and it's explained on page 38.

If your negatives are all perfectly exposed, properly developed, and include subjects having average lighting contrast, you'll be able to make good prints without using the control techniques we're going to discuss in this section, and you can move right on to "Improving Composition and Appearance" on page 39.

But many times the brightness range of a subject is far beyond the range of tones that you can reproduce in a "straight" print. By using contrast control, you'll be able to print the detail in both the highlight and shadow areas to produce a print having a full range of detail and tones.

Where have all the clouds gone? You remember they were there when you took the picture, and they're visible in the negative. You can make the clouds visible in the final picture by printing in. The top picture was given an exposure to properly print the lighthouse and rocks, but the sky turned out to be too light. The bottom print was given the same exposure as the top print and then the sky area was given additional exposure to bring out the detail in the clouds. You can often tell how much additional exposure you will need by studying your initial test strip. The main part of the scene may look good printed at ten seconds while the sky looks best when printed at twenty seconds.

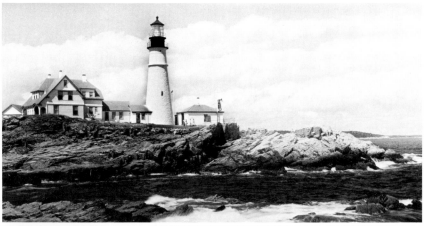

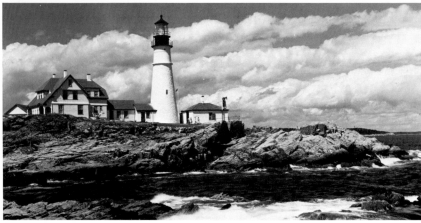

The rock was very bright in the initial print, so the photographer printed it in to tone it down. Later, he spotted out the white areas with KODAK Retouching Colors. For more information on adding color to prints, turn to page 131.

PRINTING IN

You can give additional exposure to highlight areas that would otherwise print too light and have no detail. For example, a flash picture of a white wedding cake will often lack detail in the cake when the rest of the print is well exposed. This can be corrected by the technique called "printing in." You can easily make a tool for printing in by cutting a hole in a piece of black cardboard. Many people find that their hands make flexible printing-in tools.

First, give the print its normal exposure. Then, without touching the print or the easel, hold your cardboard tool or your hands under the enlarger lens about midway between the lens and the print. Start the exposure and move your printing-in tool so that *only the area of the print which was too light receives the additional exposure.* For your first trial, give an exposure equal to the exposure you used for the whole print. Then adjust this time for later prints if you need more or less exposure in the printed-in area. Keep your printing-in tool in continuous motion during the exposure so that you won't get a dark edge in the area of additional exposure.

If the line between the well-exposed area of a print and an area that you want to darken is rather intricate, you can make a printing-in tool from a dry, test enlargement of the same size as the enlargement you're printing. Or, you can place a piece of stiff paper on the easel and sketch the outline of the area you want to darken. After you've given your final print its normal exposure, print in the area that is too light by holding the cutout print very close to the paper you are exposing. Move the cutout print only very slightly during the exposure. It may take some practice to get just the effect you want.

Printing In with a Glass Negative Carrier

Here's a technique that the pros use when they have a number of prints to make from the same negative and the negative needs some printing in. You will need a glass negative carrier, a KODAK Diffusion Sheet (.003-inch), and some petroleum jelly. Put your negative in the glass carrier, and tape the diffusion sheet on top of the upper glass. Work on an illuminator so you can see where to place the petroleum jelly. Over any areas of the negative that need printing in, apply a small amount of jelly to the diffusion sheet. Rub the jelly into the sheet and feather the edges. The areas where you have applied the jelly will become transparent, which allows more light through the negative to print in. The diffusion sheet cuts down on the amount of light printing through other areas of the negative, and the negative will print in with detail in the highlights and shadows during one exposure.

Local Flashing

Local flashing can be a great help in eliminating out-of-focus highlights shining through foliage and in darkening selected areas of a print. You can convert a pen-type flashlight into a flashing tool by taping a cone of black paper around its tip so that its light can be projected onto the paper through an aperture as small as desired. You may need to reduce the light intensity of the penlight by taping matte cellophane tape over the flashlight lens. Try one layer of tape, and then add another if the light is still too bright.

First expose the paper as you normally would and leave the paper in the easel. Place the red filter on your enlarger over the enlarging lens and then

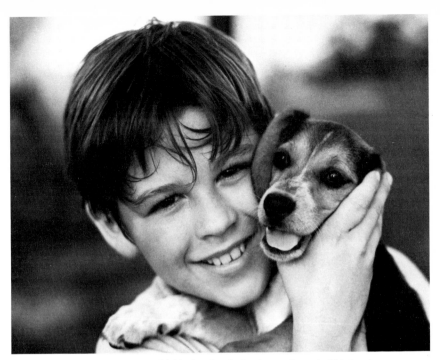

A cute shot of a boy with his dog, but that pole growing out of his head
is distracting. You can often eliminate distracting elements in the background
of your prints with some local flashing. The print below was flashed
with a penlight to blend the pole into the background.

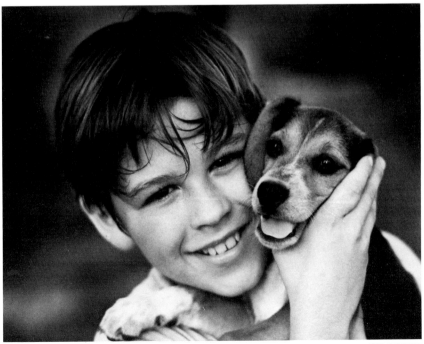

turn on the enlarger so you can see the areas that need flashing. With the penlight flashing tool, print in areas that you want to darken, then process the paper in the normal way.

It is helpful, particularly with your first few attempts at flashing, to flash small test strips and develop them to check the results. Keep track of the flashing time as well as the general negative-exposure time, and alter your reprinting procedure accordingly.

DODGING

With "dodging" you can hold back light from areas that would otherwise print too dark. You can use your hand as a dodging tool for large areas. It's also easy to make a dodging tool by taping a disk of cardboard to the end of a piece of coat-hanger wire. To use this tool for large areas, hold it close to the lens; for small areas, hold the tool close to the paper.

In dodging, you hold back light from the projected image during the basic exposure so that the paper receives less-than-normal exposure in areas that were too dark in the straight print. While you expose the print, hold your dodging tool by the end of the wire and allow the cardboard disk to cast a shadow over the area of the projected image which is too dark. The wire should be long enough so your hand doesn't cast a shadow on the paper. Make sure that you keep the whole dodging tool in motion during the exposure to make a "soft" edge around the dodged area, and to avoid getting a line on your print from the shadow of the wire.

Dodging with Matte Acetate

This is the easiest method to use when you're enlarging a 35mm negative which needs a considerable amount of *precise* dodging. By using a sheet of matte acetate in contact with the enlarging paper, you can shade the dodging onto the acetate with a soft lead pencil; when the print is exposed the pencil markings and shadings are incorporated into the print. The print will be lighter in the areas of the pencil shading. Not only is this technique a precise way of dodging, but it's easily repeatable on any number of the same-size enlargements that you want to make.

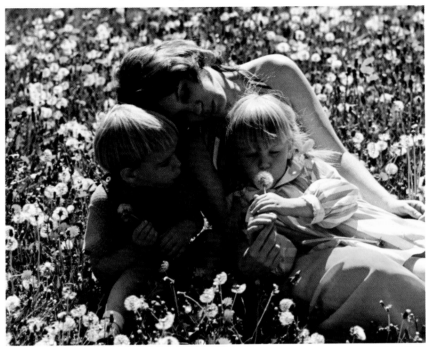

Backlighting often produces strong shadow areas. The faces are in the shadow
and too dark in the print above. In the print below, the faces were
dodged for eleven seconds of the thirteen-second exposure to lighten them.

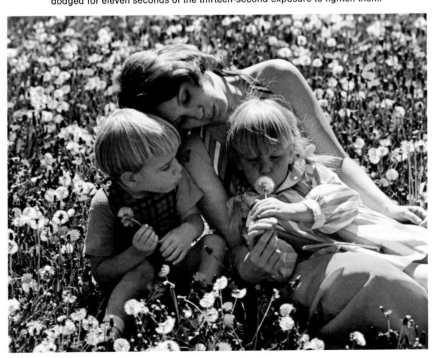

DODGING WITH MATTE ACETATE

1. Compose the projected image and adjust the enlarger height as desired. Turn the negative over and make a print. This print will have a reversed image.

2. After this print is processed and dried, tape it down on a flat, well-illuminated surface. Tape a sheet of clean matte acetate over the print so that the diffusing or matte side is facing up. Matte acetate, such as KODAK Diffusion Sheets, is available from photo dealers.

3. Use a medium-soft pencil and very light strokes to gradually shade in the areas that you want to print lighter. For broad areas, cover the area with pencil lines and then smudge them into an even tone with a ball of cotton.

4. After the retouching is complete, turn the negative over in the enlarger to its normal position with the emulsion side down. Turn on the enlarger, and with the acetate sheet *matte side down* in the enlarger easel, register the retouching with the projected image. Registration may require a slight adjustment of the height of the enlarger because the reversed-image print may have changed dimensions as a result of being processed. After the retouching has been lined up with the projected image, tape down one edge of the matte acetate sheet so that the retouching can be swung like a page of a book into or out of position.

5. Now make a dodged print by inserting the photographic paper under the matte acetate with the emulsion side facing up. To insure good contact between the acetate and the paper, place a clean sheet of glass over them. Make the exposure and process the paper as usual.

Dodging with a Glass Negative Carrier

For large areas of black-and-white negatives, apply red lipstick to the glass over the areas of the negative that you want to hold back or dodge. Smear the lipstick evenly over the area, feathering it at the edges so that the dodging won't show in the print.

For small areas, you can use a film pencil, such as a Dixon Film Marker (Black 2225) or an All-Stabilo #8008 Marker, to mark on the glass over the areas that you want to dodge. Mark small dots for a stippled effect over the area to be dodged. If the negative area to be dodged is very light and needs a lot of dodging, you can use a black china marker for the stippling. This technique effectively lightens eyes that are hidden in a shadow, and other very small areas on a negative.

If you have a glass negative carrier, you can make it into an automatic dodging device. Place the negative in the carrier and work over an illuminator so you can see the details in the negative. Add density with red lipstick or a red or black china marking pencil applied to the glass. Smear the lipstick or pencil with your finger to blend it evenly. Now you're ready to make as many prints as you want, and they'll be automatically dodged in the area of the image where you applied the pencil or lipstick.

Here's the improved print made from the negative illustrated above.

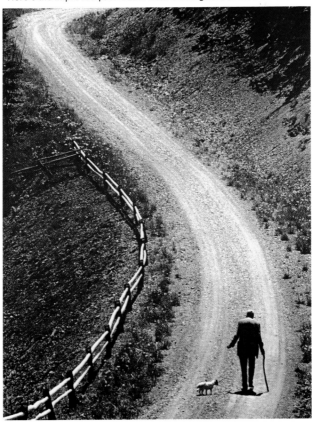

PAUL D. YARROWS

Dodging with Dye

You can hold back areas of a black-and-white negative with dye so that prints made from that negative are automatically dodged. Since applying anything directly to a negative takes practice and patience and always involves the possibility of ruining the negative, consider this method of dodging only if you plan to make many prints from the negative.

Dye retouching is usually done with a red dye, such as KODAK Crocein Scarlet. The bright color is easy to see on the negative. To apply the dye, make a stock solution of KODAK Crocein Scarlet by diluting a level teaspoonful of the powder in eight ounces of water. You can use this stock solution to spot pinholes, to make vignettes, and to opaque backgrounds.

For normal retouching, dilute one part of the stock solution with ten parts of water. Apply the diluted solution repeatedly to the base side of the negative with a brush, moistening only the area to be printed lighter, until the density looks about right. Then remove any excess water and leave the negative to dry.

After making a test print, if you find that you have applied too much dye, sponge the area with water to reduce the dye slowly, or use a 3 percent solution of sodium hydrosulfite to reduce it rapidly. Sponge the area thoroughly with water to remove all traces of the sodium hydrosulfite and stop the reducing action.

To completely remove the dye, immerse the negative in a 3 percent solution of sodium hydrosulfite at 68 F, then bathe it for one minute in KODAK PHOTO-FLO Solution, and hang it up to dry.

This technique provides excellent control, but it will require practice to determine the right amount of dye needed to get the desired effect.

Dodging with Filters

To increase or decrease the contrast in a black-and-white print made on variable-contrast paper, you can print part of the photograph with one POLYCONTRAST Filter, and then change filters for the area you dodged or the area you want to print in. For example, on page 22, we mentioned printing in a white wedding cake. You might expose the whole print through a No. 2PC filter, and then use a No. 1PC filter for printing in the cake.

In color, you can dodge and print in with color compensating filters. For example, if the color balance on a print looks good overall, but you want the face of a portrait to be a little less yellow, you can dodge the face with a dodging tool made from a CC05Y or CC10Y filter.

The horse at the top right is too blue when printed with a color balance that gives a pleasing result on the rest of the print. To improve the color balance of the horse, it was dodged during the overall exposure for the print on the bottom right. Then the horse was printed in, using a different filter pack while the rest of the print was dodged.

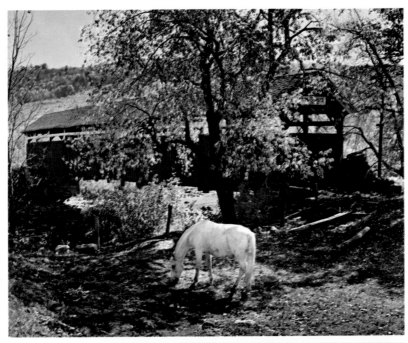

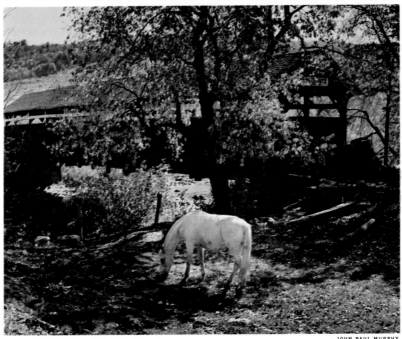

29

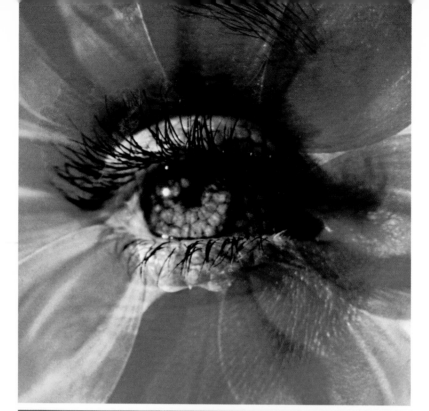

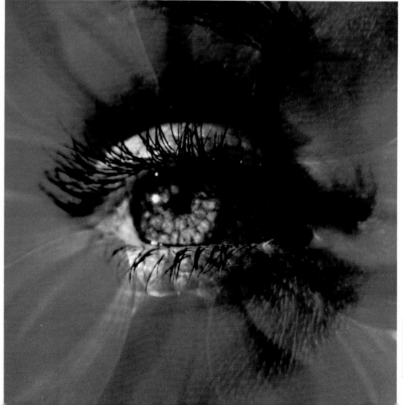

Another method of selective filtration combines dodging and changing the filter pack. In the top picture on page 29, the horse was in the shade and would have been too blue if printed with the same filter pack used for the overall picture. First, dodge the horse or the area to be selectively filtered during the exposure for the overall print. Then change the filter pack to a combination of filters that will print the dodged area correctly. While printing this selective area, be sure to dodge the rest of the picture.

The easiest way to do this type of double dodging is to make a dodging tool out of cardboard. Cut the shape of the area to be dodged out of the center of the cardboard. In the picture on page 29, this cutout would resemble the overall shape of the horse. Glue the cutout from the cardboard to a piece of wire and use it for dodging the horse while the overall print is receiving its exposure. Then use the remaining large piece of cardboard to dodge the rest of the print while the horse is receiving its exposure.

← This print was made from an internegative; the original was two slides sandwiched together in a montage. The print at the top was exposed ten seconds at $f/11$ with a filter pack of 75M + 152Y. Then, the photographer increased the color saturation and density in the print on the bottom by printing the petals for an additional eleven seconds at $f/11$ with a filter pack of 33M and 122Y while dodging the eye. Some people may prefer the lighter color and detail shown in the print at the top, but for salon exhibiting, the print on the bottom has more impact.

MASKING

If you plan to make many prints from any black-and-white or color negatives that need some contrast control, you might want to mask the negative. A mask is a film that is sandwiched with the negative and does its control work while the negative is being printed. Masking eliminates the need for dodging and printing in.

If you're using an enlarger as a light source for exposing the film when making masks, set the lens at $f/22$ and raise the enlarger as far from the baseboard as possible. Use a CC50B filter over the light source when printing color negatives onto KODAK Pan Masking Film or KODAK Separation Negative Film. You may find it necessary to use a neutral density filter with an enlarger light that is very bright.

Contrast-Reduction Masks— to decrease the contrast in selected areas.

A contrast-reduction mask is a thin, low-contrast, positive transparency made from the negative by contact-printing. This mask adds density to the negative in the shadow areas, which allows the detail previously hidden in dark shadows to show in the final print.

You can make a contrast-reduction mask by contact-printing your negative onto a piece of KODAK Pan Masking Film 4570 as shown on page 32. Make a test strip for your first exposure and develop the strip in KODAK Developer DK-50 diluted 1:4 for four minutes at 68 F. From the developed strip, select an exposure that is on the thin side. A properly exposed mask will appear thin and flat in contrast. After you've determined the exposure, make the mask by the same method.

To print a negative and mask, place the mask over the base side of the negative and line up the images until they match; then tape the mask in place. Use a glass negative carrier, and place the negative-mask sandwich with the emulsion side of the negative facing the emulsion of the paper. A properly masked negative will produce a good print with one uniform exposure time. No dodging or printing in will be needed.

Area Masks—to control the exposure in the shadow and highlight areas.

This is an unsharp mask which will bring the highlights and shadows into printing range so that the whole negative will print well with one exposure time and no additional dodging or printing in. In order to make an unsharp mask, you'll need to use a KODAK Diffusion Sheet (.003-inch). A package of twelve 8 by 10-inch KODAK Diffusion Sheets is available from your photo dealer.

Arrange your negative, diffusion sheet, plate glass, and KODAK Pan Masking Film 4570 as illustrated at the right, and make a test strip to determine the exposure. Develop the test strip in KODAK Developer DK-50 diluted 1:4 for four minutes at 68 F. A properly exposed area mask will appear unsharp, thin, and flat in contrast. After you've determined the exposure, make the final mask using the same arrangement of negative, film, diffusion sheet, and glass that you used for the test strip.

Register the mask with the negative and print the "sandwich" as described above under Contrast-Reduction Masks.

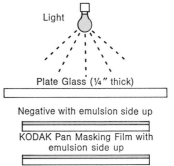

Making a Contrast-Reduction Mask

Light

Plate Glass (¼" thick)

Negative with emulsion side up

KODAK Pan Masking Film with emulsion side up

Easel covered with black paper or printing frame

Surround the negative with black paper to avoid getting flare from the glass separating the negative from the film.

Making an Area Mask

Light

Diffusion Sheet

Negative (emulsion up)

Plate Glass (¼" thick)

KODAK Pan Masking Film (emulsion up)

Easel covered with black paper or printing frame

The color and detail in the center of the flower is lost in the print at the top right. It would be a simple matter to dodge this area if only a few prints were being made; however, the photographer wanted to use the negative to print greeting cards. Dodging each print would have been very time consuming, so an area mask was made on KODAK Pan Masking Film 4570. The area mask and color negative were sandwiched together in register and used to make the greeting cards and the print at the bottom right.

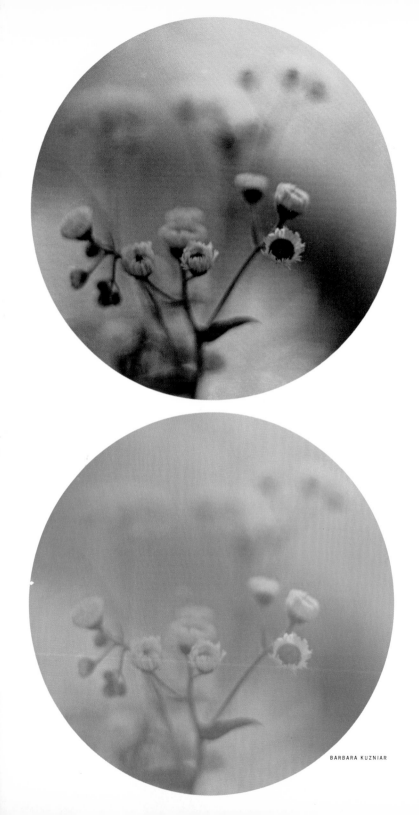

BARBARA KUZNIAR

33

Contrast-Increase Masks— to increase the overall contrast of a negative.

When a negative is too low in contrast due to slight underexposure, camera flare, low lighting ratio, or a combination of these factors, you can make a good-quality print from this negative by printing it with a contrast-increase mask. A contrast-increase mask is a negative black-and-white mask. To make a negative mask from your original negative, use a reversal film, such as KODAK High Speed Duplicating Film 2575 (ESTAR Base) or 4575 (ESTAR Thick Base).

Making a contrast-increase mask with a reversal film. Use KODAK High Speed Duplicating Film 2575 or 4575 to make a contrast-increase mask in one step. This is a graphic-arts film, and is available from graphic-arts suppliers. When you're working with it, remember that it is a reversal film, like a slide film. When this film is underexposed, the image looks too dark; when it's overexposed, the image is too light. You can handle High Speed Duplicating Film under a 1A or 0A safelight filter.

To make a contrast-increase mask, contact-print your negative onto the High Speed Duplicating Film (emulsion to emulsion) as illustrated above. Make a test strip to determine the exposure, and process the film in KODAK HC-110 Developer diluted 1:6 for three minutes at 68 F with continuous agitation. Follow the instructions on the film instruction sheet for the rest of the processing steps.

A good contrast-increase mask will appear almost completely transparent, with detail showing only in the highlight areas. After you have determined

the exposure, make the mask using the same procedure.

Register the mask on the base side of the original negative and print the negative with the emulsion facing the paper, as usual.

Light

Plate Glass (¼" thick)

Negative (emulsion down)

KODAK High Speed Duplicating Film 2575 or 4575 (emulsion up)

Easel covered with black paper or printing frame

REDUCING

Reducing is a method of lowering the density in a black-and-white negative or print. Reducers, such as KODAK Farmer's Reducer, also lower the overall image contrast on negatives very slightly. You should *never* use a chemical reducer on color films and papers because of the complex composition of color emulsions. *Caution: It's easy to ruin a negative by overreducing, and it does take practice to learn just how a particular reducer will react.* We suggest you practice on a spare film before trying to reduce a valuable negative.

REDUCING FILMS WITH FARMER'S REDUCER

In white light:

1. Soak dry film for 10 minutes in a tray of water.
2. Apply KODAK Farmer's Reducer with wet cotton or immerse film in a tray of reducer solution. Use the reducer full strength for reducing entire negatives; dilute it 1:4 for prints (see p. 38) and local areas of a negative.
3. Rinse for 1 minute in running water.
4. If more reduction is desired, repeat steps 2 and 3.
5. Fix for 5 minutes in KODAK Rapid Fixer.
6. Wash film for 20 minutes, or use KODAK Hypo Clearing Agent to reduce washing times.
7. Immerse in diluted KODAK PHOTO-FLO Solution and hang to dry.

Reducing Films

Farmer's Reducer. This reducer is supplied in packet form. To prepare it for use, dissolve and mix as directed on the label. Store the solutions in separate containers, and use the working solution immediately after mixing; it remains active for only about ten minutes. Make a working solution by mixing equal parts of Solution A and B. Mix only the amount you need, because the working solution does not keep well.

If your negative has been dried, soak it thoroughly in water for at least ten minutes before beginning the reduction. To reduce an entire negative, place the wet negative in a small tray, pour the working solution of the reducer over the negative, rocking the tray continuously. The reduction will occur rapidly, so watch the negative closely and take it out of the reducer as soon as you reach the desired amount of reduction. Wash the negative for twenty minutes in running water, put it through KODAK PHOTO-FLO Solution, and hang to dry.

To reduce local areas of the negative, dilute the working solution with water 1:4. Lay the wet negative on a sheet of glass or the bottom of a darkroom tray. It's very helpful if you put the negative on an illuminator so you can easily see the reduction taking place. However, be careful that solutions do not seep into the electrical parts of the illuminator. With a damp piece of cotton, wipe away any water from the area you want to reduce.

If the area is small, pick up the reducer on a brush; if the area is large, use a cotton swab. Remove the excess reducer from the brush or cotton; then apply it with a continuous motion over the area to be reduced. Repeat the procedure until you have achieved the desired degree of reduction, washing the area with wet cotton each time before applying fresh solution, then washing as described above. To stop the reducing action, wash the area several times with wet cotton.

Abrasive Reducer. With KODAK Abrasive Reducer you can reduce dense areas of a negative without having to refix the negative. This reducer comes in a paste form and is ready to use right out of the jar. Since Abrasive Reducer works by actually "grinding" away portions of the negative, you should try it on scrap negatives until you've learned to control the reduction. Tape your negative to an illuminator so you can see the reduction.

Pick up a small amount of the Abrasive Reducer on a tuft of cotton; for a small area, use a cotton swab. Work the reducer into the cotton by rubbing it on a glossy surface such as a piece of glass, and then rub the area of the negative you want to reduce until you see the desired result. Be careful not to overreduce; too little is better than too much. When you're satisfied with the reduction, remove any excess reducer with clean cotton.

Reducing Black-and-White Prints

Soak dry prints in a tray of water for ten minutes before applying the reducer. Make a working solution of Farmer's Reducer by mixing Solution A and Solution B in equal parts and then dilute the working solution with water 1:10.

To reduce the overall density of a slightly overexposed print and to clear veiled highlights, soak the print in diluted reducer for five to ten seconds with continuous agitation. Put the print on the back of a tilted tray in the sink, and rinse the print in running water often to check progress of the reduction. Repeat this procedure if you desire further reduction. Rinse the print in running water for one minute, fix for five minutes in an acid-hardening fixer, such as KODAK Rapid Fixer, wash for one hour (you can use KODAK Hypo Clearing Agent and cut down on the washing time), and hang to dry. Some additional density loss may occur in the last fix.

PETER CHIESA

Here's an unusual application of overall print reduction. Believe it or not, the photograph on the left *was* planned! The photographer needed an illustration for a stereo salon entry form, so he took the picture of another photographer and then outlined with india ink the areas of the print he wanted to reproduce. Then he soaked the print in a solution of Farmer's Reducer until the photographic image was reduced away and the only thing left was the india ink outline. This is one way to create a line drawing if you're an artist with a camera instead of a pen.

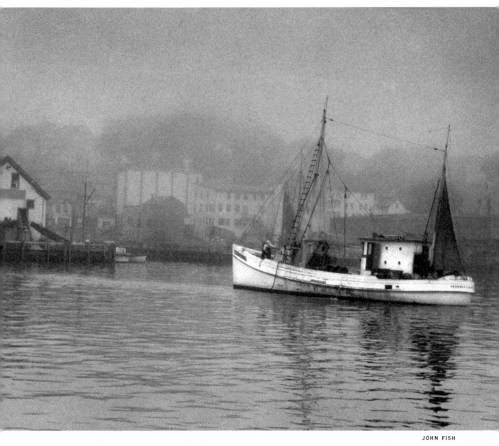

You can lighten the highlights in prints very effectively with KODAK Farmer's Reducer. The boat in this picture was locally treated with Farmer's Reducer to brighten it and make it the center of interest.

To brighten local areas, such as veiled highlights, apply the reducer with a damp wad of cotton or a cotton swab. Place the wet print on the back of a tray and rinse the print with running water between applications of reducer. Rinse, fix, and wash the print as described above.

Local reduction may cause a yellow stain on the print, so work the reducer into the print for a brief period while the reducer is most active and then rinse with water and reapply fresh reducer. Warm-tone papers generally reduce more rapidly than cold-tone papers. If you plan to tone your prints, do any reduction *before* toning. Reduced prints tone differently than prints that have not been reduced. We don't recommend toning for prints that have been locally reduced.

REDUCING PRINTS WITH FARMER'S REDUCER

In white light:

1. Soak dry prints in a tray of water for 10 minutes before applying the reducer.
2. Make a working solution of KODAK Farmer's Reducer by mixing Solution A and Solution B in equal parts and then dilute the working solution with water 1:4.
3. Soak the print in the diluted reducer for 5 to 10 seconds with continuous agitation.
4. Put the print on the back of a tilted tray in the sink and rinse with running water to check the progress of the reduction.
5. Repeat steps 3 and 4 if you desire further reduction.
6. Rinse print in running water for 1 minute.
7. Fix for 5 minutes in an acid-hardening fixer, such as KODAK Rapid Fixer.
8. Wash for 1 hour. You can use KODAK Hypo Clearing Agent and cut down the washing time.

INTENSIFICATION

Intensification is a process of strengthening the density and contrast of a photographic image on a black-and-white film negative or positive. Because of the complex nature of color emulsions, intensification is not possible with color negatives. Most methods of chemical intensifying increase the effective density proportional to the existing density of the image; the highlights are intensified more than the shadows and the overall contrast of the negative is increased. You can do all stages of the intensifying process in white light.

Intensifying Black-and-White Negatives and Transparencies

KODAK Chromium Intensifier increases the density and contrast of black-and-white films, producing a light yellow stain over the negative. If you don't like the results, you can wash the stain off and start over with no damage to the negative. This intensifier comes in packet form, and contains a bleach and a clearing bath. In addition, you'll need a quick-acting, nonstaining developer such as KODAK DEKTOL Developer diluted 1:3. Follow the instructions on the package for mixing the working solutions.

The film must be fixed thoroughly in an acid-hardening fixing bath, such as KODAK Rapid Fixer, and thoroughly washed prior to intensification. If in doubt, refix the film. If the film has been dried previously, soak it in water for at least ten minutes. Handle the film carefully by the edges, because any fingerprints will be intensified and become very obvious with this process.

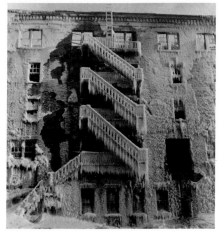

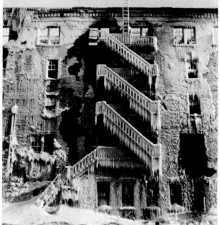

PETER CHIESA

All these pictures were made from the same roll of film, which was accidentally underexposed because the photographer set the wrong ASA speed in his meter. The prints on the left are flat because they were made from thin, underexposed negatives. The prints on the right show a full range of tones because the negatives were intensified.

INTENSIFYING BLACK-AND-WHITE FILM

In white light:

1. Immerse the film in the Chromium Intensifier Bleach Bath until the black image is bleached yellow—3 to 5 minutes at 68 F.
2. Rinse the film in water.
3. Immerse the film in the Chromium Intensifier Clearing Bath until the yellow stain has been removed and a nearly white negative image remains—about 2 minutes at 68 F.
4. Rinse film in water for 30 seconds.
5. Redevelop film in KODAK DEKTOL Developer diluted 1:3 until the white image is darkened completely.
6. Wash for 10 to 20 minutes in running water.
7. Put the film through KODAK PHOTO-FLO Solution and dry.

NOTE: No fixing is necessary, and the complete process may be repeated if you desire additional intensification.

MORE INFORMATION

Processing Chemicals and Formulas, KODAK Publication No. J-1 ($1) has more information on reducers and intensifiers, and instructions on mixing your own solutions.

In addition to the methods mentioned here, there are several different ways of controlling the image through retouching. For information on black-and-white retouching techniques, write for a free copy of KODAK Publication No. 0-10, *Retouching Black-and-White Negatives.* Send your request to Eastman Kodak Company, Dept. 412L, Rochester, New York 14650. Be sure to ask for the pamphlet by title and code number.

Improving Composition & Appearance of Prints

Vignetting is a means of isolating the subject and eliminating unwanted background areas. Diffusion techniques will allow you to soften the lines in a portrait or create a blurred background for creative effects.

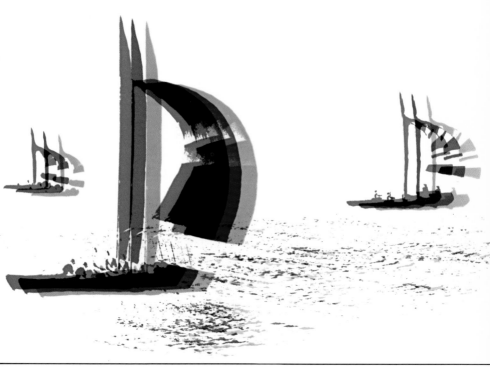

BARBARA AND PAUL KUZNIAR

You may want to deliberately distort a photograph during printing for creative effects. The technique used for this picture is described on page 51.

With vignetting, you can turn a backyard
snapshot into a portrait. Vignetting is very
helpful for isolating a subject and eliminating
busy, unwanted areas in a photograph.

This chapter will help you add those extra touches that can turn good pictures into great ones. You'll learn how to eliminate or diffuse a background, and how to soften facial lines for flattering portraits. You'll also learn darkroom techniques for correcting distortion, producing distortion for creative effects, and creating moving subjects.

VIGNETTING

Vignetting is a printing technique used to eliminate distracting or unwanted background. This technique is primarily used for enlargements of people and it's popular for printing high-key portraits which are made up mostly of light tones.

You can easily vignette a print by projecting the image from the negative through a hole in an opaque cardboard. Cut the hole in the cardboard the same shape as the area you want to print. The hole should be the size that will give you the effect you want when you hold the cardboard halfway between the enlarger lens and the paper. Cut the edges of the hole in a sawtooth pattern so that the image fades gradually into the white paper. In vignetting, keep the vignetter in continuous motion during the print exposure.

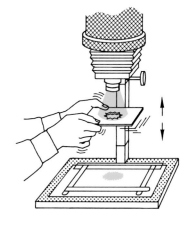

You can make a vignetting tool by cutting a hole in a piece of opaque cardboard. Hold the vignetting tool halfway between the lens and the paper in a position that allows the part of the image you want to print to project on the paper. Keep the tool in continuous motion during the print exposure.

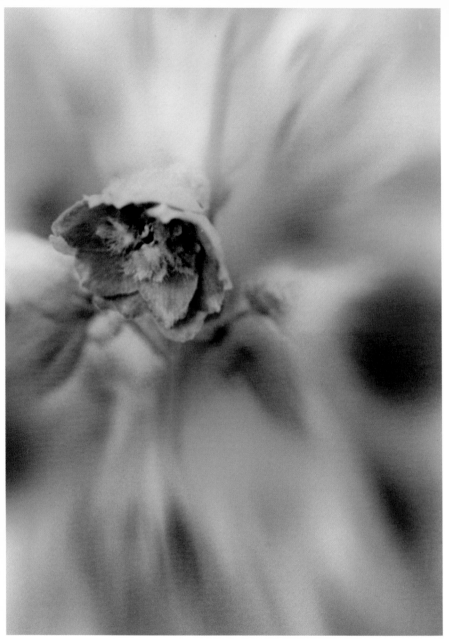

BARBARA KUZNIAR

You can create diffusion so subtle that the viewer is not aware of it, or you might want to make it obvious for a creative effect. This print was enlarged through a sheet of glass which had petroleum jelly smeared on it except for one small, clear area. The glass was moved up and down between the enlarger lens and the paper during the exposure, and the clear area was centered over one flower so it would be sharper and stand out. The color in the center of the flower was added later with transparent dye (described on page 131).

Printing Several Images with Vignetting

You can use the vignetting technique to print portraits from more than one negative on a single sheet of enlarging paper. Assume you want to print from three negatives. Decide where you want each image to appear on the final print, and draw circles on a sheet of white paper on the enlarger easel to indicate the location of each image. Put the first negative in the enlarger and adjust it so that the image you want fills a circle. Remove the white sheet of paper and make your exposure test for the first negative. It isn't necessary to use the vignetting technique for your exposure test. Now, using the vignetting technique, make the first exposure on the enlarging paper that will be your final print. (It's a good idea to put a small "X" in one corner on the back of the enlarging paper to help keep it properly oriented.) After you make the exposure, put the paper with the circles on it back in the easel and adjust the enlarger and easel position for the second picture. Follow the same procedure you did for the first negative. After you've exposed the second negative, follow this same procedure for the third negative. Then, process the print.

DIFFUSION

With diffusion, you can soften or blur sharp lines in an image. By diffusing the projected image when exposing an enlargement, you're actually spreading some of the light from the shadows into the highlights. In pictorial photography, diffusion is most often used to produce a hazy effect to simulate an early-morning scene. Partial diffusion can also be used to blend in background areas. In portraiture, diffusion is used to subdue blemishes and wrinkles in the subject's face or to soften the effect of harsh lighting or coarse retouching. Slight diffusion simulates the effect of a soft-focus camera lens.

Diffusing the Whole Print Area

Diffusing devices are available from your photo retailer, or you can use a transparent negative sleeve or the transparent wrapper from a cigarette package. Hold the diffusion sheet under the enlarging lens during the exposure, and move it back and forth to prevent any imperfections from printing sharply on the print. This method produces slight diffusion, and you can increase the amount of diffusion by wrinkling the material you are projecting through. You can also use a piece of gray or black nylon stocking as a diffuser. Stretch it across a hole in a piece of cardboard and tape it in place. The amount of diffusion is controlled by the distance of the diffusing material from the lens; the nearer the material is to the lens, the greater the diffusion effect will be.

Take care not to overdiffuse the print, or the highlights will be degraded. Because diffusion tends to reduce print contrast, you will probably want to use a higher contrast grade of paper than you'd use to make an undiffused print. For the most pleasing effect, diffuse the image for part of the exposure time—try one-third—and give the remaining exposure without diffusion.

Diffusing Selected Areas of a Print

You can blend together troublesome sharp and distracting areas of a background by diffusion. The easiest way to do this is with a glass negative carrier and a small amount of petroleum jelly. Apply the petroleum jelly on the top of the upper glass of the negative carrier over any area that you want to blend in. Feather the edges of the smear so that they won't show in the print. The amount of diffusion depends on the thickness of the glass in the carrier and the amount of petroleum jelly you use. Thicker glass gives better results because it provides more diffusion. You can also surround a center of interest with petroleum jelly and produce an interesting type of vignette.

DISTORTION

You can correct the distortion caused when parallel lines are photographed at an angle and appear to be converging. You can also use distortion to improve pictures of people who have been photographed from an unflattering angle. For example, if a person appears short and stout because he was photographed from too high an angle, you can make him appear taller and slimmer. You may also want to use distortion for creative effects by greatly exaggerating a part of a picture or by adding an effect of movement to the picture.

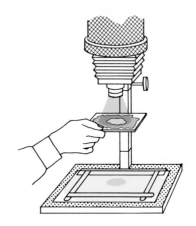

You can diffuse selected areas of the print by using petroleum jelly smeared on a sheet of glass. Feather the edges of the petroleum jelly so that the diffused area will blend into the areas that are being printed straight. Hold the glass between the enlarger lens and the paper and move it slightly during the exposure. If you have a large negative and a glass negative carrier, you may want to put the petroleum jelly right on the glass carrier.

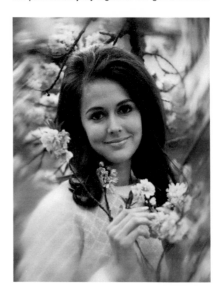

Here's the petroleum jelly on glass technique again—easy to do in black-and-white or color.

The straight print above had a very busy background which the photographer
wanted to subdue without eliminating the surroundings completely. The picture
below was printed through a sheet of glass with petroleum jelly
smeared on it. A clear area was left in the center of the glass. During printing,
the photographer centered the clear area over the main blossom and
moved the glass up and down slightly.

You can create a more subtle type of diffusion by painting a sheet of glass with clear nail polish. Leave a clear area for centering the glass over the area of the print that you want to look the sharpest. Move the glass slightly during printing for an even diffusion. One advantage of using nail polish instead of petroleum jelly is that it's not as messy, and once you've painted the glass with polish it will last forever.

Convergence Controls

When you take a picture with your camera pointed up or down, vertical lines in the picture appear to be converging. You can correct for this when you're enlarging. First, tilt the enlarger easel by lifting up one edge until the vertical lines in the projected image appear parallel. Then place something under that edge to hold the easel in place. Focus the image at a point one-third of the way in from the high edge. You may be able to keep the image in focus over the entire picture area by using a small lens opening. However, if the easel is tilted at a considerable incline, you must tilt the negative carrier in your enlarger. (You won't be able to correct for severe converging lines.) Tilt the negative carrier until the image on the easel appears sharp.

Incidentally, tilting the enlarger easel to correct for converging vertical lines will probably give a "slimming" effect to your subject. When the easel is tilted, the proportions on the print equal those in the original scene only when the enlarger lens-to-negative distance is equal to the camera lens-to-film distance when the picture was made. Since the enlarger lens is likely to have approximately the same focal length as the camera lens, the enlarger lens-to-negative distance is likely to be greater than the camera lens-to-film distance (due to the shorter "subject distance" involved in enlarging). With the easel tilted, you'll get a greater magnification of height than width, resulting in the slimming effect. This slimming effect can be helpful in making more flattering pictures of people who may have been photographed from an angle that makes them appear short and stout.

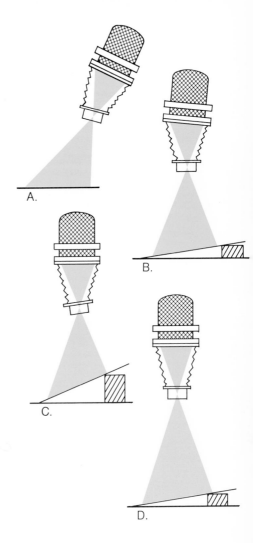

Means for correcting converging lines include:

A. Fixed easel but tilted enlarger. The lens is tilted to make the image plane uniformly sharp even at a large lens aperture.

B. Tilted negative and tilted easel. Sharpness over the image area is provided by tilting the negative in the indicated direction.

C. Fixed negative but tilted lens and easel. Notice that this condition is similar to A except that the enlarger is upright.

D. Fixed negative and lens but tilted easel. In this case the depth of field is quite shallow and lens must be well stopped down.

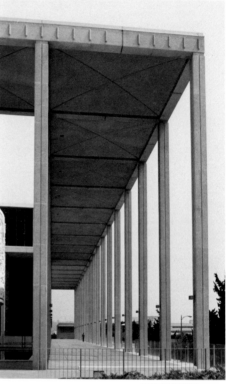

Notice how the buildings lean in on the print on the left. When the picture
on the right was printed, the easel was tilted to correct the converging lines.

Distortion for Creative Effects

By using the above method of con-
vergence control on some subjects,
you can create very dramatic pic-
tures. For example, in a picture of a
person extending his hand for a hand-
shake, you can tilt the easel to make
the hand look very large. Experiment
with this technique and see what new
pictures you can create with nega-
tives you've printed "straight" before.

Another way you can distort the im-
age for creative effects is to bend the
paper before exposure. Bend the pa-
per toward the base side (convex
bend) to stretch out the image; bend
toward the emulsion (concave bend)
to condense and shorten the image.

Moving the easel. Ever think of adding a third dimension—movement—to a print in the darkroom? You can add movement by putting your easel on several dowels or round pencils which will make it easy to move during the exposure. If you allow the print to remain still for half the exposure time and then move it during the second half of the exposure, you'll produce a sharp image with horizontal streaks, which makes the subject look as though it was traveling very fast. This technique is most effective with a subject that would normally be moving, such as a racing car or a running figure.

You can also produce a feeling of movement by making multiple exposures of the same subject and moving the easel between exposures. It's best to select a very simple subject for this technique, preferably with a plain background.

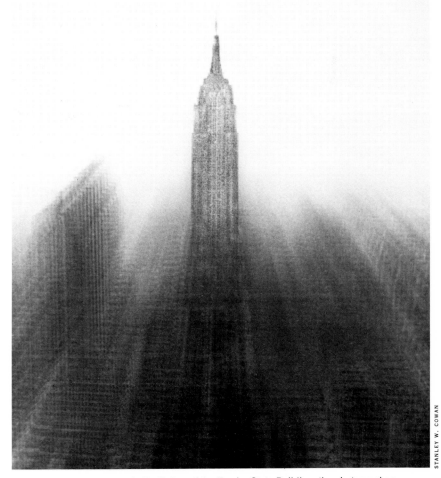

STANLEY W. COWAN

To create this "exploding" view of the Empire State Building, the photographer made an exposure on the paper, and then moved the enlarger up and made another exposure. He repeated this many times without moving the paper, but always dodging the main building. Then he dodged the rest of the paper while printing in the building.

This color print is made from a black-and-white KODALITH Negative. Three
exposures were made, each through a different color filter. After each exposure

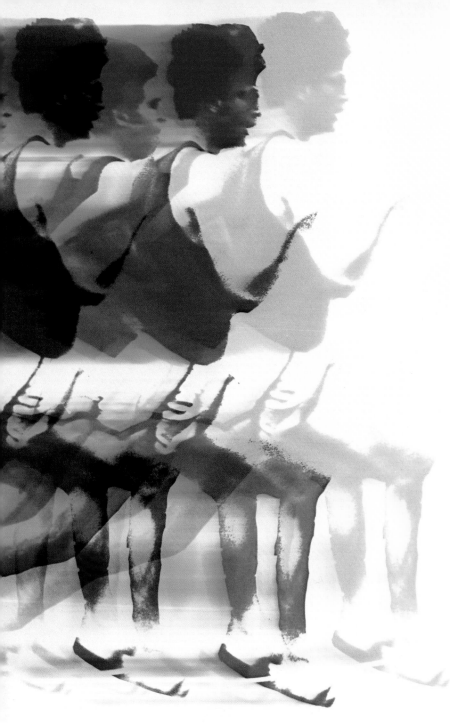

the easel was moved slightly to give the feeling of movement in the runners.
For more information on printing color from black-and-white negatives, turn to page 129.

53

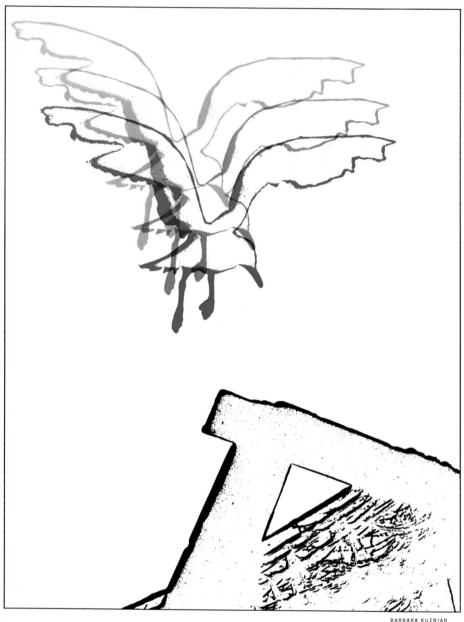

BARBARA KUZNIAR

This print was also made from a black-and-white KODALITH Negative, and it was
printed in the same manner as the runners on page 53. The bottom area was masked out
with black paper while the bird was exposed through the filters; then the bird was
masked with paper while the bottom half of the negative was exposed to
white light to produce the black in the print. There are other variations
on this subject on pages 15 and 194.

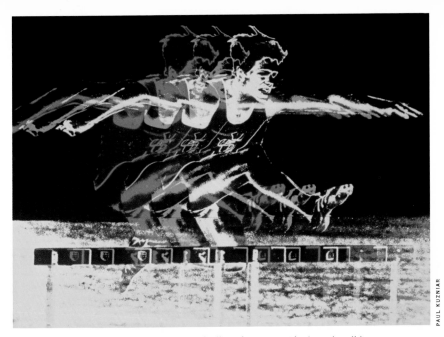

PAUL KUZNIAR

It's also possible to incorporate a feeling of movement in the color slides you create from KODALITH Film. This KODALITH Film was copied using an electronic flash (refer to page 253). Three exposures were made through yellow, green, and red filters, and the film was moved slightly after each exposure.

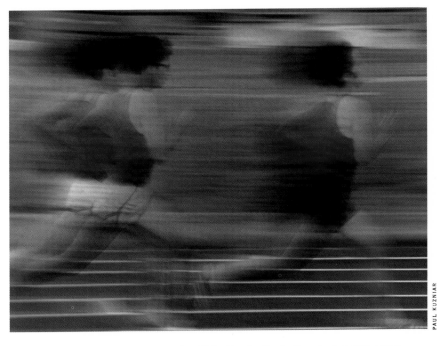

PAUL KUZNIAR

Panning during the exposure wasn't sufficient to give the feeling of movement, so the photographer placed the easel on dowels and moved it while exposing the print.

55

Creating New Pictures from Old Negatives & Slides

Ways of creating new images from existing ones. Texture screens add an overall texture to the photograph. Combination printing involves using two or more negatives to make one print so that you can add clouds to a bare sky or combine images for creative effects.

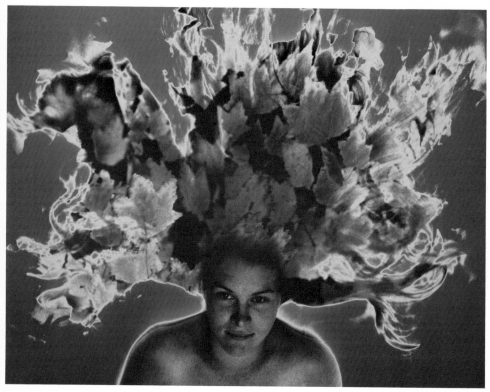

JAMES B. COWART

This is a combination print and a combination of techniques. The girl was photographed lying down so her hair could be spread out. That negative was printed with a mask so that only her head and shoulders, but not her hair, were exposed. Then a second mask was made which exposed only her hair, and that mask was printed with a negative of leaves. During development, the print was given the Sabattier Effect (described on page 195) after one minute to add density to the background, which had been covered by the masks.

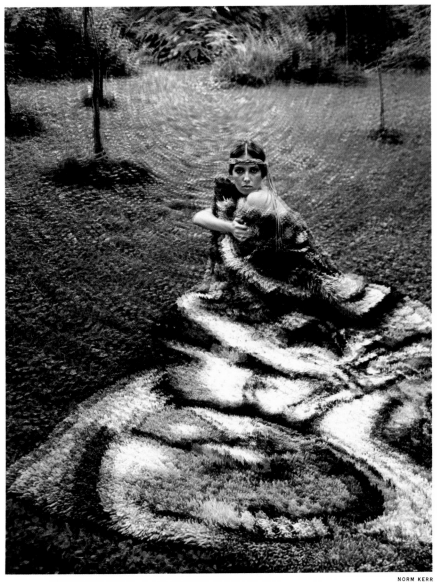

If you bracket your exposure when taking pictures, don't throw away those
slightly overexposed slides. You may be able to create a picture like this one
which was made by registering two ''thin'' transparencies of the same subject
and then rotating them slightly until a moire pattern formed.

Texture screens like this sunburst screen can create dramatic impact and lead the viewer's attention to the center of interest.

This is a combination print made with a texture screen. The plane was printed from a high-contrast negative, and then that negative was removed from the enlarger. The background was printed from a film sandwich of a moire pattern which produced the circle design, and a bromoil texture screen which created the pattern in the circles.

58

PAUL D. YARROWS

This combination print was conceived in an airport. The photographer took a picture of the tunnel in the TWA Building at Kennedy Airport. While waiting for the plane, he saw in a magazine just the image that he needed for a center of interest. He made a close-up slide of the magazine picture and then printed the slide on KODALITH Film. After printing the tunnel picture, he printed the slide on KODALITH Film with the image of the man on the same sheet of paper.

You can create mood and mystery in your photographs with combination printing.

SUSAN TINDALL

59

You can add a new dimension to your black-and-white and color prints with texture screens. This print was made with a Mona Lisa texture screen in contact with the paper.

DONALD J. MAGGIO

Most advanced darkroom enthusiasts have enough old negatives and slides to keep them busy printing in the darkroom for several years. But you've already printed all those pictures, you say? You may have printed them straight, but after you read this chapter, you'll want to get them out and use them again to create new pictures.

TEXTURE SCREENS

You can make some interesting and unusual enlargements by printing through a "texture screen," which is a device that gives the print a textured appearance.

The texture itself can be prepared in a variety of ways using cloth, wire, glass, net, plastic, or most any translucent material with a grained appearance. Some texture screens are commercially available in film sheets; others are good do-it-yourself projects.

Commercially Made Texture Screens

Commercial texture screens come in two types; small screens which are laid over the negative and printed with it, and large screens which are printed in contact with the paper.* Small screens give good results and they are less expensive than large screens. Small screens are easier to use because there is much less area to clean, and it's easy to keep them in complete contact with the negative by using a glass negative carrier. Place the emulsion of the texture screen next to the emulsion of your negative in a glass negative carrier, and print them as one negative.

*Texture screens are available from photo dealers. One mail-order company that supplies both small and large texture screens is Texturefects, 7557 Sunset Boulevard, Hollywood, California 90046. They will send a free pamphlet, on request, showing the various textures available.

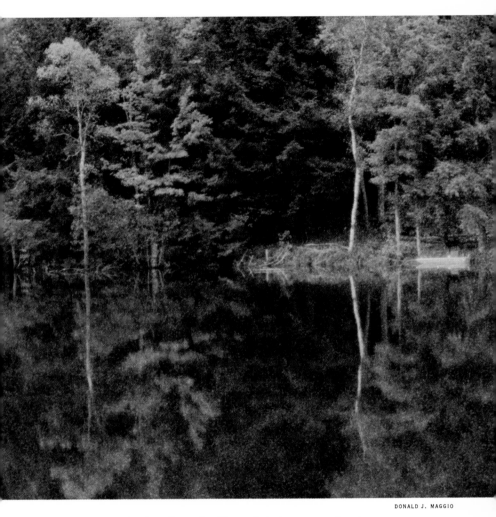

A color print made with a grain texture screen placed
directly on the paper during printing.

Print from a grain texture screen alone.

Print from a Mona Lisa texture screen alone.

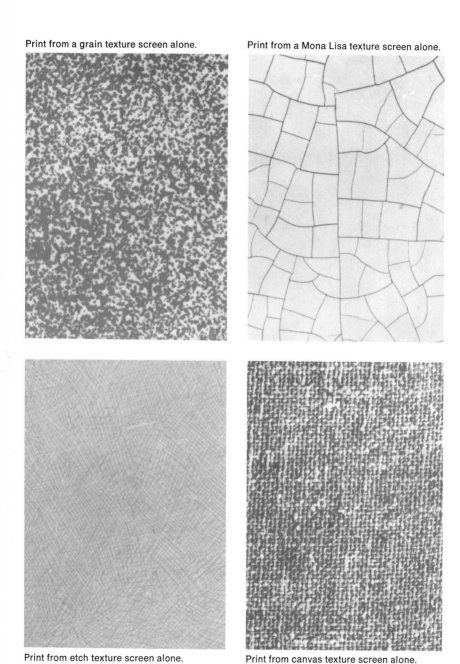

Print from etch texture screen alone.

Print from canvas texture screen alone.

A color print made with an etch texture screen placed
directly on the paper during printing.

A black-and-white print showing the effects of a mezzotint texture screen.

A color print made with a canvas texture screen on the paper during the exposure.

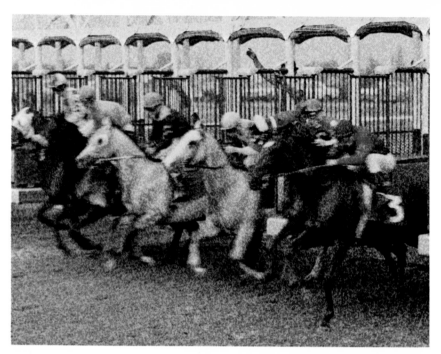

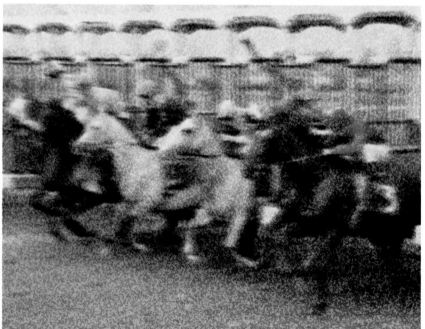

Both prints were made with a grain texture screen on the paper during
the printing. The bottom print was jiggled slightly during
the exposure to add the feeling of movement.

PAULA LYONS

A piece of textured glass placed on the paper added the texture to this scene.
The paper was prefogged slightly to add to the mood.

With any kind of texture screen, you can use dodging and printing in, just as you would when printing a negative without a texture screen. A texture screen may cause a slight loss of print contrast, so you may want to use a paper of a higher contrast grade than you would select if printing the negative normally.

Large texture screens are used on contact with the emulsion of the enlarging paper on the easel. You may need to place a sheet of clear glass over the texture screen to hold it in contact with the paper. Otherwise you could get a blurred texture effect where the screen isn't in good contact with the paper. You can keep the screen in position during all or part of the exposure, depending on the degree of effect you want. If you want the screen in place for only part of the exposure, divide the total exposure time in parts so that you can remove the screen when the enlarger is off. Make sure you don't move the paper between exposures.

Making Your Own Texture Screens

You can make a simple texture screen by stretching a sheer cloth tautly over a frame that can be placed over your enlarger easel. The cloth should be in contact with the paper. Flocked nylon cloth, which has designs woven into it, will add an overall texture and also reproduce a cloth design in white on your print. Your local yard-goods store will have a variety of materials that you can use for texture screens. If you want the design to print black, contact-print the flocked nylon onto a piece of KODALITH Ortho Film 6556, Type 3. After printing the original negative, remove the negative and then print the KODALITH Film texture screen onto the same sheet of paper.

You can easily make other varieties of texture screens by photographing textured surfaces. For example, use strong sidelighting to bring out the texture of a material such as charcoal-type drawing paper, or a sheet of unprinted KODAK EKTALURE Paper, X surface. Take a close-up picture of this and you can use the negative as a texture screen. Put the texture screen in the negative carrier together with the negative you are going to enlarge, and print them both at the same time. This procedure gives your print a much more pronounced texture effect than a contact texture screen.

A sheet of clear plastic with a textured surface makes a good texture screen. A plastic-supply company will have a variety of textures to choose from, and they'll cut the plastic to the proper size to fit your easel. Simply place the plastic over your enlarging paper, with the textured side toward the lens and the flat side on the paper, and print through it.

You can build a dot-type texture right into your negative by printing a slide onto KODALITH AUTOSCREEN Ortho Film 2563 (ESTAR Base). This is a graphic-arts film and it's available from a graphic-arts supplier.* As the name indicates, this film has a texture screen built right into it. Develop the film in KODALITH Super Developer (also available from graphic-arts dealers), following the processing instructions on the film instruction sheet. Since your original was a slide, you'll get a negative image on the KODALITH AUTOSCREEN Film, and you can print this film without going through any other intermediate steps.

*Listed under Printing Supplies in the yellow pages of your telephone book.

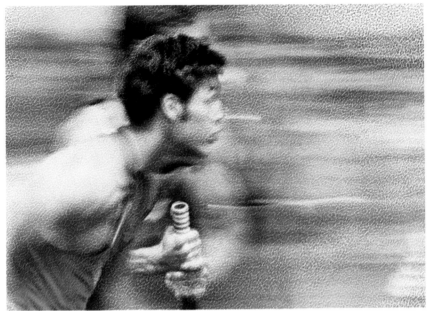

This homemade texture screen is a piece of clear textured plastic which was placed on the paper during the exposure. Plastic suppliers have a large variety of textures to choose from.

A print made from a KODALITH Negative with a piece of clear textured plastic on the paper during the exposure.

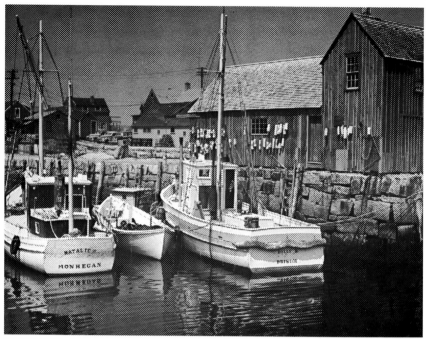

This texture screen is built right into the negative, which is on
KODALITH AUTOSCREEN Ortho Film 2563 (ESTAR Base).

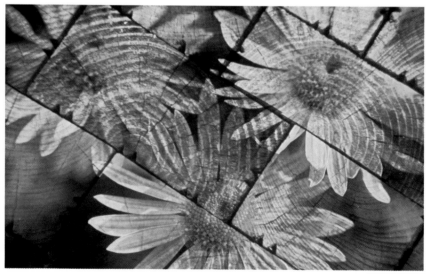

An easy way to add a texture to your color pictures is with a montage.
The photographer sandwiched a color slide of a wooden sidewalk with a slide of
pink daisies, and then had an internegative made. The internegative
has the texture built in, and it's easy to print because you only
have to handle (and clean) one piece of film.

Here's a print made from a texture screen alone. The texture screen was made by contact-printing a piece of lens cleaning tissue on a sheet of KODALITH Film.

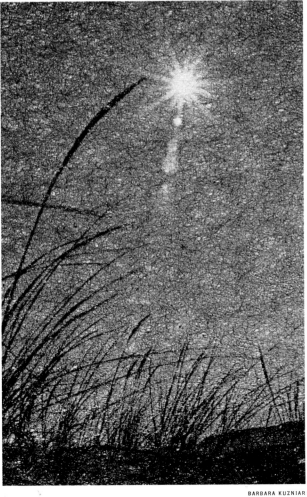

The lens-cleaning tissue texture screen was sandwiched with a color negative and they were enlarged together to produce this color print.

BARBARA KUZNIAR

COMBINATION PRINTING

In combination printing, you use two (or more) negatives to make a print. The most common use of combination printing is adding clouds to a cloudless sky. Here's how to do this:

Adding Clouds to a Sky

Select a cloud negative, making sure that the direction of the lighting on the clouds is the same as the direction of the lighting on the subject in your foreground negative. Often you can reverse the cloud negative, if necessary, in order to make the lighting in the two negatives correspond. Then proceed as follows:

1. Determine correct exposure for each negative with the enlarger set at the degree of magnification you're going to use. Record the enlarger position (degree of magnification) and the correct exposure for each negative.

2. Expose the foreground area of the print and, at the same time, use your hand or a card (cut to the contour of the sky) to hold back light from the sky area within about one inch of the horizon and any foreground buildings or trees that project into the sky. Hold your hand or the card a few inches above the easel, and keep it moving. This leaves a gray-tone margin into which you can blend the clouds.

3. Replace the foreground negative with the cloud negative. Print the cloud negative and, at the same time, use your hand or a card cut to the contour of the foreground (use the other half of the piece you used to hold back the sky) to hold back light from the previously exposed foreground area. Hold your hand or the card a few inches above the easel, and keep it moving so that the edges of the two images blend smoothly.

Clouds can add drama and interest in a photograph, and you can add clouds to your prints in the darkroom. When adding clouds, it's important to make sure that the direction of the light on the clouds and the foreground is the same, or the picture won't look natural. The clouds were added to this print in the darkroom, and then the print was toned with KODAK Blue Toner (described on page 112). A dodging tool was cut out of black cardboard to prevent the lighthouse from receiving any additional exposure while the cloud negative was printed.

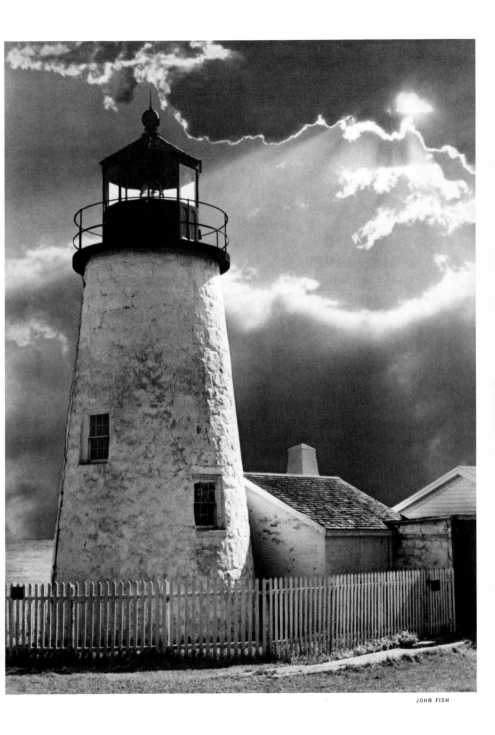

JOHN FISH

73

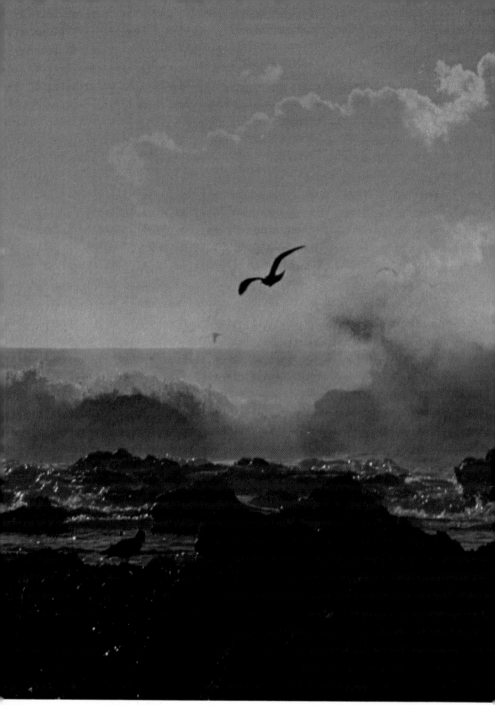

Good photographers usually try to avoid getting a white "bald" sky in their pictures, but you can't control the weather conditions. If you see a good picture with a bald sky, take it anyway. You can fill in that empty sky later in the darkroom or make a slide montage. This slide is a montage. The birds, waves, and rocks

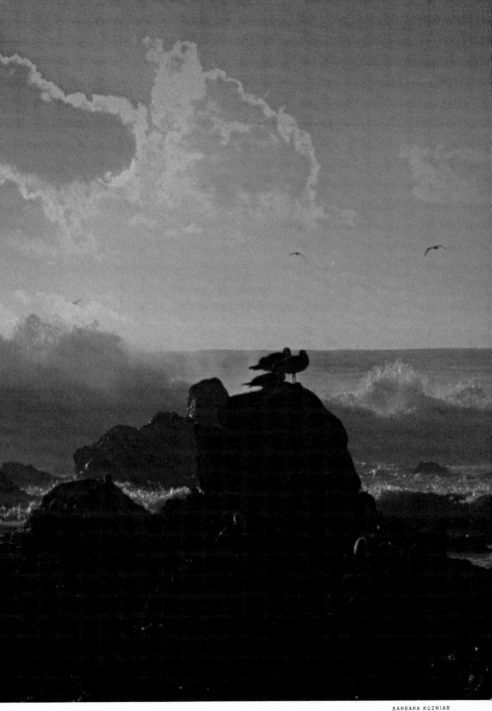

are on one slide and the clouds and sun are on another. After sandwiching
the slides together, you can have a color internegative made by your photofinisher,
and then you can make a print in black-and-white or color.

Combining Images for Creative Effects

The easiest way to obtain a double image in a print is to make a montage by putting two or more slides together, then have an internegative made from the montage. Because slides are positive images, they allow you to see exactly what the combination will look like before you go into the darkroom. This technique makes it easy to make combinations in color without having to worry about printing the correct color balance of two separate color negatives. All you have to do is make a "straight" print from the internegative because the images will be combined on it.

If you have problems with Newton's rings in your slides, dust the film with a spray of fine talc. Brush off the excess talc and then mount the slides together. Fine talc is available from graphic-arts suppliers.

Combination printing from separate negatives requires that you visualize the combined images before you go into the darkroom so that you know where to begin when you get there. The best candidates for combination printing include at least one negative with a large area of blank space. This space is where the image of the second negative goes during the printing.

If the blank space in the negative is a clear area and if both negatives are the same size, you may be able to sandwich the negatives together in a glass negative carrier and print them both at once.

If the blank space in the negative is dark, or if the images on the two negatives need to be enlarged by different degrees, you'll have to print them separately. Follow this procedure. →

COMBINATION PRINTING FROM SEPARATE NEGATIVES

1. Put the negative with the blank space in the enlarger and compose the picture on the easel. Put a white sheet of paper in the easel and sketch the boundaries of the blank space. Remove the sketch.

2. Make a test strip to determine the exposure of this negative, note the position of the enlarger and the exposure, and then remove the negative.

3. Put the second negative in the enlarger and place the sketch on the easel. Compose this negative in the area indicated on the sketch. Remove the sketch and make a test strip. Be sure to record the position of the enlarger and the exposure.

4. Print the second negative onto a fresh sheet of paper. Dodge any areas of the negative that might overlap and print into areas of the first negative. Mark the paper so that you can place it back in the easel in the same position, and put it in a lighttight box. Remove the negative.

5. Place the first negative back in the enlarger in the same position that you used for step 1. You can use the sketch to help you recompose the picture. Place the exposed paper back on the easel in its original position and print the first negative. If the blank area would turn out black, dodge it during this exposure.

6. Process the paper in the normal way.

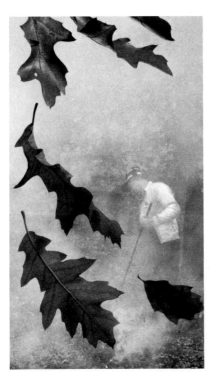

The print of the man raking leaves lacked depth, so the photographer arranged some leaves on a white background and photographed them. Then he printed the two negatives together to produce a prize-winning print.

JOHN FISH

You can also simply print two images on one sheet of paper if you want the images to overlap and show through one another.

To add silhouetted subjects to a print, such as a flock of birds in front of a sunset, print the silhouette onto a sheet of KODALITH Ortho Film 6556, Type 3. The film should be clear where the subject appears and black in all other areas. (For more information on using high-contrast films, refer to page 150.)

Print your original negative, and then print the KODALITH Negative. Because the background of the KODALITH Negative is solid black, it does not require any dodging in the background area during the exposure. The black background acts as a mask, protecting the original image from any overprinting.

Once you've tried combination printing, you'll probably find yourself taking some pictures with this technique in mind. The photographer knew that the picture of the hockey players needed a foreground, but there just wasn't a suitable one around. He took the picture anyway and saved it. Later he found just the right foreground and photographed it. Then he made a negative on KODALITH Film to increase the contrast and eliminate the details in the area where the hockey players were to be printed. The negatives were then printed one at a time to create the final picture.

RICHARD FELDMAN

This was a planned combination print. The lighting on the portrait made the face fade into the background and created a muddy image. The face was printed to a high contrast, and the negative of cracked mud added the middle tones as well as the texture.

ROBERT KRETZER

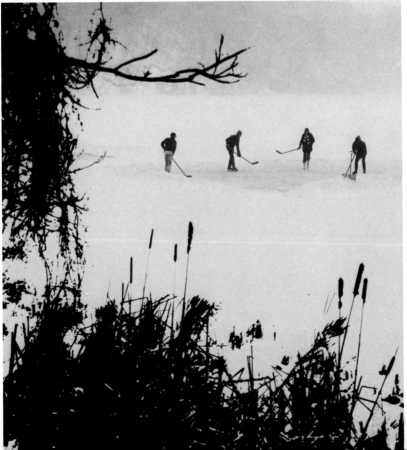

79

The sand dunes were photographed on KODAK PLUS-X Pan Film, and that
negative was printed on KODAK Commercial Film to produce a positive image.
The nude was photographed against a black paper background. While printing
the positive film of the sand dunes, the photographer dodged the bottom of
the paper with a piece of cardboard. Then the negative with the nude was
printed at the bottom of the paper while the top was dodged.

A straight print was made from the negative containing the window. No dodging
was necessary, because the sky was clear. Then the photographer printed
the girl's face in the window area, and used a vignetter during the exposure
to allow only the head area to print.

The picture of the water and rocks was printed first and the area where the face was to appear was dodged during the exposure. Then the girl's face was printed and everything but her face and hair were dodged during the exposure.

The model wearing black was photographed four times against a black background so that the only density recorded in the negatives was her face and hair. The four negatives were sandwiched together and printed to create this composition.

NORM KERR

JEFFREY R. BLACKMAN

Both images were printed from high-contrast negatives and no dodging was necessary. The negative with the smokestacks was given a long exposure to produce a black tone; then the negative with the cars was given a short exposure to produce a gray tone.

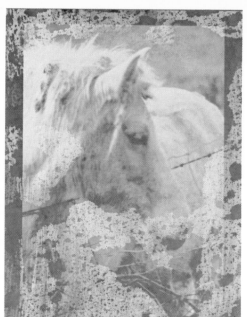

LESLIE FRIED

This is a combination print made from a paper negative. A slide was printed on color paper and the paper was processed normally. While the paper was wet, it was contact-printed onto another sheet of color paper and exposed to filtered light (filter pack of 20M + 80Y). Then the second print was processed normally.

SHELDON JACOBVITCH

This is a combination print with a photogram. (Making photograms is explained on page 93.) The only part of the photo made from a negative is the two people holding hands. Black paper letters for the word "LOVE" were laid on the enlarging paper, and the photographer placed his head directly on the paper while he made the exposure to produce the outline of the face.

A combination print made from a color negative. The color negative was printed, and then a tone-line KODALITH Negative was printed in register to produce the black tones. The tone-line process is described on page 163.

The color negative was contact-printed onto KODALITH Film; then the color
negative and the KODALITH Positive were sandwiched together in register and printed.

Selective development is another way you can create new pictures in
the darkroom, and that's how this print was made. The photographer
projected the image on a piece of heavy paper and traced the face.
The face area was cut out to create a mask. After making an exposure
on a piece of enlarging paper, she left the paper in place in the easel
and swung the red filter over the enlarger lens so she could turn on the
enlarger light and see the image. Using a cotton swab saturated with
developer, she developed the important facial details (eyes, nose, and
mouth) by swabbing them with developer. After the facial areas were
developed to her satisfaction, she placed the paper facial mask over the
face and sprayed the rest of the print with developer in a plastic
squeeze bottle. The print was fixed and washed normally.

GUNGOR H. DEMIREZER

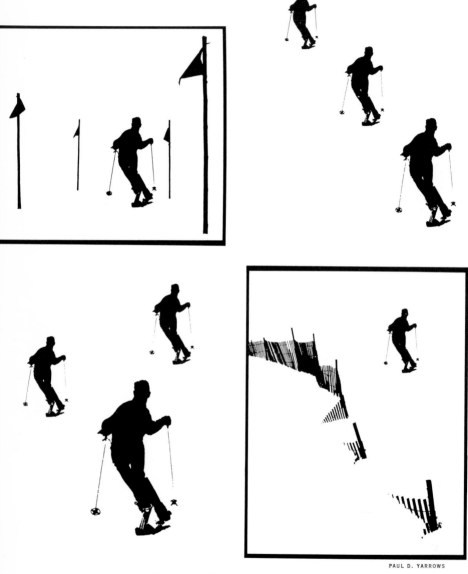

PAUL D. YARROWS

Here are just some of the combinations that this photographer was able to create by using the same subject in many different ways. The negatives were on KODALITH Film so it was easy to mask out unwanted areas with opaque or black tape. For more information on using KODALITH Film, turn to page 150.

Another way of combining images is with a collage. Make your prints in the
normal way, and then cut them up and mount them in an unusual composition.
The picture above is from one negative, the one below is a
combination of two photographs.

Printing
Without Negatives

A photogram is a shadow picture made in the darkroom without a camera. A paper negative is an image printed on photographic paper; then that paper is used as a negative to make another print. Printing slides is another way of making prints without negatives.

BARBARA KUZNIAR

A photogram made on KODAK RESISTO Rapid Paper and hand-colored
with transparent water colors. For information on coloring
black-and-white prints, turn to page 131.

A photogram on KODAK
POLYCONTRAST Rapid Paper.
The dried weeds were not pressed
flat—they were just laid on the
paper and the paper was exposed.
The butterfly is a costume
jewelry pin.

PENNY ILLINGWORTH

Lengths of string stretched
across the paper created the
fence, and then the photographer
placed his hands on the paper
during the exposure.

ROBERT KRETZER

Combining translucent and opaque objects is effective in a photogram.

A three-dimensional print created from a photogram. The pots are plastic foam coffee cups cut up and colored with a felt marker.

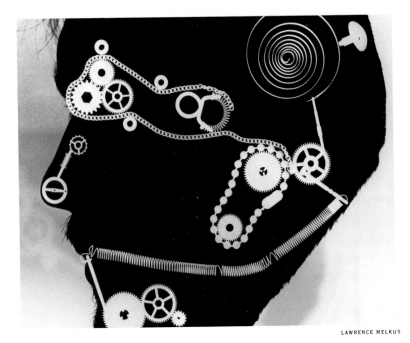

This is a combination print with a photogram. For more information on combination printing, turn to page 72.

PHOTOGRAMS

Black-and-White Photograms

Photograms are photographs made without a camera. A photogram is a shadowgram made in the darkroom by placing opaque objects on a sheet of photographic paper, exposing the paper to light, and then processing it. The resulting print will have a dark background and a silhouette of the objects in white. By adjusting the exposure, you can create a black background or any shade of gray.

You can also make a photogram by placing a flat object in the negative carrier of the enlarger and projecting it onto the paper. A glass negative carrier is necessary to hold the subject in a flat plane. The best subjects for this type of photogram are flat nature objects, such as leaves, feathers, transparent insect wings, weeds, and grasses. Since a negative is not used, image degradation is held to a minimum and enlargements produced by this method will have superb sharpness and faithfully reveal the most minute detail.

You can make more sophisticated photograms by arranging objects on a sheet of glass suspended above the paper to obtain a softened or blurred outline. By combining this technique with objects placed directly on the paper, you can simultaneously produce sharp and blurred images. You can also make multiple exposures and add or remove objects to obtain overlapping silhouettes in different shades of gray. Photograms can be printed with negatives, too. Simply place the objects on the paper, place your negative in the enlarger, and print them both at the same time.

Color Photograms

You can make color photograms on color paper, and negative or reversal color film. If your darkroom includes facilities for color printing, you can make color photograms in the same way that you make black-and-white ones. Of course to record the color, you'll need to use a color paper and process it in color chemicals.

If you do not have facilities for color printing, make your color photograms by using a color reversal film, such as KODAK EKTACHROME Film 6116, Type B (Process E-3). We suggest a reversal film because you can see the final result as soon as the film has been processed; then you can easily copy the photograms onto 35mm film. For the greatest flexibility in composition, use 8 by 10-inch sheet film. Put the film in the enlarger easel just as you would a sheet of paper. With the enlarger head about three feet from the baseboard, try an exposure of five seconds at $f/5.6$. For your first photograms, make an exposure series to determine the best exposure for your equipment. You can have the EKTACHROME Film processed by a photofinisher or custom photofinishing laboratory, or do it yourself using the KODAK EKTACHROME Film Processing Kit, Process E-3.

To reduce 8 by 10-inch films to a usable format, copy the photograms onto your favorite color-slide film. A copying technique is illustrated on page 253. With this method you can even combine more than one image to create a never-ending variety of pictures from photograms.

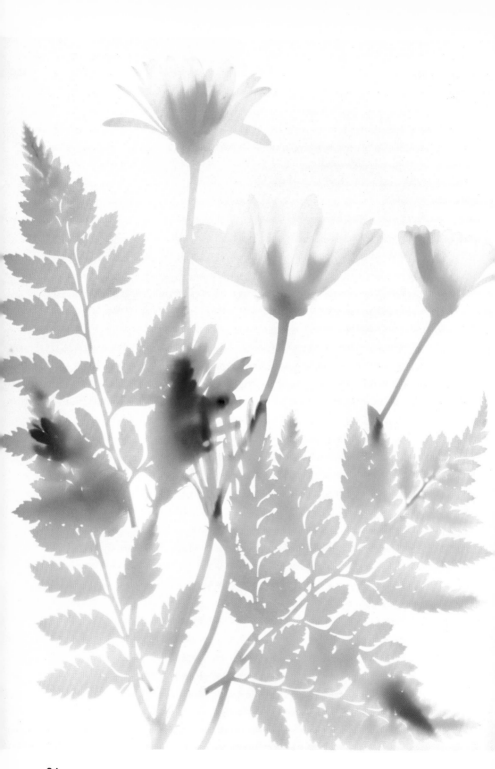

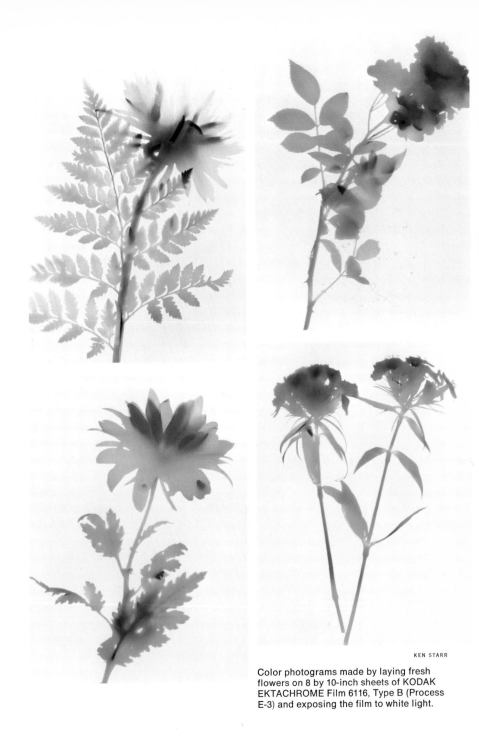

KEN STARR

Color photograms made by laying fresh flowers on 8 by 10-inch sheets of KODAK EKTACHROME Film 6116, Type B (Process E-3) and exposing the film to white light.

A sheet of KODALITH Film was exposed to white light and then processed. While the film was wet (and the emulsion soft), the drawing was scratched on the film, and this print was made from that film/drawing.

ROBERT KRETZER

This is a collage of three photograms printed on color paper. The photograms were made by placing glass crystal ornaments directly on the paper and exposing through colored filters. Then the prints were cut up and combined in the design you see, and copied to produce a slide.

FREDERICK C. ENRICH

THE PAPER NEGATIVE PROCESS

Use the appropriate safelight for the paper.

1. Starting with a normal negative, make an enlargement, cropped and dodged as you want the final print to be. Use a pencil to darken any detail or area which needs to be subdued.
2. Make a paper negative by contact printing the enlargement onto another sheet of paper. You can do additional pencil retouching on the paper negative to make the final print lighter in the areas of retouching. Do not use papers with any printing on the back.
3. From the retouched paper negative, make the final print by contact.

PAPER NEGATIVES

Prints made from paper negatives look like charcoal drawings. Your original image can be either a negative or a slide. The paper-negative technique offers considerable potential for local control and retouching.

As in any artistic technique, there are some pitfalls you should avoid when making a paper negative.

In the first place, you want the contrast and the shadow and highlight details of the final paper-negative print to match those of a carefully made, top-quality "straight" enlargement from the same negative. There's no point in being evasive about it—this close match is not easy to achieve! If you have had any experience in making copies, you probably know it's generally advisable to make both of the intermediates low in contrast and fairly heavy in density. Since they actually are used as transparencies, judge these intermediates by transmitted light, not by reflected light as you do an ordinary print.

Viewed by reflected light, each intermediate should seem far too dark. But hold each dark positive or negative up to a fairly bright illuminator and judge them by transmitted light. Even the darkest shadow areas should appear luminous with full detail. Your aim should be a transparency that appears normal in density, but has easily discernible detail in both highlights and shadows and is very low or flat in contrast. The lower the contrast, particularly in the positive, the easier it is to retain the details of both ends of the tonal scale in the final print. Consequently, you should use the softest grade of paper—No. 1 contrast. Don't be concerned at this point about the flat appearance of the picture; in going from step to step, the process has a tendency to gain contrast and, unless you intentionally keep the intermediates at a low contrast, the final print will be extremely contrasty and unusable. Then, too, it's an easy matter to make any necessary adjustments in contrast in the final print by simply choosing an appropriate grade of printing paper. Paper negatives can be easily retouched with a soft pencil to build up the highlight areas.

You can control the texture and detail shown in the final print by the way you expose it. For maximum texture, expose the print normally with the emulsion side up. For minimum texture and maximum detail, flash the print through the base with the light from the enlarger, then turn it over and expose it, emulsion side up, to the paper negative. To soften the de-

(1)

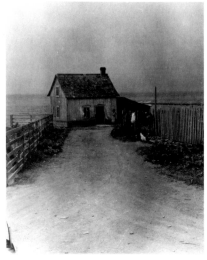

(2)

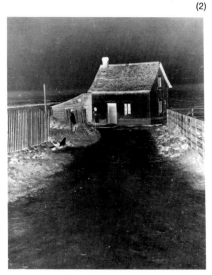

Picture (1) is a straight print made from the original negative. The photographer enlarged the original negative onto a sheet of KODAK SUPER-XX Pan Film 4142 (ESTAR Thick Base) which was the same size as the final print, and the film was developed in KODAK Developer DK-50 for seven to eight minutes. You can retouch this film using a pencil for fine detail and a chamois stamp (available from art-supply stores) rubbed in black chalk for the large areas. Or, you can tape a piece of matte acetate to the film and do your retouching on the acetate.

The film positive was contact-printed onto a sheet of single-weight paper to produce the paper negative (2). After the paper negative was dry, the photographer rewet the back of the print and put it between two blotters under pressure to flatten it while it dried. Then he did extensive retouching with black chalk and pencil on the back of the paper negative, which is shown in (3). He added clouds to the sky, and density to the house and road. To set the retouching so that it wouldn't rub off, he ran the print through a tray of water once, using the same kind of motion you would use to develop a roll of film in a tray. After the print dried, he flattened it again using the method mentioned above.

Then the paper negative was ready for printing, and the photographer made contact prints by using a printing frame. The finished print is shown in (4).

(3)

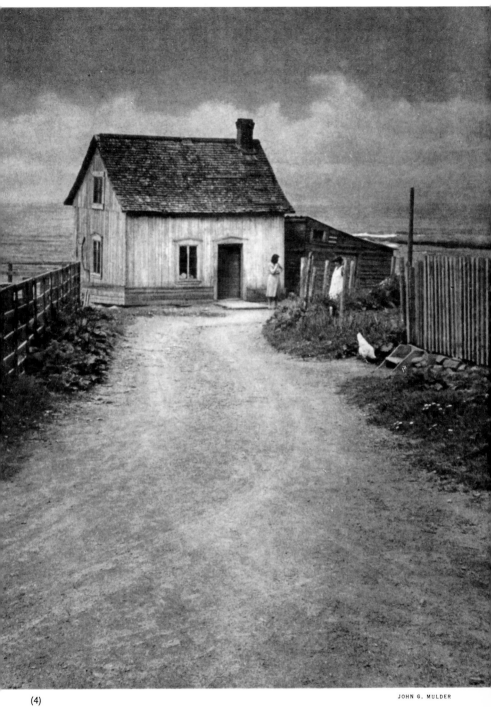

(4)

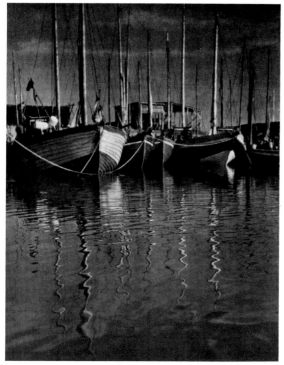

These two prints were both made by the paper-negative process. The photographer has been working with the paper-negative technique for many years and has refined it in a number of ways which produce consistently good results for him. More recently, he prefers using a film positive and film negative (refer to the chart below) rather than a paper negative. By using a sheet of matte acetate taped to each film positive and film negative, he can do the extensive retouching which the paper-negative technique is known for, and the finished photograph shows the same texture that it would if it were made with a paper negative.

The photographer increases the apparent texture in the final print by contact-printing the enlarged film negative onto KODAK EKTA-LURE Paper with a textured surface such as R, Y, or X.

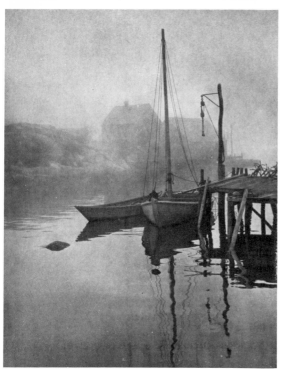

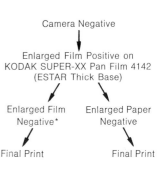

Camera Negative

↓

Enlarged Film Positive on
KODAK SUPER-XX Pan Film 4142
(ESTAR Thick Base)

Enlarged Film Enlarged Paper
Negative* Negative

↓ ↓

Final Print Final Print

*You can use KODAK SUPER-XX Pan Film 4142 (ESTAR Thick Base) or other sheet films for this step.

JOHN G. MULDER

PAUL KUZNIAR

BARBARA KUZNIAR

It's easy to make black-and-white prints from color slides. Just put the slide in your enlarger and print it onto black-and-white paper as you would a negative.

A color-slide close-up of a white flower was used to make this print on KODAK EKTACOLOR 37 RC Paper. No internegative was used; the slide was printed directly onto the paper.

tail and obtain the minimum texture, expose the paper through the base with no separate flash.

The texture and appearance of a print made from a paper negative is controlled by the surface of the paper you select for the first step. For very little texture, select a smooth-surface paper such as a J, F, or N surface. For a heavily textured effect, use R, Y, or X surface. KODABROMIDE Paper, A surface (light weight) is the paper most commonly used for making paper negatives.

PRINTING SLIDES

Don't limit yourself to printing negatives; try making a direct print from a slide. You can print slides on either black-and-white or color paper for dramatic effects. Of course, your print will be a negative image because your slide is a positive image.

In negative prints, shadow detail has greater clarity than in positive prints. Negative prints also accentuate the structural aspects of a subject and stress its graphic, abstract quali-

ties. You can blend fact and fantasy in a negative print to show reality in a form that otherwise can't be seen. The more abstract the subject, the more suitable it is for negative printing. Bold simplicity is preferable to complex design and, in general, pictures of people do not look good as negative prints.

To print a slide on black-and-white paper, simply place the slide in the enlarger and print it as you would a negative. Your result will be a negative image.

When you make a color print from a slide, you'll need to use a piece of unexposed, processed negative color film, such as KODACOLOR-X Film, in the light path. Color paper is designed to be used with color negatives that have a color mask. You can't produce a wide range of colors when printing a slide unless you use the color mask. Place the mask in the filter drawer of the enlarger or between the light source and the lens, if possible. Put your slide in the enlarger and make a print in the normal way.

101

These crystals were grown on a piece of plate glass, and this print was
made directly from the glass with the crystals on it.

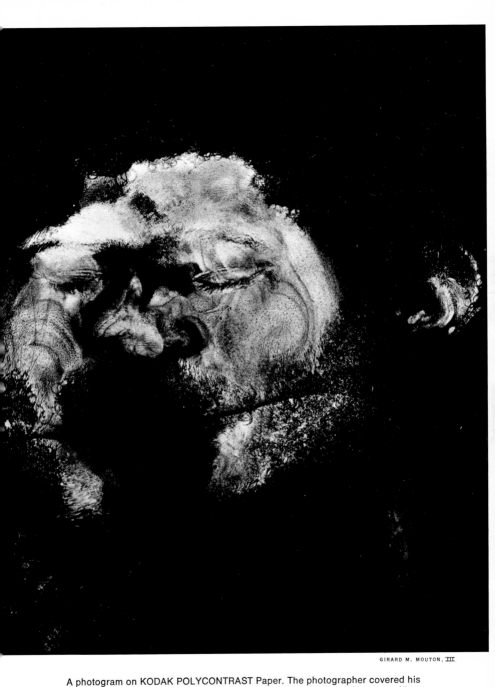

A photogram on KODAK POLYCONTRAST Paper. The photographer covered his face with hair oil and then pressed his face to the paper, rolling it from one side to the other. The paper was exposed to white light for three seconds and developed. While rinsing the print in running water, the photographer rubbed the oil off the paper; then the print was put through the stop bath, fixed, and washed normally.

Combining Black-and-White & Color

Techniques for making black-and-white prints into colorful pictures by using toners, hand coloring, and printing black-and-white negatives on color paper. Special photographic papers allow printing color in black-and-white, and making monochrome color prints which show black and one color.

BARBARA KUZNIAR

A black-and-white KODALITH Negative was turned into a color slide by placing a small piece of yellow filter behind the flower and copying the film by the method described on page 253.

Creativity in photography is often the result of simply taking several "old" techniques and combining them in a new way. This slide was made by copying a black-and-white print through a yellow filter. The print was made by sandwiching a black-and-white negative with a linen texture screen. Experiment with your old pictures and try to visualize them in new ways.

You can produce color prints from black-and-white negatives by printing them on monochrome color paper. This technique looks best with high-contrast negatives of simple, graphic subjects, and it's described on page 124.

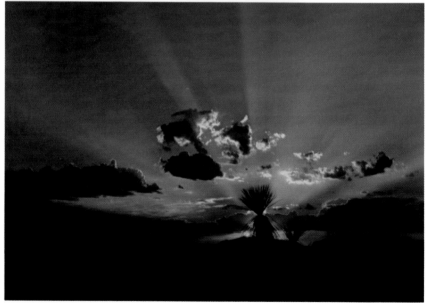

You can add color to a black-and-white print by using toners. This print is on KODAK MEDALIST Paper. It was sepia-toned and then blue-toned to produce the red color. Turn to page 120 to see two more variations of this picture with toning.

Brown toner is very effective on prints containing old wood, because it makes the wood look so natural that the viewer might think it's a color print.

You can add color to black-and-white prints, either over the whole print or in selected areas. You can also make color prints from black-and-white negatives, and transform your color slides and negatives into black-and-white prints to get more use out of your pictures. This chapter is all about turning black-and-white into color and color into black-and-white. It will help you make new prints from pictures you have in your file and show you how versatile photography can be.

BARBARA KUZNIAR

This black-and-white print on KODAK RESISTO Rapid Paper was colored by immersing it in a tray of water that was colored with Peerless Water Colors (refer to page 131). This is a combination print (described on page 76) and a combination of techniques.

TONING

You can make many black-and-white prints more interesting by changing the color of the existing image through toning. Toning will help you create moods and impressions in a picture. In some cases, a slight change in the color of the image gives the desired effect; in other cases, a bold change transforms a drab picture into a spectacular one. The color produced by toning depends on the toner you select, but each toner yields a number of variations on its characteristic hue when used with different kinds of paper. Some toners, such as KODAK POLY-TONER, produce different hues according to the dilution you use.

Toning helps to recreate the atmosphere and mood of the original scene. Impersonal objects and cold subjects—abstract designs, glass, ice formations, marine and snow scenes, stone, night views—all invite the use of a blue toner. Toners that produce brownish tones help render the warmth of flesh tones; they are used for portraits. A warm-brown tone on cream-white paper provides a genuine feeling of warmth and sunniness for any sunlit view. It imparts an especially friendly atmosphere in pictures of people. The combination of a sulfide toner followed by a gold-type toner, such as KODAK Blue Toner, will produce a fiery red color for sunsets and fireside pictures.

Toning is a technique that will enhance many photographs, but there is no need for this extra treatment unless it will improve the picture.

108

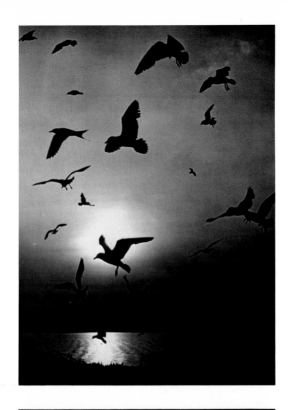

With toning you can create moods in a picture. Notice how blue toning adds to the mood in the bottom picture. Both prints were made on KODAK MEDALIST Paper, but the print on the top was not toned.

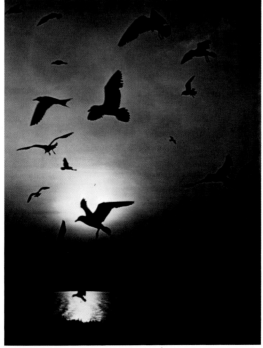

Portrait photographers have used toners for years to help render the warmth
of flesh tones. This print on KODAK PANALURE Paper was sepia-toned.

Blue toner usually improves the appearance of marine and
snow scenes, ice formations, and night pictures.

Processing Prints for Toning

Process the print normally following
the instructions on the paper instruction
sheet. Using warm-tone developers,
such as KODAK SELECTOL or
KODAK SELECTOL-SOFT Developer,
in place of a colder-tone developer,
such as KODAK DEKTOL Developer,
will yield a warmer black-and-white
image.

Improper fixing and washing is
probably the main cause of stains in
toned prints, so always use a fresh
fixing bath but avoid excessive fixing.
Fix the prints for the recommended
time—five to ten minutes.

Traces of hypo remaining in the paper
after washing can also cause
stains in a toned print. Wash the prints
for one hour or use KODAK Hypo
Clearing Agent according to the directions
on the package. This product
not only reduces the washing
time, but also removes residual chem-

icals so your toned prints will have
cleaner, whiter highlights and borders.

KODAK Prepared Toners

Kodak toners are easy to use because
the chemicals are premixed—
all you have to do is dilute them with
water, following the instructions on
the package. These toners can be
used in white light. The following toners
are available from your photo
dealer: KODAK Blue Toner, KODAK
Brown Toner, KODAK POLY-TONER,
KODAK Rapid Selenium Toner, and
KODAK Sepia Toner.

Be sure to soak dry prints in water
for at least ten minutes before immersing
them in any toner. Refer to
the chart on page 112 for toning procedures,
subject suggestions, and
recommended papers for use with
Kodak toners. When using toners, be
sure to work in a well-ventilated room.

USING *KODAK* TONERS

Abbreviations Used: HCA = KODAK Hypo Clearing Agent
SW = Single Weight Papers
DW = Double Weight Papers

NOTE: Prints to be toned should be properly fixed; two-bath fixing is recommended. All times of treatment in KODAK Hypo Clearing Agent and washes are minimum times. The temperature of the HCA should be 65-70 F. Recommended wash temperature is 65-70 F, although in most cases cooler washes are acceptable except for the wash after selenium toning.

KODAK Toners	Rapid Selenium	POLY-TONER	Sepia	Brown	Blue
Suggested Subjects	Portraits Sunlit Scenes	Portraits Sunlit Scenes Wood	Portraits Sunlit Scenes	Portraits Sunlit Scenes	Water Scenes Snow Scenes Glassware Night Scenes
Papers Recommended	For cold-brown tones on KODAK EKTALURE, PANALURE Portrait, PORTRALURE, and Portrait Proof Papers.	For sepia tones from cold to warm on KODAK EKTALURE, PORTRALURE, and POLYLURE Papers.	For sepia tones on most Kodak papers—particularly recommended for KODABROMIDE, KODAK MEDALIST, Mural, POLYCONTRAST, POLYCONTRAST Rapid, PANALURE, and VELOX Papers.	For sepia tones on most Kodak Papers.	For cold-blue tones on Kodak papers except AZO, AD-TYPE, and KODABROMIDE.
Print Exposure and Development	Causes slight increase in print density, which may require slight reduction of developing time. Degree depends on grade of paper.	POLY-TONER 1:4 or 1:24 Usually little change in exposure or development required. POLY-TONER 1:50 causes loss in density; compensate by increasing print development. Degree depends on grade of paper.	Causes some loss of print density; compensate by increasing exposure. Degree depends on grade of paper.	Causes some loss in contrast; compensate by increasing print develop-ment. Degree depends on grade of paper.	Usually no change in exposure or development time is required.
Wash before Toning	This toner is sensitive to silver content of clear areas and also to acid retained in the print. Treat prints for 2 min in a solution of KODALK Balanced Alkali (2/3 oz per qt or 20 grams per liter) and wash 30 min at 65-70 F.	This toner is relatively sensitive to both hypo and silver salts. Wash 1 hour at 65-70 F or SW-HCA 2 min, wash 10 min; DW-HCA 3 min, wash 20 min.	Particularly sensitive to hypo content, which causes excessive loss of print density. Wash 1 hour at 65-70 F or SW-HCA 2 min, wash 10 min; DW-HCA 3 min, wash 20 min.	This toner is relatively sensitive to both hypo and silver salts. Wash 1 hour at 65-70 F or SW-HCA 2 min, wash 10 min; DW-HCA 3 min, wash 20 min.	Uneven toning is caused by retained hypo. Sulfide-toned prints to be toned red should be thoroughly washed. Wash 1 hour at 65-70 F or SW-HCA 2 min, wash 10 min; DW-HCA 3 min, wash 20 min.

KODAK Toners	Rapid Selenium	POLY-TONER	Sepia	Brown	Blue
Toning Recommendations	For normal usage, dilute the toner stock solution 1:3. Complete toning occurs in 2-8 min, depending upon the paper grade. Intermediate tones can be obtained with dilute toner, such as 1:9, but uneven, incomplete toning may occur with some papers. With dilute toner, toning continues for a short time in the wash; allow for this action.	Immerse and agitate the prints: POLY-TONER 1:4— about 1 min at 70 F, POLY-TONER 1:24— about 3 min at 70 F, POLY-TONER 1:50— about 7 min at 70 F. Rinse prints in running water (about 2 min).	Bleach in Solution A until blacks of shadows have disappeared (about 1 min). Rinse thoroughly in clean, cold, running water (at least 2 min). Place in Solution B until original density returns (about 30 sec). Rinse prints thoroughly.	CAUTION: This toner contains potassium sulfide. The gas given off during use is both disagreeable and poisonous. Use the toner in a well-ventilated area. Immerse and agitate the prints for 15-20 min at 68 F, or 3-4 min at 100 F. Rinse prints in running water (about 2 min).	Tone with agitation at 68 F until desirable tone is obtained (8-45 min), or 2-15 min at 100-105 F. Prints previously sulfide-toned produce pleasing red to orange tones.* Prints to be matched should be toned simultaneously in the same solution.
Post-Toning Steps	Rinse toned prints thoroughly in water if they are to be treated in HCA and if you plan to use the HCA bath later for black-and-white prints.	Treat the prints for about 3 min in HCA solution (use fresh bath and maintain for this purpose only) or in a sodium bisulfite solution containing 1 oz per qt. Hardening: Treat prints for 2-5 min in a bath composed of 1 part KODAK Liquid Hardener and 13 parts of water.	Hardening: Treat prints for 2-5 min in a bath composed of 1 part KODAK Liquid Hardener and 13 parts of water.	Treat prints for about 1 min in HCA solution (use a fresh bath and maintain for this purpose only). Hardening: Treat the print for 2-5 min in a bath composed of 1 part KODAK Liquid Hardener and 13 parts of water.	Not necessary.
Final Wash	Wash prints toned to completion at least 30 min at 65-70 F. Wash partially toned prints 1 hour at 65-70 F, or: Treat completely or partially toned prints; SW-HCA 2 min, wash 10 min at 65-70 F; DW-HCA 3 min, wash 20 min at 65-70 F.	Wash 30 min at 65-70 F.	Wash 30 min at 65-70 F.	Wash 30 min at 65-70 F.	Wash 30 min at 65-70 F.

*Cold-tone papers yield red tones; warm-tone papers yield orange tones.

RAY ATKENSON

KODAK MEDALIST Paper toned with KODAK Blue Toner.

KODAK EKTALURE
Paper toned with
KODAK POLY-TONER.

HANS KADEN

RONALD JOHNSON

KODAK EKTALURE Paper toned with KODAK Brown Toner.

Mixing Your Own Toners

If you don't find the colors you want in the prepared toners or if you prefer to "do it yourself," you can mix your own toners. Here are the formulas for some popular toners to get you started.

KODAK Hypo Alum Sepia Toner T-1a

This toner produces sepia tones very similar to those produced by KODAK Sepia Toner which is available in prepared form.

MIXING *KODAK* HYPO ALUM SEPIA TONER T-1a

	Avoirdupois U.S. Liquid	Metric
Cold water	90 oz	2800 ml
KODAK Sodium Thiosulfate (Pentahydrated)	16 oz	480.0 grams

Dissolve thoroughly, and add the following solution:

Hot water, about 160 F	20 oz	640 ml
KODAK Potassium Alum. (Dodecahydrated)	4 oz	120.0 grams

Then add the following solution (including precipitate) slowly to the hypo-alum solution while stirring the latter rapidly:

Cold water	2 oz	64.0 ml
KODAK Silver Nitrate, Crystals	60 grains	4.0 grams
Sodium Chloride	60 grains	4.0 grams
After combining the above solutions, add water to make	1 gal	4.0 liters

NOTE: Dissolve the silver nitrate completely before adding the sodium chloride, and immediately afterward add the solution containing the milky white precipitate to the hypo-alum solution as directed above. The formation of a black precipitate in no way impairs the toning action of the bath if the proper manipulation technique is used.

USING *KODAK* HYPO ALUM SEPIA TONER T-1a

NOTE: This toner causes loss of density and contrast which can be corrected by increasing the exposure (up to 15 percent) and increasing the developing time (up to 50 percent).

In room light:

1. Pour the toner into a tray supported in a water bath and heat it to 120 F. Using the toner at temperatures above 120 F will produce blisters and stains on the print. Separate the prints occasionally during the first few minutes.
2. Slip wet prints into the toner and tone for 12 to 15 minutes—do not continue toning longer than 20 minutes.
3. Drain prints and wipe them with a soft sponge and warm water to remove any sediment.
4. Wash for 1 hour in running water or treat with KODAK Hypo Clearing Agent as recommended.

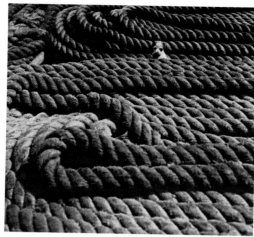

KODAK PORTRALURE Paper toned with KODAK Rapid Selenium Toner.

FRANK D. CHRISTHOFF, JR.

KODAK Polysulfide Toner T-8

This single-solution toning bath produces sepia tones and has the advantage, compared with hypo-alum toners, that it does not require heating, although raising the temperature to 100 F reduces the time of toning from fifteen to three minutes. For a packaged toner with similar characteristics, use KODAK Brown Toner.

MIXING KODAK POLYSULFIDE TONER T-8

	Avoirdupois U.S. Liquid	Metric
Water	96 oz	750 ml
Sulfurated Potassium (liver of sulfur)	1 oz	7.5 grams
KODAK Sodium Carbonate, monohydrated	145 grains	2.5 grams
Water to make	1 gal	1.0 liter

Dissolve the chemicals in the order given.

USING KODAK POLYSULFIDE TONER T-8

In room light:

1. Slip wet prints into the toner and tone for 15 to 20 minutes at 68 F or for 3 to 4 minutes at 100 F. Agitate continuously.
2. Rinse prints in running water.
3. Soak in freshly mixed KODAK Hypo Clearing Agent—use the Hypo Clearing Agent for this purpose only.
4. Prepare a hardening bath by adding 1 part of KODAK Liquid Hardener to 13 parts of water, and treat the print for 2 to 5 minutes in this solution.
5. If any sediment appears on the print, wipe the surface with a soft sponge.
6. Wash for at least 30 minutes at 65 to 70 F before drying.

KODAK Gold Toner T-21

This toner yields a pleasing range of tones from warm black to neutral brown with most warm-tone papers. It has little effect on cold-tone papers. Gold toner is one of the few chemical formulas that tones both highlights and shadows at a uniform rate.

MIXING *KODAK* GOLD TONER T-21
Solution A

	Avoirdupois U.S. Liquid	Metric
Warm water, about 125 F	**1 gal**	**4.0 liters**
KODAK Sodium Thiosulfate (Pentahydrated)	**2 lbs**	**960.0 grams**
KODAK Potassium Persulfate	**4 oz**	**120.0 grams**

Dissolve the hypo completely before adding the potassium persulfate. Stir the solution vigorously while adding the potassium persulfate. If the solution does not turn milky, increase the temperature until it does.

Cool the above solution to about 27 C (80 F) and then add the solution below, including the precipitate, slowly and with constant stirring. The *bath must be cool when these solutions are added together.*

	Avoirdupois U.S. Liquid	Metric
Cold water	**2 oz**	**64.0 ml**
KODAK Silver Nitrate, Crystals	**75 grains**	**5.0 grams**
Sodium Chloride	**75 grains**	**5.0 grams**

NOTE: The silver nitrate should be dissolved completely before the sodium chloride is added.

Stock Solution B

	Avoirdupois U.S. Liquid	Metric
Water	**8 oz**	**250.0 ml**
Gold Chloride	**15 grains**	**1.0 gram**

NOTE: Gold chloride is a deliquescent chemical; it will liquefy rapidly in a normal room atmosphere. Store the chemical in a tightly stoppered bottle in a dry atmosphere.

To prepare a working solution, add 4 ounces (125 ml) of Stock Solution B slowly to the entire quantity of Solution A while stirring the latter rapidly.

Before using the bath, allow it to stand for about 8 hours. By this time, a yellow precipitate will have formed at the bottom of the container. Pour the clear solution off into another container and discard the precipitate.

Revive the bath at intervals by adding Stock Solution B. The quantity to be added will depend upon the number of prints toned and time of toning. For example, when toning to a warm brown, add 1 dram (4 ml) of Stock Solution B after each fifty 8 by 10-inch prints or equivalent has been toned.

KODAK MEDALIST Paper toned with KODAK Blue Toner.

USING *KODAK* GOLD TONER T-21

In room light:

1. Pour the toner into a tray supported in a water bath and heat the water to 110 F. During toning, maintain the water bath at this temperature.
2. Slip wet prints into the toner and leave until the desired tone is visible—keep prints separated throughout the toning procedure. Use an untoned black-and-white print for comparison to help you determine how much toning has taken place.
3. Rinse prints in cold water. Some sediment will form in the toning tray especially if many prints are toned. The sediment is harmless, but it may form a scum on the print surface. If so, wipe the print with a wet sponge or a wad of cotton immediately after toning.
4. Wash prints for 1 hour in running water or use KODAK Hypo Clearing Agent as recommended.
5. To prevent formation of spots, be sure to sponge all the water off the prints before drying them.

Producing Red Tones

If you are inclined to experiment, try for spectacular red tones. Sepia-tone the print and wash it in the normal way; then blue-tone the sepia print. The result is a red to orange color, depending on the type of paper used. Cold-tone papers yield a rich red color, whereas warm-tone papers give a more orange hue.

KODAK Sepia Toner or KODAK Brown Toner can be used for the first stage. Then, after the print has been washed thoroughly, toning with KODAK Blue Toner yields the red color in about fifteen to thirty minutes. There is usually a loss of density in the shadow areas of the picture with this method of toning; therefore, you should start with a print exposed 20 percent longer than normal.

ARTHUR UNDERWOOD

These prints and the example shown on page 106 were all made on KODAK MEDALIST Paper and toned with KODAK Sepia Toner. The top print shows the effects of the sepia toner. The bottom print and the print on page 106 were also toned in KODAK Blue Toner for twenty minutes. If you compare the two prints, you'll see that they look different. They were toned in exactly the same way, but the results are different because the print on page 106 was printed darker. When making prints for toning, make several different exposures and tone them all. Then you'll have a variety to select from after you see how the toner changed the print.

This print on KODAK POLYCONTRAST Rapid Paper was selectively toned. The bottom of the print was covered with Maskoid Frisket, and then the print was toned with KODAK Brown Toner. The frisket was removed, and the whole print was toned with KODAK Blue Toner.

JOHN O. BOWMAN

Producing Multiple Tones

For a combination of colors on the same print, try selective or multiple toning. Selective toning consists of toning only certain areas of the print while the rest of the print is covered with rubber cement or frisket. Multiple toning involves selective toning with more than one toner. You can produce various colors by the action of one toner on the image previously toned by another. For example, as we mentioned before, an area that has been toned sepia can be changed to red by further toning in blue toner.

Selective toning can be used to separate the foreground from the background. For example, you could tone the waves in a seascape a rich blue, while keeping the rocks over which the waves are breaking a natural gray color. The possibilities are almost limitless!

You'll get the best results with subjects that have a clear line of demarcation. A sail against the sky, buildings and mountains against the sky, and still-life subjects are the easiest types to start with.

The only materials you'll need, in addition to the toners, are a bottle of

121

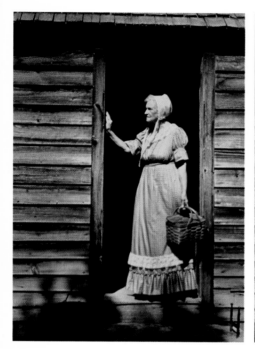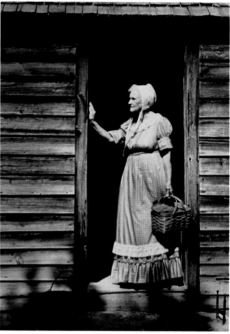

PAUL D. YARROWS

Both prints were toned with KODAK Brown Toner. Before toning, the area of the model in the picture on the right was carefully covered with rubber cement to protect it from the toner. After the print was toned and washed, the rubber cement was rubbed away.

rubber cement and some thinner, or a frisket material, such as Photo Maskoid Liquid Frisket (available from art-supply dealers); a fine brush and a wider one, and an appropriate print.

Maskoid Frisket is easier to use than rubber cement because it is a brilliant red, making it easy to see which areas of the print have been covered. If you use rubber cement, thin it with rubber-cement thinner. Dilute the rubber cement about 1:1 with thinner, and mix well.

Use a small, soft brush that points up well and does not lose its bristles. The large brush will be a time-saver for filling in broad areas. Apply the rubber cement or frisket in two or three thin coats, rather than one heavy coat. Do not work the rubber cement over—just flow it on with the brush, smooth it out, and then immediately move on to another area.

For uniform toning, you should soak a dry print in water for ten minutes. However, to minimize the risk of having the toner creep under the edges of the mask and ruin the job, place the

dry print directly into the toner. Don't be alarmed if the print buckles and curls due to uneven wetting as a result of the mask. If you can hold the portion of the print not to be toned out of the toning solution, there is less chance the toner will bleed through the coating. Make sure that the toner is kept flowing evenly over the uncoated portions.

Wash the print as recommended, and then remove the rubber cement or frisket material. You can remove Maskoid Frisket by picking it up with sticky tape. Remove rubber cement by rubbing your fingers across it while it is still in the wash. Once the coating is removed, you can dry the print in the usual manner.

When you want to use two or more toners, you must follow this procedure for each separate toner.

Recommendations for Toning KODAK Papers in KODAK Toners

In the following chart, the Kodak toners checked as recommended for use with the various Kodak papers are ones that *will produce a tone acceptable* to most people. Since the tones vary considerably in both color and strength, some experimentation is necessary to determine the one best suited to a particular use. The toners checked as not recommended produce either no change in tone or a very slight change toward an unpleasant tone.

TONING CLASSIFICATION CHART

KODAK Paper	Hypo Alum Sepia T-1a	Sepia or Sulfide Sepia T-7a	Brown or Poly-sulfide T-8	Gold T-21	Rapid Selenium	POLY-TONER (1:24)	Blue
AD-TYPE	X	X	P	NR	X	P	NR
AZO	X	X	P	NR	X	P	NR
EKTALURE	X	X	X	P	P	P	X
KODABROMIDE	X	P	NR	NR	NR	NR	NR
MEDALIST	P	P	P	NR	X	P	X
Mural	P	P	P	NR	X	P	X
PANALURE	P	P	P	X	X	X	X
PANALURE Portrait	X	X	X	X	P	P	X
POLYCONTRAST POLYCONTRAST Rapid	P	P	P	NR	X	X	X
PORTRALURE	P	P	P	P	P	P	X
Portrait Proof	X	X	X	P	P	P	X
VELOX	P	P	X	NR	NR	NR	X
VELOX PREMIER	X	X	X	NR	NR	NR	X
VELOX Rapid	P	P	X	NR	NR	NR	X
VELOX UNICONTRAST	P	P	X	NR	X	NR	X

P—Primary recommendation NR—Not Recommended

X—Although not a primary recommendation, it will produce a tone which may have special-purpose applications.

Bold designs with a graphic quality look very dramatic when printed on metallic paper. This print is from a KODALITH negative on Argenta Superpress Gold Paper.

BARBARA KUZNIAR

PRINTING ON A MONOCHROME COLOR PAPER

There are monochrome photographic papers available that have a color built right into the paper. These papers are used exactly as other black-and-white papers, but instead of producing a black image against a white background they produce a black image against a colored background. They are particularly appropriate for printing high-contrast images because they help contribute to the graphic quality of the image. Continuous-tone black-and-white negatives and color negatives do not usually have enough contrast to produce good prints on these papers.

One brand of paper that's available in a large variety of colors in both matte and metallic finishes is Argenta. If your local photo dealer doesn't carry monochrome color papers, you can order Argenta paper directly from Delta Import/Distribution, 319 West Erie Street, Chicago, Illinois 60610.

Argenta paper is processed the same way as KODABROMIDE Paper —in KODAK DEKTOL Developer 1:2 for 1½ minutes at 68 F. You can handle this paper under the light of a KODAK Safelight Filter, No. 1A (light red). Fix, wash, and dry the paper as you would any black-and-white paper. You can dry the metallic and iridescent papers with a matte finish or ferrotype them.

A print on Argenta Superpress Metallic Paper—saphir color. The paper was exposed from a KODALITH Negative and processed in KODAK DEKTOL Developer (1:2). Simple compositions on high-contrast film print best on this type of paper. Other versions of this photograph are shown on pages 206, 207, and 208.

BARBARA KUZNIAR

Many people have asked if this print was made on metal because the surface looks so metallic. They're surprised to find it's printed on paper—Argenta Superpress Silber Paper.

You can use the techniques described in this book to "stretch" your photographic images—these techniques will help you make many different pictures from the same original image. Another version of this picture is shown on page 158.

BARBARA KUZNIAR

PRINTING COLOR NEGATIVES IN BLACK-AND-WHITE

When color negatives are printed on paper designed for black-and-white negatives, such as KODABROMIDE Paper, the increase in apparent grain and the balance of tones in the monochrome print are often unsatisfactory. This is because most black-and-white printing papers are sensitive mainly to blue light. In other words, these materials "see" a color negative as though it had a blue filter over it. As a result, objects that were red in the original scene print too dark, and objects that were blue in the scene print too light. Red lips and ruddy complexions are too dark, blue eyes are too light, and blue skies with white clouds lack detail.

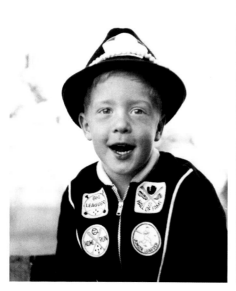

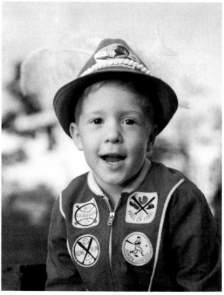

BARBARA KUZNIAR

These prints were all made from the same color negative. The black-and-white print on the left is on KODABROMIDE Paper; the blue sky is reproduced too light and the red jacket and hat are too dark. The print on the right is on KODAK PANALURE Paper, which is a panchromatic paper. This paper is sensitive to all colors so it can reproduce the colors in a color negative in the relative tones of gray.

KODAK PANALURE Paper

When a color negative is printed on KODAK PANALURE Paper—which is a panchromatic paper sensitive to red, green, and blue light—all the colors in the picture are rendered in relative tones of gray. The print will look as though it were made from a black-and-white negative.

There are two kinds of this paper. KODAK PANALURE Paper (F Single Weight), glossy, and warm-black in tone—is for general purposes. KODAK PANALURE Portrait Paper E—white, fine-grained lustre, and double weight —is for portraits or other subjects that require a brown-black image tone.

You can handle PANALURE Paper by the light of a dark amber safelight, such as a KODAK Safelight Filter, No. 10 (dark amber). Follow the processing instructions on the paper instruction sheet.

Filters with KODAK PANALURE Paper. With PANALURE Paper you can use filters during the printing exposure to alter the balance of tones and get effects similar to those obtained by using filters over the camera lens. For minor changes in tonal balance, use KODAK Color Compensating Filters. For more dramatic effects, use the same filters as for ordinary camera work.

To lighten the gray-tone rendering of a color, use a filter of a color similar to that of the object in the scene. To darken the rendering, use a filter of a color complementary to that of the object. Remember, however, that when you change the rendering of one color, you also change the rendering of other colors in the scene. For example, if the subject in a portrait had deep red lips and blue eyes, the lips may be too dark in the black-and-white print. You can lighten the lips with a red filter, but at the same time you darken the eyes. In a case such as this, a CC40R (red) filter yields about the maximum correction that can be applied without making the eyes too dark. If you want a strong orthochromatic rendering with darker reds and lighter blues, use two CC50C filters over the enlarger lens.

MAKING BLACK-AND-WHITE NEGATIVES FROM SLIDES

One easy way to get a black-and-white print from a slide is to have a color internegative made, and print the negative on KODAK PANALURE Paper as described above.

Another way is to make your own black-and-white negatives from slides by printing the slide onto a sheet film, such as KODAK Commercial Film 6127 or 4127 (ESTAR Thick Base).

Simply enlarge your slide onto the sheet of film, just as you would print a negative onto a sheet of enlarging paper. Place a sheet of black paper behind the film to prevent halation, and cover the enlarger with a cloth to minimize stray light and fog. Make a test strip to determine the exposure. Process the film according to the instructions on the film instruction sheet.

KODAK Commercial Film is a blue-sensitive film, so you can handle it under a red safelight (KODAK Safelight Filter, No. 1) and see what you're doing. This film will not reproduce red and green in their proper tonal values, so if areas of your subject are red or green, use a panchromatic film, such as KODAK PANATOMIC-X Film or KODAK SUPER-XX Pan Film 4142 (ESTAR Thick Base). Since these films are sensitive to red, green, and blue light, they must be handled in total darkness.

127

This print was made from a negative on KODAK Commercial Film. A color slide was enlarged onto a sheet of Commercial Film with an exposure of five seconds at f/22, and the film was processed in KODAK Developer DK-50 full strength. Variations of this same photograph are on pages 190, 191 and 203.

PRINTING BLACK-AND-WHITE NEGATIVES ON COLOR PAPER

Some black-and-white subjects look very effective when printed in color. You can make color prints from black-and-white negatives by printing them on KODAK EKTACOLOR 37 RC Paper. The resulting print will be one color, but it will show a range of tones of that color. Because this paper is designed to be used with color negatives which have a built-in color mask, the mask is necessary for good color prints. Make the mask by having a piece of unexposed color negative film processed. Place the mask in the filter drawer of your enlarger or between the light source and the lens if possible. Use this mask in the enlarger whenever you're printing black-and-white negatives on color paper. Once the mask is in place, simply print your black-and-white negative, just as you would any color negative. Process the paper in the normal way.

You can get dramatic, saturated colors by printing through "sharp-cutting" filters. These filters transmit only one color of the spectrum, and they produce a very bold color when used in conjunction with a black-and-white negative and color print paper. The following table lists the filters and the colors they will produce.

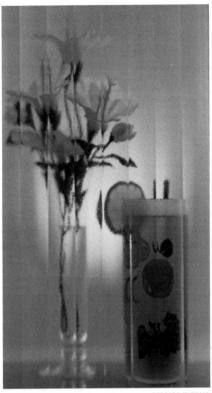

BARBARA C. KUZNIAR

A color print made from a black-and-white negative by printing on KODAK EKTACOLOR Paper through a magenta filter and an orange KODACOLOR-X Film mask.

Sharp-Cutting Filters

Use the following KODAK WRATTEN Filter	To produce this color
No. 25 Red	Cyan
No. 58 Green	Magenta
No. 47 Blue	Yellow
No. 44 Light Blue-Green (Cyan)	Red
No. 32 Magenta	Green
No. 12 Deep Yellow	Blue

FREDERICK C. ENRICH

This print was made from a black-and-white negative by printing each half of the negative separately through the appropriate filters onto KODAK EKTACOLOR Paper. The figure was hand-colored after the print dried.

A color print made from a negative on KODAK Super Panchro-Press
Film 6146, Type B, and printed on KODAK EKTACOLOR Paper without
using any filters or color mask.

This is a photogram made on KODAK RESISTO Rapid Paper; photograms are covered on page 93. The print was soaked in a solution of orange transparent watercolor and water for several minutes, rinsed in clear water and then air dried.

ADDING COLOR LATER

At one time the only way of producing a color print was to hand-color a black-and-white print, and this method is still being used in portrait studios. Some photographers are also experimenting with hand-coloring selected areas of prints and slides to produce unusual visual effects. There are many types of colors available for coloring prints and slides.

You can color black-and-white or color prints with KODAK Retouching Colors or Marshall's Photo Oil Colors, and instructions are included with the colors. It's easy to add color to small areas of prints with watercolors, food coloring, or felt-tipped marking pens.

There are also several transparent dyes made for photographic uses, such as Nicholson's Peerless Transparent Water Colors, and Martin's Synchromatic Transparent Water Colors.* These dyes will color prints or slides.

You can also glue colored tissue paper over the surface of a print using a colorless glue, such as Elmer's Glue. One effective way of adding color to black-and-white is combining tissue paper with a "print" made on a large sheet of KODALITH Film.

Photography is a medium that allows expression in an infinite variety of ways, so don't confine yourself by traditional techniques of print finishing. Experiment with colors on a spare print and see what interesting effects you can create.

*Both of these products are available by mail if you can't find the colors locally in art-supply stores. Nicholson's Peerless Transparent Water Colors are available in liquid or dry form from Peerless Color Laboratory, 11 Diamond Place, Rochester, New York 14609. Martin's Synchromatic Transparent Water Colors are available from B. Aronstein & Company, P. O. Box 543, New Hyde Park, New York 10040.

Both these black-and-white prints were colored with the same shade of blue, transparent water-color. You can obtain light pastel colors by putting a small amount of color in a tray of water and soaking the print. Use just enough water to cover the print. You'll get more intense color by applying the color with a wad of cotton directly from the bottle to the surface of a wet print.

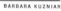

BARBARA KUZNIAR

CONRAD G. HOULE

These prints were printed in exactly the same way on KODAK EKTACOLOR Paper.
The white areas in the sky were colored in with a wet brush
and KODAK Retouching Colors. You may have used retouching colors
to spot color prints or increase the color saturation as we did here, but you can
also use them to add color to a black-and-white print.

A print made from a color negative and printed on KODAK PANALURE Paper; it was colored by swabbing the surface of the wet print with a wad of cotton saturated with purple, transparent watercolor.

This photogram on KODAK RESISTO Rapid Paper was hand-colored on the dry print using a piece of cotton saturated with green, transparent water-colors to color the leaves. The stem and flower were colored with a cotton swab saturated with transparent watercolor. Cotton swabs work well for coloring small areas and filling in details, but they show streaks if you use them on large areas.

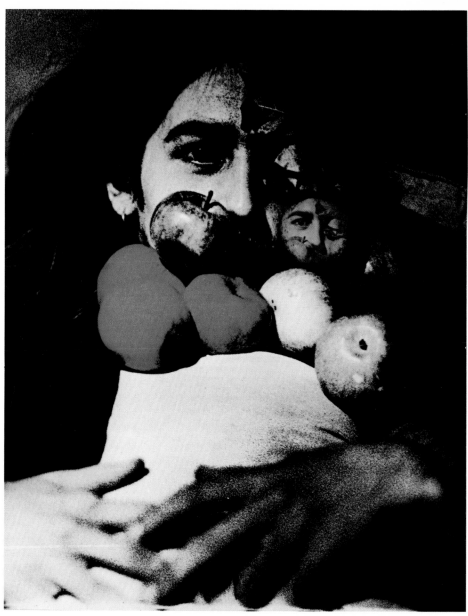

MICHAELA ALLAN MURPHY

This photograph shows a number of different techniques. The picture is printed
on an 8 by 10-inch sheet of KODALITH Film. The film is glued to a white board
with red tissue paper placed behind the apples and between the film and the board.
A combination of images on KODALITH Film was used to make the original negative.

This print was made as an extra proof, and it was colored in with an orange
felt-tipped pen just as an experiment. It's easy to use a felt-tipped pen to color
fine lines in a print, but large areas will show the strokes of the pen.
Save your extra prints and experiment with them.

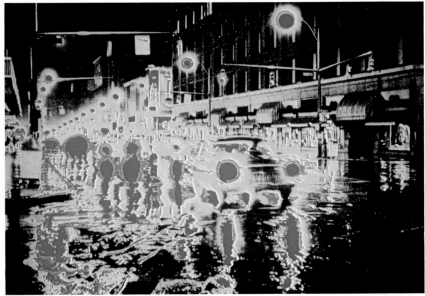

This posterization was made from a black-and-white original. There are a number
of techniques discussed further on in this book that will show you how to turn
black-and-white negatives into color slides and prints. They are: The Sabattier
Effect—page 190, Posterization—page 230, Gum Bichromate Printing—page 264,
and The Photo Silk-Screen Process—page 273.

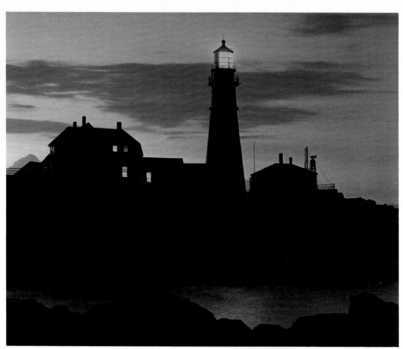

PAUL D. YARROWS

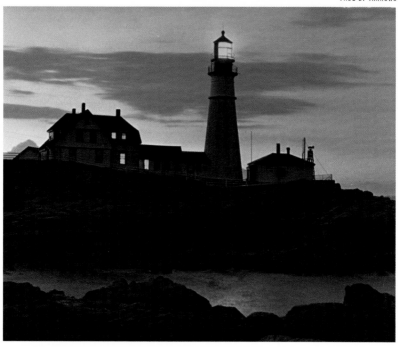

Two prints from the same negative—the color and mood were altered by
changing the filter pack. Both prints had color added later to the lighthouse
light and windows. It's easy to bring out details in color prints with
KODAK Retouching Colors and a wet brush.

The owls' eyes become the center of interest and most colorful area of the print when they're intensified with yellow KODAK Retouching Color.

The yellow skis really add impact to this color print. No, the photographer didn't ask the skier to paint his skis; the skis were brightened up with yellow dye after the print was made. This technique of adding color works equally well with prints or slides— try it sometime!

Another way of combining black-and-white and color is with a montage. This slide is a film sandwich of a color slide and a KODALITH Film positive. The film positive was made by contact-printing a black-and-white negative onto KODALITH Film. For more information on techniques with KODALITH Film, turn to page 154.

Creating High-Contrast Pictures

High-contrast pictures are black-and-white with no intermediate tones, and they're made by printing continuous-tone negatives or slides onto high-contrast film or paper. High-contrast films are the basis of many of the other techniques discussed further on in this book.

ROBERT KRETZER

This "straight" print made from the original continuous-tone negative has potential but it lacks dramatic impact.

By using KODALITH Film, the photographer was able to isolate this composition. The original negative was printed on KODALITH Ortho Film 6556, Type 3, to produce a high-contrast positive film. Then, that film was contact-printed onto another sheet of KODALITH Film to produce the high-contrast negative used to make this print. KODAK Opaque was used liberally to paint out the unwanted areas of the picture.

High-contrast films offer the opportunity of creating many different compositions from one original image. This tone-line print was produced from the same original as the photograph above, using the process described on page 163.

141

Simple compositions can become dramatic photographs in high contrast.

It's easy to print multiple images with high-contrast negatives because no dodging is required. The high density of a high-contrast negative is a built-in mask.

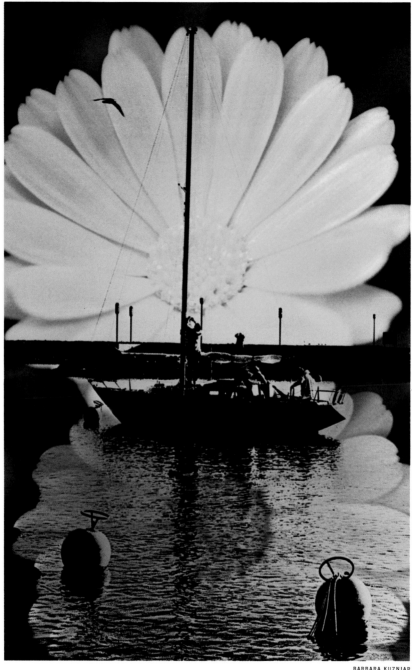

A montage made from a color slide and a positive printed on KODALITH Film.
A black-and-white continuous-tone negative was contact-printed onto KODALITH
Ortho Film 6556, Type 3, to produce the high-contrast positive of the boat.
Then the positive was sandwiched with a slide containing two flowers
to produce this montage slide.

A continuous-tone black-and-white negative printed on KODALITH
Ortho Paper. For the details on this technique, refer to page 146.

A combination of high-contrast films was used to create this print. A series of
high-contrast films was printed from the original image using different exposure
times; then these films were contact-printed onto additional sheets of
high-contrast film. From the series of negatives and positives created,
the photographer selected the lightest negative and the lightest positive and
sandwiched them together. That film sandwich was used as a
"negative" to print this picture.

145

A high-contrast print is a black-and-white print with no intermediate gray tones; and without the gray tones, only the essential shapes of the original photograph are reproduced. The solid black and stark white tones combined with the sharply outlined subject make high-contrast prints eye-catching. With this process, you can turn cluttered negatives into clean, dramatic pictures; salvage flat negatives and underexposed slides; combine images from several photographs to create a new composition; and turn black-and-white negatives into color prints and slides.

Producing high-contrast negatives and positives is the foundation for many of the techniques described in the following chapters in this book. It's very important that you develop a basic knowledge of producing good high-contrast images before you attempt more sophisticated photo processes such as posterization. In order to produce a successful posterization, you must be able to control the printing of high-contrast film.

High-contrast films and paper are easy to use because most of them are orthochromatic. If "ortho" is a part of the name, the material is not sensitive to red light and can be handled under a red safelight. Check the instruction sheet packaged with the material for the safelight recommendation. The obvious advantage to being able to work under the light of a safelight is that you can see what you're doing and watch the film developing.

High-contrast paper, films, and developer are available from graphic-arts suppliers (listed under Printing Supplies in the yellow pages of your telephone book), or your photo dealer can order these products for you. KODALITH Ortho Paper is available in sheet sizes from 8 x 10 inches to 20 x 24 inches.

KODALITH Films are also available in a variety of sizes, but the 4 x 5-inch sheets are the best. When working with high-contrast films, it's best to make the largest negative that your enlarger will accept because it makes retouching as easy as possible. You can also contact-print negatives and slides onto KODALITH Film; this method allows you to reproduce several small images on one sheet of 4 x 5-inch film. Use the contact-printing method only if no retouching is required. By contact printing, you can also produce bas-relief images (refer to page 159).

USING HIGH-CONTRAST PAPER

With high-contrast paper, you can produce a high-contrast print or a subtle image that looks like a toned print, depending on your original image and development time. High-contrast materials offer an infinite variety for the creative photographer.

KODALITH Ortho Paper is an extremely high-contrast paper originally designed for photomechanical reproduction. This paper offers the photographer an opportunity to produce a high-contrast print in a single step—by enlarging a continuous-tone negative or slide directly onto the paper just as you would use any enlarging paper. Of course, if you start with a slide, you will have a negative image on the print.

KODALITH Ortho Paper produces tones from a cold brown/black to a warm peach/brown shade depending on the temperature of the developer and the original negative. Develop KODALITH Paper in KODALITH Super Developer (full strength) with continuous agitation. The development time

BARBARA KUZNIAR

A print made from a contrasty negative printed on KODALITH Ortho Paper.
The paper was developed for two minutes in KODALITH Super Developer
at 60 F to produce cold brown tones.

will vary from forty-five seconds (when the image first becomes visible) to two minutes or more, depending on the visual results and the tones you're trying to achieve.

The longer the print is in the developer, the darker and more contrasty it will become. For brown tones, start with a slightly contrasty negative and develop the print at 68 F for one minute. To produce brown/black tones, use cold developer (about 60 F) and develop for two minutes. To produce peach/brown tones, use a high-key negative which has a limited tonal range, and develop the print at 75 to 80 F.

The development times given here are meant as guides, and they will vary according to the type of negative you use, the strength of the developer, and the result you're trying to achieve. Experiment and learn to judge the development visually. Watch the print carefully during develop-

ment and pull the print from the developer before it looks as dark as you want it. KODALITH Super Developer is a very active developer and the print will turn dark quickly if it's left in the developer an instant too long. Also keep in mind that the print will look darker after it's dried.

When you're using any highly active developer, such as KODALITH Super Developer, it's important to use a fresh stop bath and fresh fixer to stop the action of the developer as quickly as possible. Using fresh solutions is the only way to achieve consistent results with these materials.

KODALITH Ortho Paper is lighter weight than other photographic papers and it's best to order the "standard" weight because the "thin" paper is very difficult to handle. The paper curls when immersed in the developer, so for handling ease and even development, slip it into the developer face down.

147

A print on KODALITH Ortho Paper processed in KODALITH Super Developer at 80 F to produce the soft peach-brown tones. The negative was made on KODAK 2475 Recording Film (ESTAR-AH Base). The photographer used this film to deliberately incorporate a grain pattern in the picture.

By using a slow shutter speed with KODAK 2475 Recording Film, the photographer recorded the movement in the scene. The film was developed in KODAK Developer DK-50, and this print was made on KODALITH Ortho Paper. To create this effect with KODALITH Paper, start with a high-key negative—one with a limited tonal range. This is the kind of negative you'll usually get when photographing a softly lighted scene.

A print on KODALITH Ortho Paper from a negative on KODAK TRI-X Pan Film. The paper was developed in KODALITH Super Developer at 70 F for approximately 45 seconds—it was pulled from the developer when the photographer was satisfied with the degree of development. When working with KODALITH Paper, you can give in to that urge to pull a print out of the developer when it looks good! ➔

PROCESSING *KODALITH* ORTHO PAPER

Use a KODAK Safelight Filter, No. 1A (light red)

1. Develop for 45 seconds to 2 minutes at 60 to 80 F (depending on the tone desired) with constant agitation.
2. Rinse in KODAK Indicator Stop Bath for 10 seconds.
3. Fix at 65 to 70 F (18-21 C) for 5 to 10 minutes with frequent agitation.
4. Wash for 10 minutes in running water.
5. Wipe the surface carefully with a KODAK Photo Chamois and air-dry.

USING HIGH-CONTRAST FILMS

With high-contrast films, you can make negatives directly from slides. Or you can print a negative onto the film to produce a high-contrast film positive. Then contact-print the film positive onto another sheet of film to produce a high-contrast negative. You use both the high-contrast positive and negative for some of the techniques described in this and later chapters.

One of the biggest advantages of using high-contrast films is the ability to eliminate distracting areas of the picture quickly and easily by painting them out with opaque. It's also easy to combine two images from different films or to rearrange the composition of an image by simply cutting the film, rearranging the image into a new composition, and then taping the pieces of film along the edge. By combining these techniques of cutting and rearranging images with the ability to paint out areas of a picture or add details in other areas, you can create an almost unlimited variety of new pictures from negatives and slides you have on file.

BARBARA KUZNIAR

One of the big advantages of working with high-contrast films is that you can completely rearrange the composition of a picture. In the original slide, this gull was flying out of the picture. After enlarging it onto KODALITH Film, the photographer cut the negative apart and taped the gull in this position.

Selecting the Film

There are several high-contrast films available and the film you use will depend on the original image you select as well as the final result you're trying to achieve. For general use in making high-contrast positives or negatives from negatives and slides or for making contact negatives (or positives) from KODALITH Film positives (or negatives), use KODALITH Ortho Film 6556, Type 3.

If your original image is in color and has a lot of red in it that you want to record in detail, use KODALITH Pan Film 2568 (ESTAR Base) to make the high-contrast negative or positive. Because this film is panchromatic it will accurately record all the colors in your original as various shades of gray, while the ortho films record reds as black, often without much detail.

KODALITH AUTOSCREEN Ortho Film 2563 (ESTAR Base) is a high-contrast film which produces a dot pattern automatically. Use the film if you want a built-in texture screen. Because of the built-in pattern, you can't retouch this film with opaque as easily as the other KODALITH Films. Use KODALITH AUTOSCREEN Ortho Film as a positive for silk screening. Refer to page 273 for more information on the photo silk-screen process.

ALICE HALL

High-contrast derivations work best with simple compositions, and high-contrast films allow you to eliminate details that often clutter the background.

PROCESSING *KODALITH* ORTHO FILM 6556, TYPE 3
KODALITH PAN FILM 2568 (*ESTAR* BASE)
KODALITH AUTOSCREEN ORTHO FILM 2563 (*ESTAR* BASE)

Use a KODAK Safelight Filter, No. 1A (light red) with KODALITH Ortho and AUTOSCREEN Films. Use a KODAK Safelight Filter, No. 3 (dark green) with KODALITH Pan Film.

1. Develop the film in KODALITH Super Developer for 2¾ minutes at 68 F with continuous agitation.
2. Rinse in KODAK Indicator Stop Bath for about 10 seconds.
3. Fix for 1 to 2 minutes in KODAK Rapid Fixer at 65 to 70 F. Agitate the film frequently in the fixing bath.
4. Wash about 10 minutes in running water.
5. Treat in KODAK PHOTO-FLO Solution and hang to dry.

These horses didn't just happen to be visible through the opening in the fence. The fence was enlarged on one sheet of high-contrast film and the horses were enlarged to just the right proportion on another sheet of high-contrast film; then the two films were combined to make this print.

CAROLE G. HONIGSFELD

152

Retouching High-Contrast Films

It's easy to retouch the pinholes that are so common on KODALITH Film (this film seems to attract dust like a vacuum cleaner) with an Eberhard Faber Thinrite Marker 690 black or KODAK Opaque. KODAK Opaque comes in red or black and either color works well. Stir the opaque and then take a small amount on the tip of a brush and retouch the pinholes. You can spot either the base or emulsion side of the film.

You can also paint out large areas of a film with opaque to eliminate distracting backgrounds. Since the opaque acts as a mask, it's easy to eliminate any clear parts of the image. Just paint out the unwanted clear areas with opaque. To cover large areas, you may find it easier to use Scotch Brand #616 Lithographer's Tape which is available from graphic-arts dealers. Simply place the tape over any areas that you want to mask.

You can remove density (black areas) on a KODALITH Film by treating the area with a strong solution of Farmer's Reducer. Removing density with reducer is not difficult unless there is an area of density that you want to save close to the area that you want to remove. Because reducer is a liquid and tends to run, it is harder to control than retouching with opaque.

To remove density (black areas) with opaque, make a positive (or negative) from the original KODALITH Film. Since the area you want to remove was black on the original, it will be clear on this second film. It's easy to opaque out the clear area, but then you'll have to print this image onto another sheet of KODALITH Film to get it back where you started.

If your KODALITH Films show yellow processing stains, you can remove these stains by immersing the film in a very dilute solution of KODAK Farmer's Reducer. After the stain disappears, wash and dry the film following the instructions on page 35. Processing stains are a warning signal that your chemicals are exhausted or that you need to rinse your hands more carefully after you handle film in the fixer and before you put a fresh sheet of film into the developer.

JANE A. DIFLOURE

You can paint out large areas of KODALITH Film with opaque to eliminate distracting details.

A VARIETY OF USES FOR HIGH-CONTRAST FILMS

As we said earlier, knowing how to produce good-quality high-contrast images is the basis for many of the techniques mentioned in the following chapters of this book. High-contrast films open new horizons to the photographer. Here are some quick and easy things that you can do with the high-contrast images you create.

Prints and Slides

It's obvious that you can use a high-contrast negative to make a print. If you print a positive, you'll get a negative print. Because high-contrast images are more graphic than realistic, it often doesn't matter whether you start with a negative or positive to produce a positive or negative print. In fact, if you've put the image through several stages of KODALITH Films, you may completely lose track of whether the image is negative or positive. It certainly won't matter to anyone viewing the print as long as you have produced an interesting image.

Another way you can use your high-contrast films is for making slides. If you've produced 4 by 5-inch images, try copying them using transmitted light on color-slide film. Refer to page 253 for one method of illuminating films for copying. You'll need a close-up lens or other close-up equipment to allow you to fill the picture area with the image. Try different colored filters over the camera lens or cut up pieces of gelatin filters and place them behind the clear areas on the film to produce a multicolored image.

If you've contact-printed 35mm slides or negatives onto high-contrast film, you can mount the piece of high-contrast film itself and use it as a slide. To add an overall color, mount a piece of gelatin filter material with the film. For the best results, bind high-contrast slides in glass. These slides tend to "pop" more during projection than conventional slides.

You can also add color directly to high-contrast film (and other films too) with water-soluble dyes, such as KODAK Retouching Colors and dyes made for photographic use (two are listed in the footnote on page 131). Some people have also used vegetable food coloring with success.

To apply one color over the whole film, simply dip the film in a solution of the dye. To add different colors to several areas on the film, use a cotton swab or a brush. You can apply the color to either the emulsion or the base of the film.

A grainy negative on 35mm film was enlarged onto KODALITH Film, and the KODALITH Film was developed in KODALITH Fine Line Developer. The film was agitated during the first fifteen seconds in the developer, and then still developed with no agitation for another 2¼ minutes. This produced a positive film which was contact-printed onto a sheet of KODAK Separation Negative Film 4133, Type 2.* The Separation Negative Film was developed in KODAK Developer DK-50 (1:1) for 2½ minutes to produce the negative that made this print.
*Note: You could also use KODAK Commercial Film for this step.

This picture was planned in advance, and a picture was taken of each building on negative film. These two negatives were enlarged onto KODALITH Film to produce positives, and then the positives were contact-printed onto more KODALITH Film to produce two high-contrast negatives. The foreground negative was printed to a black silhouette, and the background negative was given a shorter exposure to produce a light gray tone.

This picture happened when the photographer was experimenting in the darkroom. The original negative on KODAK PLUS-X Pan Film was enlarged onto 4 by 5-inch KODALITH Film. That KODALITH Film was contact-printed onto another sheet of KODALITH Film. These two films were sandwiched together in register and contact-printed on a third sheet of KODALITH Film. The resulting third sheet of film was used to make this print.

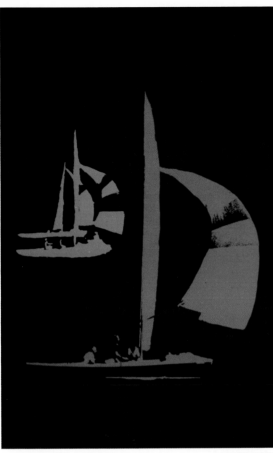

This slide on KODAK EKTACHROME-X Film was made by photographing a KODALITH Negative. Cyan and magenta gelatin filters were placed behind the boats (clear areas in the negative) so that they were recorded in different colors.

BARBARA KUZNIAR

BARBARA KUZNIAR

You can also use KODALITH Film to create a montage with a color slide. Birds or trees printed on KODALITH Film can add a foreground or center of interest to sunsets and other scenes.

A slide on KODAK
EKTACHROME-X Film made
by photographing a
KODALITH positive through
an orange filter.

High-contrast films often make
effective slides as a montage.
The skyline of New York is a
KODALITH positive contact-
printed from a black-and-white
negative. The moon is one color
slide, and the trees are another
color slide which was taken with
a multiple-image lens—three films
and a combination of darkroom
and in-camera techniques to
create a photograph you could
never see in your viewfinder!

BARBARA KUZNIAR

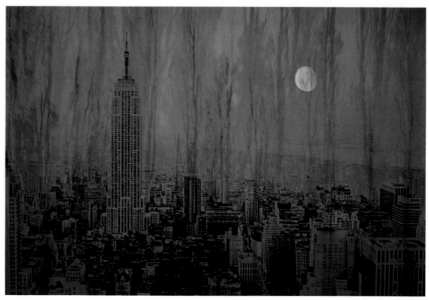

PAUL KUZNIAR

A title made on KODALITH Film and hand-colored with dye.

KEITH BOAS

It's easy to color KODALITH Film with dyes, and you can color selected areas of the picture.

KEITH BOAS

Titles

You can make dramatic title slides by copying lettering onto high-contrast film. The easiest way to make these titles is in the camera rather than in the darkroom. Copy your titles onto KODALITH Ortho Film 6556, Type 3. This film comes in the sheet-film sizes that we mentioned earlier and in 35mm 100-foot rolls. To use the film in a 35mm camera, you'll have to load lengths of it into a 35mm magazine, such as a KODAK SNAP-CAP Magazine. Expose and process the film according to the directions on the film instruction sheet. Mount and color your titles as explained on page 154.

KEITH BOAS

The photographer created this slide for a travelog by tracing a map with a black marking pen, and then photographing the tracing on KODALITH Film. Selective coloring with dyes emphasizes one country while showing its surrounding area.

Here's a title made by a double exposure. The photographer took a close-up of the flower pattern in a rug for the background; then she photographed a KODALITH Negative with the title in clear letters against a black background. The additional exposure in the area of the title completely over-exposed the film and left the letters clear. The background image was not affected by the second exposure because the black background of the KODALITH Negative acted as a mask and prevented additional exposure in that area.

PICTURE SEQUENCES

BARBARA KUZNIAR

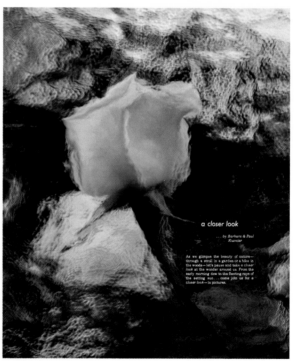

a closer look

... by Barbara & Paul Kuzniar

As we glimpse the beauty of nature—through a stroll in a garden or a hike in the woods—let's pause and take a closer look at the wonder around us. From the early morning dew to the fleeting rays of the setting sun . . . come join us for a closer look—in pictures.

BARBARA AND PAUL KUZNIAR

You can also add lettering to prints with KODALITH Film. Photograph black type against a white background on KODALITH Film to produce a film with white letters on a black background; then contact-print this film onto another sheet of KODALITH Film to produce black letters on a clear background. Sandwich the KODALITH Film (with the black letters) with your negative and print them together to produce white letters on your print. Obviously, you'll have to plan ahead to make sure the size of the type fits into the picture where you want it. This print was used as a title picture for a print show.

160

This is a bas-relief made by contact-printing the transparency onto KODALITH Film. Then the KODALITH Film was sandwiched with the transparency and copied to produce this slide.

This bas-relief was made from a slide and a KODALITH Negative; then the photographer had a color internegative made so he could make a color print from it.

Creating a Bas-Relief

A bas-relief is a picture with the subject outlined by a dark or light line and with a somewhat distorted overall tonal gradation. You can create a bas-relief in black-and-white or color (negative or slide) with the use of high-contrast film. Contact-print the original image onto KODALITH Ortho Film 6556, Type 3, and process the film as directed on page 152. After the high-contrast film is dry, place it with the original film and arrange the images so that they're just slightly out of register. Tape the edges of the film together to keep them from slipping. If your original image was a negative, place the film sandwich in your enlarger and print it. If the original image was a slide, bind the film sandwich between glass and you have produced a bas-relief slide.

If you want to go one step further with high-contrast film and bas-relief, you can create some very interesting images. Contact-print your original image onto a sheet of KODALITH Ortho Film 6556, Type 3, and then print this sheet of KODALITH Film onto a second sheet of KODALITH Film. Bind the KODALITH negative and positive films together with the images just slightly out of register. Put this film sandwich in your enlarger and print it to produce a high-contrast bas-relief print.

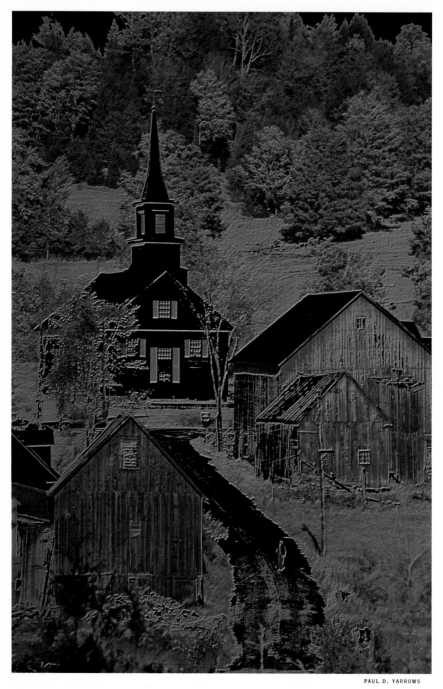

This slide is a bas-relief—the subject is outlined by a dark line and the highlights are black from a KODALITH Film sandwiched with the original slide.

Creating a Tone Line Negative

A print made by the Tone Line Process looks like a pen and ink drawing. This is a multistage process, and it requires considerable experimenting to get the proper exposure of the various films involved.

Start with a black-and-white negative and make a contact positive on any black-and-white film. KODAK Commercial Film 6127 is an easy film to use for this step because you can process it under a safelight. For more information on this film refer to page 127. The contrast and density of the positive should be as close as possible to that of the negative. Register the images of the negative and positive with the base sides together, and tape together along the edge.

Place the film sandwich in a printing frame with a sheet of KODALITH Ortho Film 6556, Type 3, as illustrated in the drawing at the right. Place the printing frame on a turntable and rotate it during the exposure or move the light source in a circle over the printing frame. Expose the film to the light from a 100-watt frosted bulb placed three feet above the printing frame at an angle of about 45 degrees as illustrated in the drawing. You'll need to experiment to determine the exposure, and you can use small pieces of film until you get the exposure you want. Follow the instructions on page 150 for processing the KODALITH Film. This processed film is your tone line negative, and you print it just as you would any negative.

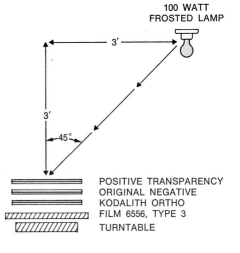

100 WATT FROSTED LAMP

3'

3'

45°

POSITIVE TRANSPARENCY
ORIGINAL NEGATIVE
KODALITH ORTHO
FILM 6556, TYPE 3
TURNTABLE

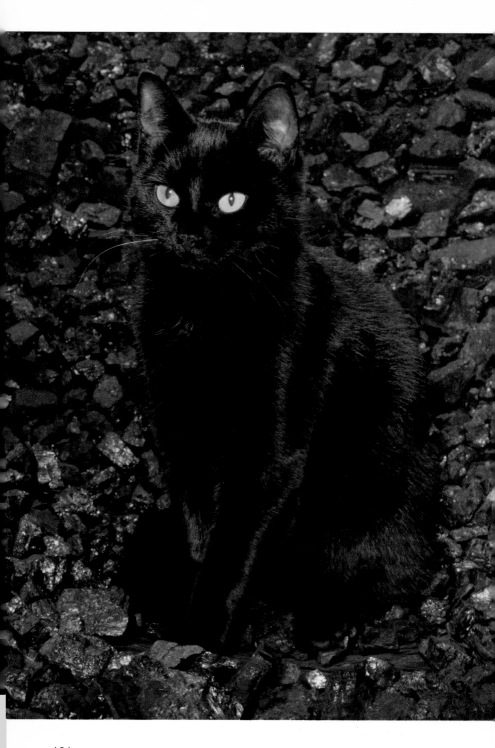

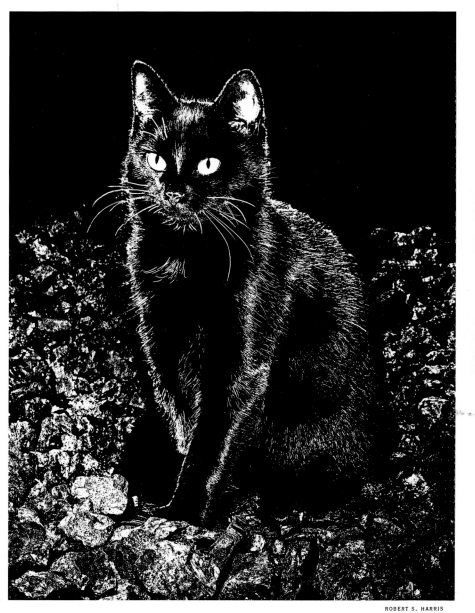

The print on the left is a straight print made from the original
black-and-white negative. That same negative was used as the original
image to produce the tone-line image above.

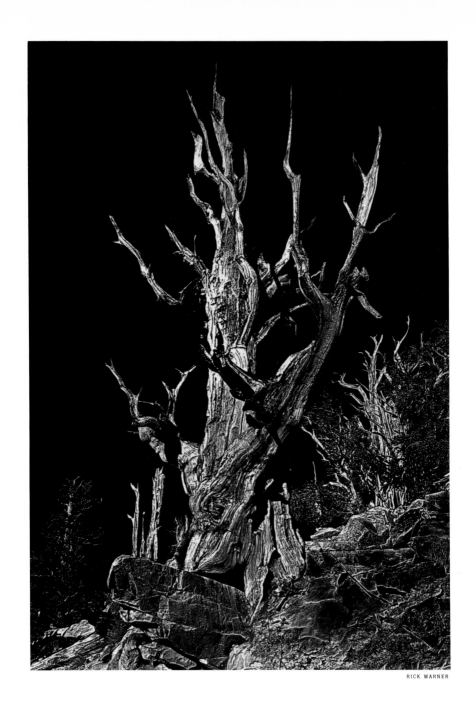

RICK WARNER

The tone line on the left looks like the negative used to print the tone-line print on the right. To produce a print that looks like the tone-line negative, you'll need to contact-print that negative onto another sheet of KODALITH Film, and then use the resulting film (positive) to make your print.

167

This is a tone line made from a film sandwich where the negative and positive films had different densities. Because the densities didn't match, some detail throughout the subject, as well as the tone-line outline, was exposed.

KODALITH Ortho Film was used for all the stages (except the original) in creating this tone line.

Here's a tone line printed in register with the original color negative. The color negative was used as the original image to create the tone line. After printing the color negative on color paper, the paper was given a second exposure from the tone-line negative to add the black detail to the print.

169

The tone line helps isolate the subject, and the diagonal composition
adds to the feeling of action.

LYN ADAMS

These high-contrast techniques offer you unlimited opportunities for creating new photographs. Experiment with combining techniques mentioned in this book. This photograph shows a combination of techniques.

Two black-and-white photographs were made of the model, and one was cut up to serve as a pattern. The photographer printed 35mm negatives onto KODALITH Film to produce small positive images; then these positive films were arranged into the cut pattern of the model's leotard. The films were taped together with clear tape. These taped KODALITH positives were contact-printed onto another sheet of KODALITH Film. Using the pattern again, the negative film was then cut out in the shape of the leotard, and the clear areas of the image were painted on one side with paint. When the paint was dry, this negative film was glued to the original mounted enlargement with rubber cement.

171

Reticulation

Reticulation is distorting the emulsion layer to create an overall pattern in the film. The distortion is produced during processing by extreme changes in the temperature of the solutions.

BOB CLEMENS AND FREDERICK C. ENRICH

This print was made from a negative on KODAK TRI-X Pan Film. The film was reticulated using the process described on page 180; then it was frozen. Save the reticulation process for those pictures which have simple composition.

A print from reticulated KODACOLOR-X Film. The reticulation pattern can add interest to a photograph which has a strong design with large, plain areas.

A reticulated color slide on KODAK
EKTACHROME-X Film. This film was
reticulated during processing by the
double prehardener method (see page 188)
and then it was frozen for 15 minutes.
Since reticulation is strictly experimental,
it's best to copy your original
photograph and reticulate the copy.

Reticulation is a distortion of the emulsion layer of a film, usually caused by extreme change in temperature during processing, which causes silver grains in the emulsion to "clump together" into a regular pattern. The resulting pattern is called reticulation, and it ruins the film for normal photographic purposes. However, reticulation can enhance some photographs with the texture that it adds. The texture can add interest particularly to photographs having strong design with large plain areas. It can also enhance the mood of a scene such as a seascape or a sunset.

Because reticulation is undesirable, unless you're trying to produce special effects, photographic manufacturers have worked to improve films so that they resist reticulation. Twenty years ago, reticulation occurred often and easily if the temperature of the processing solutions varied slightly. Today, black-and-white and color films have been improved so much that moderate variations in temperature will not damage film or cause it to reticulate. You have to create extreme temperature changes during processing to achieve reticulation.

Since the techniques described in this chapter are strictly experimental and the film might be ruined in the process, you may want to copy your original photograph and reticulate the copy negative or slide. In addition to reticulating, this chapter includes a method of freezing the emulsion for the photographer who likes to experiment with "way out" techniques.

You can add texture to color slides with montage. This rose was slightly overexposed. Putting a close-up of a concrete block over it added texture and density. Adding texture with a montage rather than with reticulation allows you to see exactly how your original image will look with a pattern without changing that original image. If you don't like the results, you can change your mind and the original image hasn't been altered.

SIMULATING RETICULATION WITH TEXTURE SCREENS

By far the easiest way of producing a regular pattern on film which simulates reticulation is with a texture screen. Texture screens allow you to add a regular pattern without altering your original image. They work equally well with black-and-white negatives, color negatives, and color slides. As we mentioned earlier, you can make your own texture screens or order ready-made screens. For more information on making, ordering, and using texture screens, refer to page 60.

With color slides, you can easily add texture by making a montage. Photograph any interesting textures you see, such as the patterns in a cement sidewalk, cloth, wall coverings, and rugs. Sandwich these texture slides with other slides that need additional interest to create a good picture. Make a variety of exposures of the texture, from a normal exposure to a light exposure, so that you can match the texture slide to the density of the main slide to create a well-exposed montage.

Photograph ice crystals on a window; then you can put the
ice-crystal pattern over any subject by making a montage.

A print made from KODAK TRI-X Pan Film, which was reticulated using the process on page 180.

RETICULATING BLACK-AND-WHITE FILMS

A little knowledge of the film's structure and what happens during processing can help you obtain successful results with reticulation. A black-and-white negative is composed basically of grains of silver suspended in a gelatin emulsion and spread on a clear plastic base. When the film emulsion is wet, it becomes very soft. A hardener is usually included in the fixer to harden the emulsion and make it less fragile. Extreme changes in temperature while the film is in its softest state will cause uneven swelling and shrinking of the gelatin and produce a relief pattern in the emulsion called reticulation.

The reticulated pattern shows up distinctly in the large, plain areas of the windows.
A print made from reticulated KODAK PLUS-X Pan Film.

BOB CLEMENS AND FREDERICK C. ENRICH

KODAK PLUS-X Pan Film was reticulated and was then placed in the freezer for about 10 minutes. Reticulation created the overall spotted appearance and the freezing added another pattern. Refer to page 188 for more information on freezing film.

RETICULATING BLACK-AND-WHITE FILMS

Use KODAK PLUS-X Pan or KODAK TRI-X Pan Film.

In total darkness:

1. Use KODAK Developer D-76 and develop the film according to the film or developer instructions.
2. Rinse the film in an *acetic acid* stop bath for 1 minute at a temperature of 140 F to 150 F.
3. Immerse the film in a cold water bath (below 40 F) for 1 minute.
4. NOTE: This step is optional, it emphasizes the reticulation pattern of the emulsion. It doesn't change the pattern, it just makes it more prominent. Immerse the film in hot water (180 F to 190 F*) for 1 minute. Then quickly immerse it into another cold water bath (below 40 F).
5. Fix the film in the normal way with a fixer that contains a hardener such as KODAK Rapid Fixer.
6. Wash the film in running water for 20 to 30 minutes.
7. Do not use KODAK PHOTO-FLO Solution. Dry the film quickly using a portable hair dryer. Lay the film emulsion side up on a clean, lintless cloth and direct the warm air back and forth across the surface of the film. You can also freeze the film before drying or when it's partially dry; refer to page 188.

*You can measure these temperatures without a thermometer by watching the water as you heat it. The water will be about 180 F when it begins to swirl, and 190 F when small bubbles start forming along the sides of the container.

RETICULATING COLOR FILMS

Color films have essentially the same structure as black-and-white films, but they are more intricate because they contain many layers of emulsion. Three emulsion layers, which are sensitive to blue, green, and red light, are coated on a clear plastic base to make color film. The yellow, magenta, and cyan color dyes that the respective emulsion layers produce are developed along with the silver while the film is in the color developer.

Heating and chilling the film affects these layers differently, and the top yellow dye layer is affected the most. Because the layers react differently during the reticulation process, a reticulated negative or slide will show a slight shift in color balance. With color negatives, you can compensate for this shift during the printing process. With color-slide films, you must compensate for the color change when you expose the film in the camera if you want the final slide to show a normal color balance (see page 186).

There are two ways to reticulate negative films and each produces different reticulation patterns. Reticulating the film before processing produces a fine pattern of black lines marbled throughout the image. Reticulating the film during the process gives a coarse pattern with tiny patches of yellow visible when the pattern is examined closely. These patches indicate that the yellow dye layer has reticulated to a much greater extent than the magenta or cyan layers.

Reticulation on color films adds both a pattern and additional color in that pattern because the layers react differently during the reticulation process. A print made from KODACOLOR-X Film reticulated by the double prehardener method.

BOB CLEMENS AND FREDERICK C. ENRICH

Remember to keep your subjects for this process as simple as possible,
and select subjects that will be improved with a color pattern added to them.
Many intricate subjects become busy and look jumbled when they are reticulated.

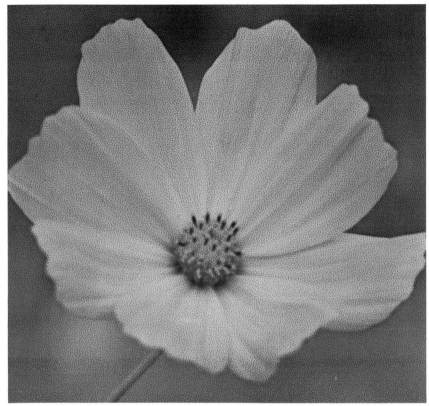

A print made from KODACOLOR-X Film reticulated to produce a fine marbled pattern.

Reticulating Color-Negative Films

We've produced repeatable reticulation patterns on KODACOLOR-X Film and KODAK EKTACOLOR Professional Film 5026, Type S, by using the processes described on page 185 and KODAK Color Film Processing Chemicals, Process C-22. The reticulation process calls for the use of ice water. Crushed ice works better than ice cubes for making the ice water.

Since reticulation is an experimental technique and the results may vary due to your individual processing technique, the age of the chemicals, and the amount of film already processed in the chemicals, it's advisable to run a test with a few frames of your film before processing the whole roll. If you do not obtain an even reticulation pattern with the suggested processes on page 185, raise the hot water temperature 5 F. If you have a good pattern but find the edges of the emulsion coming off, lower the hot water temperature 5 F, and increase the time in the hardener from four to five minutes.

At the end of the process, you can shorten the drying time by drying the film with the warm air from a portable hair dryer. Lay the film (emulsion side up) on a clean, lintless cloth and direct the warm air back and forth across the surface of the film.

BOB CLEMENS AND FREDERICK C. ENRICH

A print made from KODACOLOR-X Film reticulated to produce a coarse pattern.

RETICULATING COLOR-NEGATIVE FILMS TO PRODUCE A COARSE PATTERN

Use KODACOLOR-X Film or KODAK EKTACOLOR Professional Film 5026, Type S, and KODAK Color Film Processing Chemicals, Process C-22.

In total darkness:

1. Develop the film according to the processing instruction sheet and use a normal stop bath procedure.
2. Turn on the white lights after the stop bath.
3. Immerse the film in running water at 110 F for 2 minutes.
4. Rapidly remove the film from the hot water and plunge it into ice water. Soak in ice water for 1 to 2 minutes.
5. Harden for 4 minutes and continue normal development following the instructions on the processing instruction sheet.

RETICULATING COLOR-NEGATIVE FILMS TO PRODUCE A FINE MARBLED PATTERN

Use KODACOLOR-X Film or KODAK EKTACOLOR Professional Film 5026, Type S, and KODAK Color Film Processing Chemicals, Process C-22.

Steps 1-4. In total darkness:

1. Wind the film onto the reel from your developing tank and then immerse the film in water at 105 F for 2 minutes and agitate gently.
2. Rapidly remove the film from the hot water and plunge it into ice water. Soak in ice water for 1 to 2 minutes.
3. Bring the film to the normal processing temperature of 75 F with a 15-second wash in 75 F water.
4. Process the film as you normally would, using the C-22 chemicals and following the processing instruction sheet.

Reticulating Color-Slide Films

We've produced reticulation patterns on KODAK EKTACHROME-X Film, KODAK High Speed EKTACHROME Film (Daylight and Tungsten), and KODAK EKTACHROME Slide Duplicating Film 5038 (Process E-4) by using the processes described on pages 186 and 188 and KODAK EKTACHROME Film Chemicals, Process E-4. The reticulation process calls for the use of ice water. Crushed ice works better than ice cubes for making the ice water.

Since reticulation is an experimental technique and the results may vary due to the age of the film, your individual processing technique, the age of the chemicals, and the amount of film already processed in the chemicals, it's advisable to run a test with a few frames of your film before processing the whole roll. Depending upon the age of the film and the strength

of the prehardener, the film may fail to reticulate. If the test film does not reticulate, raise the temperature of the hot water bath from 110 F to 115 F. With the double prehardener method you may also reduce the first prehardening time from thirty seconds to fifteen seconds. We do not recommend eliminating the first prehardener or cutting the time to less than fifteen seconds since this increases the green color shift.

With the double prehardener method, you can selectively reticulate individual frames. If you skip steps 4 and 5 and follow the rest of the process, the film will look normal provided you used a KODAK CC30 Magenta Filter over the lens when exposing it. Before step 4, you can cut out individual sections from your roll of film. Do steps 4 and 5 with these sections on a new developing-tank reel. This will reticulate the selected sections of film. Continue processing all the film together starting with step 6.

If your test film fails to reticulate, you can still add a pattern to it by freezing. Refer to page 188 for the details on freezing film.

At the end of the process, dry the film quickly by using a portable hair dryer. Lay the film (emulsion side up) on a clean, lintless cloth and direct the warm air back and forth across the surface of the film.

Using KODAK EKTACHROME Slide Duplicating Film 5038

(Process E-4). If you already have slides in your files that you would like to try with a reticulation pattern, you can duplicate them using KODAK EKTACHROME Slide Duplicating Film 5038. You may use either reticulation method and correct the color balance while exposing the duplicate. There is a loss in contrast, so start with a fairly high-contrast original slide that has good color saturation.

RETICULATING COLOR-SLIDE FILMS (THE SHORT METHOD)

Use KODAK EKTACHROME-X Film, KODAK High Speed EKTACHROME Film (Daylight or Tungsten), or KODAK EKTACHROME Slide Duplicating Film 5038 and KODAK EKTACHROME Film Chemicals, Process E-4. *Expose the film with a KODAK CC20Y Yellow Filter over the camera lens to correct for the color shift that occurs with this process.*

Steps 1-5. In total darkness:

1. Wind the film on your developing-tank reel and leave it on the reel for the entire process.
2. Immerse the film in a hot water bath at 110 F to 115 F for 1 minute. Agitate gently and continuously.
3. Rapidly remove the film from the hot water and plunge it into ice water. Soak in ice water for 1 minute.
4. Rinse in water at 85 F to bring the film back to the normal processing temperature.
5. Process normally by following the instructions on the processing instruction sheet.
6. Dry as quickly as possible by using a portable hair dryer.

KODAK EKTACHROME-X Film reticulated to produce a fine marbled pattern, and then frozen for 15 minutes. Refer to page 188 for more information on freezing film.

KODAK EKTACHROME-X Film reticulated by the double prehardener method and then frozen for 15 minutes.

RETICULATING COLOR-SLIDE FILMS
(DOUBLE PREHARDENER METHOD)

Use KODAK EKTACHROME-X Film, KODAK High Speed EKTACHROME Film (Daylight or Tungsten), or KODAK EKTACHROME Slide Duplicating Film 5038 and KODAK EKTACHROME Film Chemicals, Process E-4. *Expose the film with a KODAK CC30M Magenta Filter over the camera lens to correct for the color shift that occurs with this process.*

Steps 1-2. In total darkness:

1. Wind the film on your developing-tank reel and immerse it in the prehardener for 30 seconds (20 seconds with agitation and a 10-second drain). Use a 15-second time if the test film fails to reticulate.
2. Follow the instructions packaged with the chemicals for the neutralizer, first developer, and acid rinse.
3. Wash for 2 minutes. You may turn on the room lights.
4. Immerse the film in a hot water bath at 110 F to 115 F for 1 minute.
5. Rapidly remove the film from the hot water and plunge it into ice water. Soak in ice water for 1 minute.
6. Rinse in water at 85 F for 15 seconds to bring the film back to normal processing temperature.
7. Repeat prehardener step for 3 to 4 minutes depending on the freshness of your chemicals.
8. Repeat neutralizer step for 1 minute.
9. Wash the film for 2 minutes at 85 F.
10. Follow the normal Process E-4 instructions, starting with the color developer.
11. Dry film as quickly as possible by using a portable hair dryer.

SPECIAL EFFECTS FROM FREEZING

You can create very interesting effects if you freeze your wet film before drying it. With normally processed film, the emulsion is generally too hard, but an emulsion that has been softened by reticulation will contract when frozen. Using this method, you can salvage those test films that may not have reticulated with the other process.

When you freeze black-and-white film, you can vary the special effects by controlling the amount of moisture left in the emulsion after you air-dry it with a hair dryer. A partially dry emulsion will tend to make a blistered effect, or no effect if it is almost dry, while a very wet emulsion will form leafy frost patterns. You can create localized leafy patterns by gently touching the partially dry emulsion with a wet finger, forming a "water spot." This technique will not work with color films.

When your color negative films are frozen, a marbled effect is created in all three dye layers. The image becomes almost unrecognizable, except from a great distance. The abstract

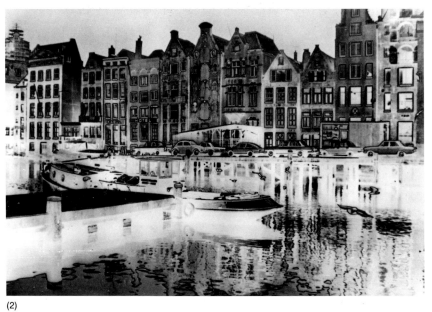

(2)

(3)

191

A slide showing the Sabattier Effect made from a color slide using the technique
described on page 219. Original exposure one minute at $f/8$ through a
40C cyan filter; re-exposure 30 seconds at $f/8$ through a 40Y yellow filter.

True **solarization** is caused by extreme overexposure—about 1,000 times the amount required to produce a normal negative image with normal development. Solarization produces a reversal of the image, and both positive and negative images will be visible on the film and in the finished print. Years ago, solarization used to occur quite regularly in long, time exposures taken at night. The lights in the scene would be so overexposed that they would reverse and produce a positive image on the negative. Solarization is very difficult to achieve today because films have been improved to the point where this reversal is almost impossible to produce. Many people incorrectly refer to the Sabattier Effect as solarization because these two techniques produce such similar-looking images.

The **Sabattier Effect** produces both a negative and a positive image on the same film, but this effect is achieved by re-exposing the film during development rather than extreme overexposure in the camera. The already developed image acts as a negative through which the rest of the light-sensitive silver in the film is exposed. This produces some reversal of the image and the result is part positive and part negative. If re-exposure is long enough, the resulting positive will develop to a greater density than the original negative image.

There is a simple way to determine whether a picture has been made by solarization or by the Sabattier Effect. The Sabattier Effect produces a narrow line or rim of low density, called a **Mackie Line,** between adjacent highlight and shadow areas. The Mackie Line occurs because there is always an increased concentration of bromide ions in the emulsion at the boundary separating a completely developed area from one that's just developing. The bromide along these boundaries greatly retards development, forming a more or less clear line. When this negative is printed, the Mackie Line will appear as a black outline around the principal image contours. The Mackie Line is not very evident on prints made when the Sabattier Effect is produced while processing the paper.

The Sabattier Effect can be produced with both film and photographic paper. You can use any white-light source for the re-exposure step. The easiest light to use is the light in a safelight positioned right over the sink. Of course, you'll have to remove the safelight filter if you use this light. The most difficult part of the Sabattier Effect is determining the length of the re-exposure. If you always use the same light source, keep it the same distance from the film or paper for each exposure, and keep good written records, you'll be able to determine the best re-exposure time for your situation after a few experimental exposures.

It's possible to produce dramatic pictures by the Sabattier Effect with any film or photographic paper, but there is an advantage to working with film rather than paper. After producing a negative with the Sabattier Effect, you can make as many prints as you want from that negative. If you use the Sabattier Effect on paper, you may not be able to produce another print exactly the same—very frustrating! The films and papers discussed in this chapter have produced good results, but you could probably get equally good results with any film or paper after some experimenting. The information given here is simply a

With the Sabattier Effect on a high-contrast film, such as KODALITH Ortho Film, you can create this outline effect. The high-contrast sheet film was then photographed with colored filters behind it to create a color slide. This same film could also be printed onto paper.

BARBARA KUZNIAR

guide to get you started in the darkroom, and you should adjust the process to meet your specific situation.

These variables affect the amount of reversal. 1) The amount of re-exposure, 2) The extent of development after re-exposure, 3) The time during development when the re-exposure takes place. If the reversal effects are too strong for your taste, reduce the re-exposure or develop the film longer before giving the re-exposure.

If you want to obtain more reversal of tones, increase the re-exposure or make the re-exposure earlier in the development. As a rule of thumb, re-expose the film or paper at about one-third of the development time, or when

a light image is visible. Stop agitating ten seconds prior to re-exposure and allow the film or paper to settle to the bottom of the developer tray. After re-exposing, continue the development to the normal development time for the first exposure and use continuous agitation.

To get the best results with the Sabattier Effect, use fresh developer and stop bath solutions. With experience, you will learn to pull the film or paper from the developer when you see the effect you want. A fresh stop bath is a necessity for stopping the action of the developer quickly and preserving the image you saw in the developer.

194

THE SABATTIER EFFECT IN BLACK-AND-WHITE

Prints

A few subjects will produce interesting pictures when the Sabattier Effect is tried directly on a print; however, most prints simply look as though they've been accidentally fogged. You can use Farmer's Reducer to bring out the highlights in these prints just as you would with other black-and-white prints. Refer to page 36. If you're not happy with your results, try printing your negative or slide onto KODAK Commercial Film 6127 or KODALITH Ortho Film 6556, Type 3. Refer to page 201.

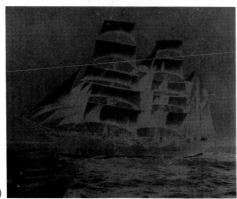

(1)

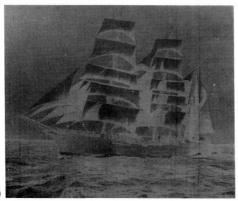

(2)

These prints were made on KODAK POLYCONTRAST Rapid Paper. (1) This is a straight print. Prints (2) and (3) show the Sabattier Effect. They were developed in KODAK DEKTOL Developer 1:1 for 30 seconds and re-exposed to a 15-watt lamp four feet from the paper, then development was continued for another minute. Print (3) was treated with KODAK Farmer's Reducer to lighten the highlights. Prints given the Sabattier Effect tend to look very dark and as though they've been accidentally fogged. This technique is much more effective on films.

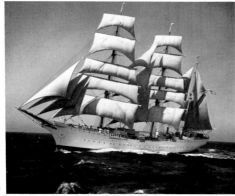

(3)

195

This print was made from a 4 by 5-inch sheet film negative on KODAK PLUS-X Pan Film. The background was dodged during the original exposure so that it would be underexposed if processed normally. After 1½ minutes in developer, the print was lifted from the developer and placed on the back of the sink so that the excess developer ran off diagonally. The room light was turned on for three seconds, and then the print was put in the stop bath and fixed.

THE SABATTIER EFFECT WITH
KODAK POLYCONTRAST PAPER

Use a KODAK Safelight Filter OC (light amber)

1. Make a test strip to determine the exposure for a normal print and process the paper in KODAK DEKTOL Developer 1:2 at 65 to 70 F with continuous agitation.
2. Print a fresh sheet of paper using the printing time you determined from the test strip.
3. Set your timer for 1 minute, 30 seconds—the total development time— and start timing with development.
4. Develop the paper with continuous agitation for 20 seconds, then turn the paper emulsion side up and allow it to settle to the bottom of the tray for 10 seconds with no agitation.
5. Re-expose the paper to white light while it's in the developer. (A safelight without a filter or the enlarger light works fine.)
6. Begin agitating after the re-exposure and continue the development to the total development time of 1 minute, 30 seconds.
7. Rinse the paper in stop bath and fix, wash, and dry the paper according to the instructions on the paper instruction sheet.

Film

Negatives made with the Sabattier Effect have a high fog level and they are difficult to judge visually. It's important to make a print before judging the effects. These negatives will usually print better on a higher-than-normal contrast paper.

Films Exposed in the Camera. You can try the Sabattier Effect directly on films exposed in the camera, but since it takes so much experimenting to get the proper re-exposure, you take a chance on ruining the film. Also, most camera films are panchromatic and must be developed in total darkness so you can't see the effect until development is complete. It's much easier to process your camera film in the normal way and then print it onto a sheet of film, such as KODAK Commercial Film. If you ruin the commercial film during the processing, nothing is lost; you still have your original image in good condition and can print as many additional sheets of commercial film as you need.

If you plan to try the Sabattier process on film you exposed in the camera, be sure to expose at least three negatives at the same exposure and of the same subject. If you're using roll film, expose the whole roll of the same subject at the same exposure, then cut the roll into three parts for the processing experiment. Process one sheet of film or part of a roll at a time and make a print from it to determine any changes you would make in processing the second sheet or portion of the roll. With this method, you should be able to get a good result by the third sheet or the end of one roll of film.

THE SABATTIER EFFECT WITH *KODAK PLUS-X* PAN FILM

Process in total darkness.

1. Process the film in a tray in KODAK HC-110 Developer diluted 1:16 at 68 F.
2. Set your timer for 3 minutes—the total development time—and begin timing with development.
3. Develop the film for 1 minute 20 seconds with continuous agitation, then turn the film emulsion side up and allow it to settle to the bottom of the tray for 10 seconds with no agitation.
4. Re-expose the film to a white light while it's in the developer. (A safelight without the filter or the enlarger light works fine.)
5. Begin agitation again after the re-exposure and continue the development to the total development time of 3 minutes.
6. Rinse the film in stop bath and fix, wash, and dry the film according to the instructions on the film instruction sheet.

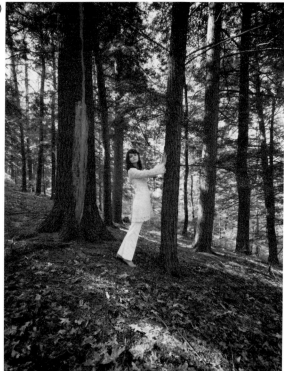

(1)

Prints made from KODAK PLUS-X Pan Film, 4 by 5-inch sheets exposed in the camera and developed in a tray in KODAK HC-110 Developer (1:16) for 3 minutes at 68 F. (1) This was developed and printed normally. Print (2) shows the Sabattier Effect. After 1½ minutes in the developer it was re-exposed for 2 seconds at f/22, and then development was continued for another 1½ minutes.

NORM KERR

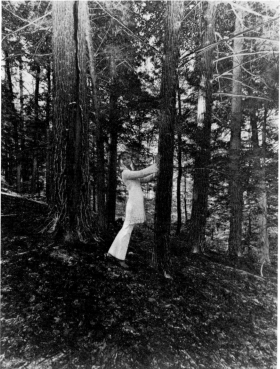

(2)

(1)

NORM KERR

Prints made from KODAK PLUS-X Pan Film, 4 by 5-inch sheets exposed in the camera and developed in a tray in KODAK HC-110 Developer (1:16) for 3 minutes at 68 F. Both prints show the Sabattier Effect and the only difference is in the amount of re-exposure given during processing. Both negatives were re-exposed after 1½ minutes in the developer. Print (1) was re-exposed for 2 seconds at $f/22$ and (2) was re-exposed for 4 seconds at $f/22$. When the length of the re-exposure is increased, the reversed image becomes more visible.

(2)

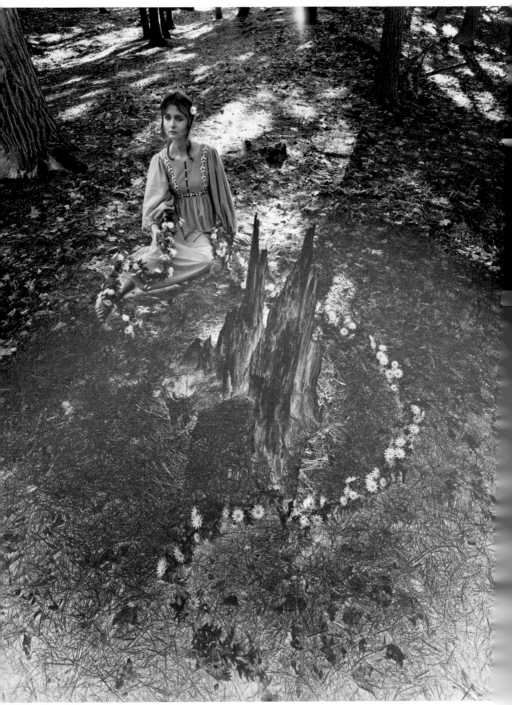

Films Exposed in the Darkroom.
Printing a negative or slide onto a sheet of film in the darkroom and trying the Sabattier Effect on the sheet film rather than on your original film is the safest way to experiment with this process. As we pointed out before, if you try the darkroom experiments on your original image, you run the risk of ruining it. However, if you save your original image and use it to print onto other films, you can experiment to your heart's content without damaging the original film.

Films made for copying continuous-tone originals can often be processed under the light of a safelight so you can see what you're doing. More important, you can watch the image develop and pull the film out of the developer when you see the results you want. The development times given here are only guides. This is the one time when it's quite permissible to give in to that urge to pull the film out of the developer too soon or to leave it in longer than the recommended time. With experience, you'll be able to judge the development visually and control the process by snatching the film out of the developer at just the right moment and plunging it into a fresh stop bath to immediately stop the action of the developer.

KODAK Commercial Film 6127 is a good film to use for the Sabattier Effect if you want a continuous-tone result. It's easiest to start with a color slide which will produce a negative image on the commercial film. The Sabattier Effect will bring out the detail in the shadow areas of the slide, so select a picture that has interesting shadow detail. If you use a negative as the original image, you'll need to contact-print the first sheet of commercial film onto another sheet of film to convert the image to a negative. Or, you might get some interesting results by trying the Sabattier Effect on the positive commercial film. Try it—if you don't like the results, you can always take the process one step further by making a negative.

If you make your original exposure properly, a full image will be visible on the commercial film after forty seconds of development. The film will turn almost black in a few seconds after re-exposure. Resist the temptation to pull this film from the developer before the full development time, because the film will clear and become much lighter after fixing. Once you are familiar with how a well-exposed film looks in the developer, you can visually judge the development and pull the film at the right moment.

← This print shows the Sabattier Effect in the lower portion of the picture only; the photographer wanted to create tension in the picture between the real and the unreal. The negative on KODAK PLUS-X Pan Film (4 by 5-inch sheets) was exposed in the camera and developed in KODAK HC-110 Developer (1:16) for 3 minutes at 68 F in a tray. After the film was in the developer for 1½ minutes, the bottom half of the negative was re-exposed, and the development continued for another 1½ minutes. Since the top half of the negative received only the original "normal" exposure, it does not show any reversal, while the bottom half of the negative (and print) shows the Sabattier Effect.

The Sabattier Effect on KODAK Commercial Film 6127. The film was
printed from a color slide with an exposure of 5 seconds at $f/22$.
After 40 seconds in KODAK Developer DK-50 (full strength),
the film was re-exposed for 3 seconds at $f/16$.

The Sabattier Effect will bring out the detail in the shadow areas of a color slide. The pilings under the dock were hardly visible in the original slide. The slide was printed onto KODAK Commercial Film 6127 with an exposure of 5 seconds at $f/22$ and the film was processed in KODAK Developer DK-50 (full strength). After 40 seconds in the developer, the film was re-exposed for 5 seconds at $f/4.5$; then development continued for a total time of two minutes.

THE SABATTIER EFFECT WITH
KODAK COMMERCIAL FILM 6127

Use a KODAK Safelight Filter, No. 1 (red)

1. Make a test strip to determine the exposure and process the film in KODAK Developer DK-50, full strength, for 2 minutes with continuous agitation. Select the best printing time from the test strip.
2. Print your original image onto a sheet of commercial film using the printing time you determined from the test strip.
3. Set your timer for 2 minutes—the total development time—and start timing with development.
4. Place the film in the developer with the emulsion side up and develop with continuous agitation for 30 seconds, then allow the film to settle to the bottom of the tray for 10 seconds with no agitation.
5. Re-expose the film to white light while it's in the developer. (40 seconds of development at this point.) (A safelight without a filter or the enlarger light works fine.)
6. Begin agitating again after re-exposure and continue development for the total development time of 2 minutes.
7. Rinse the film in stop bath, and fix, wash, and dry the film according to the instructions on the film instruction sheet.

Printed from a color slide, this sheet of KODAK Commercial Film 6127 looked like a poor exposure. After a minute or so in the developer it was placed in the sink to drain before being thrown away. The room lights were turned on briefly and several minutes went by before the film was noticed. By then an interesting image had appeared, so the film was fixed and washed in the usual way. The moral is: discards occasionally can develop into something!

BARBARA AND PAUL KUZNIAR

BARBARA KUZNIAR

With high-contrast films, the Sabattier Effect produces an outline of the image. Another version of this picture is on page 157.

KODALITH Ortho Film 6556, Type 3, produces dramatic results with the Sabattier Effect. The Mackie Line around the image is very evident with this film. By adjusting the re-exposure time, you can produce a very high-contrast image which also includes some gray tones in the areas that were re-exposed.

By using a long re-exposure or extending the development time so that the re-exposed image is the same density as the original, you'll produce a black film with the subject outlined in a clear Mackie Line. If you're trying to achieve only an outline of the subject, start with a high-contrast original —an image that has been printed onto KODALITH Ortho Film. Print the KODALITH Film onto another sheet of KODALITH Film and re-expose the second film during the development.

These dense negatives require long exposure times in printing, and you can save time in making prints by contact-printing the film with the Sabattier Effect onto another sheet of KODALITH Film. When this second film is printed onto paper, you'll have a black print with the subject outlined in white. To produce a white background with the subject outlined in black, contact-print the second KODALITH Film onto a third sheet of KODALITH Film, and then print that film on paper.

Process the film in KODALITH Super Developer. You should wait until the last minute to mix the two stock solutions together and use only a small amount of developer, because this active developer oxidizes very quickly. The developer will exhaust itself in a few hours if you mix it and then don't use it, so never try to store the developer once you've mixed the two solutions together. Eight ounces of solution in a 5 by 7-inch tray will develop three sheets of 4 by 5-inch KODALITH Film. To keep your results consistent, discard the developer after three sheets of film and mix up fresh developer. You can continue to use developer for more than three sheets of film if you increase the processing time. Since you can watch the film developing, continue the development until you see the results you want.

Agitate the film continuously in the developer prior to re-exposure but *do not agitate the film after re-exposure.* If you agitate the film after the re-exposure, the re-exposed areas will have a mottled or streaked appearance. This phenomenon is called "bromide drag," and is caused by the heavy concentration of bromide produced during the development of the high-density areas of KODALITH Film. By not agitating, you can prevent bromide drag and obtain a more vivid Mackie Line.

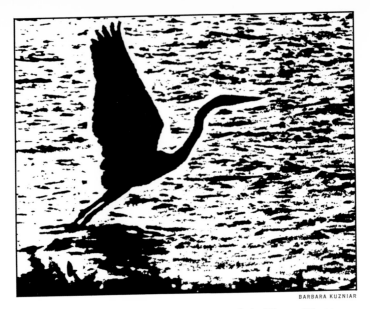

This is a high-contrast positive on KODALITH Ortho Film, and it was used as the original image for this series of pictures on the Sabattier Effect. If you're trying to create a picture with this technique that shows only the Mackie Line, you'll get the best results by starting with a high-contrast original.

Enlarge the high-contrast original onto another sheet of KODALITH Film, and during the development, re-expose the film to white light to create the Sabattier Effect. These pictures were taken in a home darkroom. One of the advantages of working with KODALITH Film is that you can use a red safelight and actually see what you're doing.

Here's what the film looks like after it's re-exposed and completely processed. As you can see, it's very dark and would require a long exposure time for printing.

You can avoid long printing times by contact-printing the dark film onto another sheet of KODALITH Film. After contact-printing and processing, the resulting film will look like this and be very easy to print. This film would produce a black print with white outlines. If you want the final print to look like this film (with black outlines on a white background), you have to go one step further and contact-print this film onto another sheet of KODALITH Film.

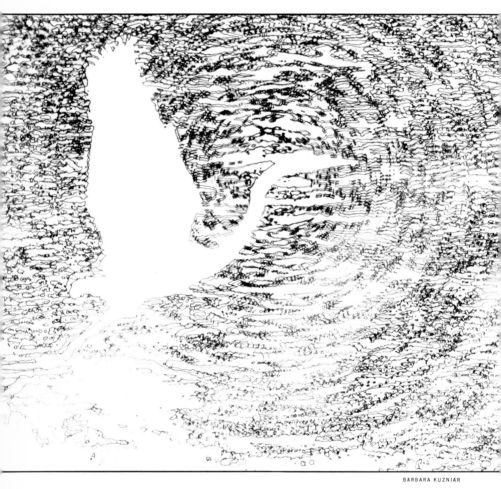

BARBARA KUZNIAR

Save your rejects and experiment with them! In working with films, you may
print some that are too light or too dark. Don't throw them away! Wash and dry
them just as you do your good films, and then use them for experimenting.
This picture is a sandwich made from ''extra'' films that were put together
in register and when one film was rotated slightly, a new picture emerged.

A print made from a high-contrast film which was re-exposed during development to produce the Sabattier Effect.

JAMES LOTT

THE SABATTIER EFFECT WITH
KODALITH ORTHO FILM 6556, TYPE 3

Use a KODAK Safelight Filter, No. 1A (light red)

1. Make a test strip to determine the exposure and process the film in KODALITH Super Developer (equal parts of Solution A and Solution B) at 68 F with continuous agitation for 2¾ minutes.
2. Print the original image onto a sheet of KODALITH Ortho Film using the printing time you determined from the test strip.
3. Set your timer for 2¾ minutes—the total development time—and start timing with development.
4. Place the film in the developer with the emulsion side up and develop with continuous agitation for 50 seconds, then allow the film to settle to the bottom of the tray for 10 seconds with no agitation.
5. Re-expose the film to white light while it's in the developer. (A safelight without a filter or the enlarger light works fine.)
6. Allow the development to continue *without agitation* for the total development time of 2¾ minutes or pull the film from the developer when you see the effect you want.
7. Rinse the film in stop bath and fix, wash, and dry the film according to the instructions on the film instruction sheet.

209

This print showing the Sabattier Effect was printed from a sandwich of two films. A normally exposed high-contrast positive was made from a negative on KODAK PLUS-X Pan Film. Then a very light negative and a normal negative were made on high-contrast film from the high-contrast positive. The normal negative was re-exposed halfway through the development to create the Sabattier Effect; then that negative was contact-printed onto another sheet of high-contrast film to produce a film with a clear background and black outline. This outline film was then sandwiched with the light negative made earlier and the two films were printed together to produce this print. The Sabattier film produced the strong white outlines, and the light negative produced the detail in the picture.

This print was re-exposed during development to create the Sabattier Effect.
This technique is very hard to repeat with exactly the same results,
so if you plan to make many prints, it's easier to do the Sabattier Effect
on film and then print from that.

THE SABATTIER EFFECT IN COLOR

The Sabattier Effect gives even more dramatic results in color than in black-and-white. In addition to creating a negative and positive image outlined with a Mackie Line, the Sabattier Effect creates new and vivid colors.

With the Sabattier Effect in color you can create vivid, wild colors in a photograph—colors that look unreal and have no relation to the "normal" colors in the original subject. Using white light for both the original exposure and re-exposure steps will create brilliant colors, or you can use colored filters over the light source during these exposures. There's a great variety of combinations you can create with filters or by using white light for one exposure and a filter for the other.

The filters listed below produce good results, and so will other filters. Experiment with those you have on hand to see if you like the colors they produce. Use the filters below as a guide to the color range. The color listed in the right-hand column is the color that filter produces with a black-and-white original with re-exposure during development. When you're printing from a color negative or slide, the color in the film acts as a filter and the color produced by the first exposure also acts as a filter during the re-exposure, so the final results might not always be exactly the color you expect.

Filter No.	Color of Filter	Color Filter Produces
40Y	yellow	blue
40M	magenta	green
40C	cyan	red
29	deep red	cyan
61	deep green	magenta
47B	deep blue	yellow

A 4 by 5-inch film was given the Sabattier Effect using the process on page 209. That film was then copied onto 35mm KODALITH Film to produce this high-contrast slide. This slide was used to produce all the slides in this series.

OE one min. f/8 w/40Y yellow; RE 30 sec. f/8 w/29 red.

OE one min. f/8 w/40C cyan; RE 30 sec. f/8 w/WL.

OE one min. f/8 w/40M magenta; RE 30 sec. f/8 w/29 red.

OE one min. f/8 w/40Y yellow; RE 30 sec. f/8 w/WL.

OE = original exposure

OE one min. f/8 w/29 red;
RE 30 sec. f/8 w/WL.

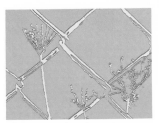

OE one min. f/8 w/47B blue;
RE 30 sec. f/8 w/47B blue.

OE one min. f/8 w/61 green;
RE 30 sec. f/8 w/WL.

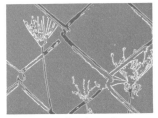

OE one min. f/8 w/29 red;
RE 30 sec. f/8 w/29 red.

OE one min. f/8 w/47B blue;
RE 30 sec. f/8 w/WL.

OE one min. f/8 w/61 green;
RE 30 sec. f/8 w/61 green.

OE one min. f/8 w/29 red;
RE 30 sec. f/8 w/61 green.

OE one min. f/8 w/47B blue;
RE 30 sec. f/8 w/40M magenta.

OE one min. f/8 w/47B blue;
RE 30 sec. f/8 w/29 red.

OE one min. f/8 w/47B blue;
RE 30 sec. f/8 w/61 green.

RE = re-exposure WL = white light

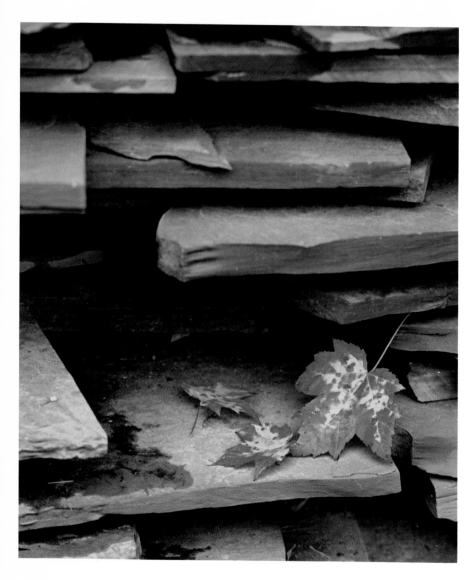

Prints

To achieve the Sabattier Effect on prints being processed on the KODAK Rapid Color Processor, it's necessary to take the print off the drum for the re-exposure step. In taking the print off the drum, keep the blanket and print together and lay them on the back of a darkroom tray with the blanket against the tray and the print facing emulsion side up. Re-expose the print and then put it back on the processor. For easier handling, keep the print and the blanket together at all times. Continue processing in the normal way.

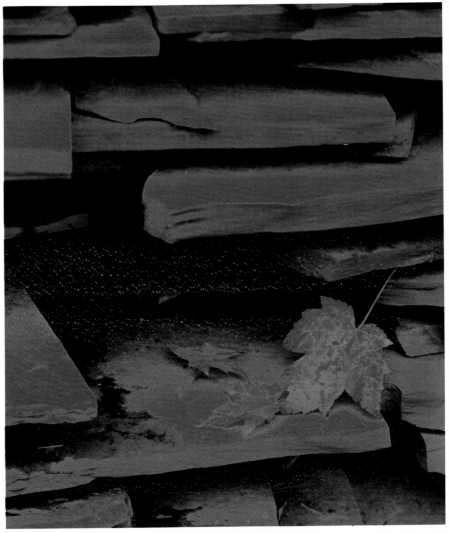

Both prints were made on KODAK EKTACOLOR 37 RC Paper and processed on the KODAK Rapid Color Processor. The original exposure for both prints was 11 seconds at f/11 with a filter pack of 40Y and 10M. The print on the left was processed normally. After one minute development, the print on the right was re-exposed for one second to white light from a 15-watt bulb at four feet.

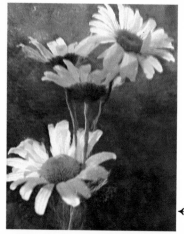

(1) A normal print from a color negative on KODACOLOR-X Film. Prints (2) and (3) were printed from the same negative onto KODAK EKTACOLOR 37 RC Paper and processed on the KODAK Rapid Color Processor. During development, they were re-exposed to produce the Sabattier Effect. (2) Original exposure 11 seconds at $f/11$ with a filter pack of 40Y and 10M; re-exposure after one minute development—2 seconds to the white light from a 15-watt bulb at four feet. (3) Original exposure 11 seconds at $f/11$ with a filter pack of 100Y; re-exposure after one minute development—1 second to the white light from a 15-watt bulb at four feet.

← (1)

(2) ↓

BARBARA KUZNIAR

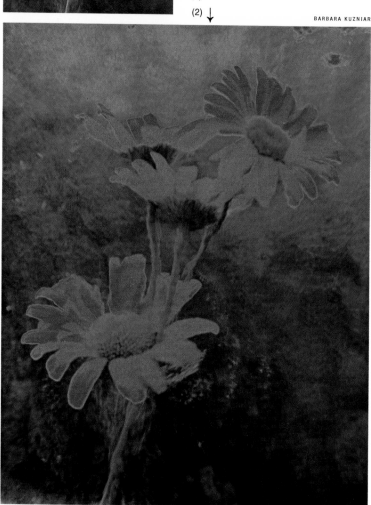

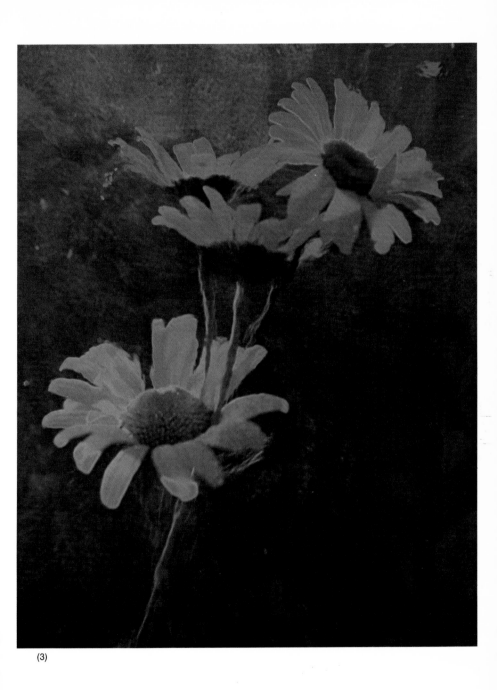

(3)

This print was re-exposed to the light from a penlight after
1½ minutes development. By using a penlight, you can easily
re-expose selected areas of the print.

THE SABATTIER EFFECT WITH
KODAK EKTACOLOR 37 RC PAPER
and the KODAK Rapid Color Processor

Use a KODAK Safelight Filter, No. 10 or No. 13 (dark amber)

1. Expose the print as you normally would.
2. Pre-wet the print in a tray of water for about 30 seconds.
3. Place the print on the drum and develop it for 1 minute.
4. Take the print off the drum, place it on a flat surface, and re-expose
 it to white or colored light.
5. Put the print back on the drum and continue development for another
 minute—total development time of 2 minutes.
6. Follow all the remaining processing steps as you normally would.

Slides

Slides produced by the Sabattier Effect show extremely vibrant colors throughout. By using the Sabattier Effect, you can turn ordinary or under-exposed slides into exciting, extremely colorful slides. This method even offers the opportunity to turn black-and-white negatives into color slides if you start with an image printed on KODALITH Film. Continuous-tone, black-and-white, and color negatives do not produce good results. If you want to produce the Sabattier Effect from a black-and-white or color negative, print the negative onto KODALITH Film and use the KODALITH Film as your original. You don't have to be concerned about whether the image is negative or positive—both will work.

The process of creating the Sabattier Effect in a slide involves the use of KODAK EKTACOLOR Print Film 4109 (ESTAR Thick Base) and KODAK Color Film Processing Chemicals, Process C-22. KODAK EKTACOLOR Print Film is a sheet film, and the 4 by 5-inch or 8 by 10-inch size is a good choice for this technique. You can gang-print at least six 35mm images onto each sheet of 4 by 5-inch film and produce six slides at a time. With the 8 by 10-inch size, you can print 36 slides at a time. The Process C-22 chemicals for processing the film are available in kit form in either one-pint or one-gallon sizes.

The temperature of the chemicals is not critical in this process, but a higher temperature produces more grain in the slide. Use eight ounces of each chemical if you're using 5 by 7-inch trays, and discard the developer after processing three sheets of film. Discard the other chemicals after processing six sheets of film. If you compare this process with the processing steps recommended on the chemical instruction sheet, you'll see that the rinsing steps between the chemicals have been eliminated. This keeps the process as short as possible and will not harm the film as long as you discard the chemicals after processing six sheets. Agitate the film continuously throughout the process (except just prior to and during re-exposure) by tipping up first one side of the tray and then tipping up the adjacent side.

You can create an almost unlimited variety of colors in these slides by using different combinations of colored filters for the original exposure and for the re-exposure. You can use the filters listed on page 212 or any other colored filters. For the greatest amount of control in using filters and in controlling the exposure, use your enlarger for both the original exposure and the re-exposure.

Place as many 35mm slides as you can fit onto the film in a printing frame. In the dark, place a sheet of KODAK EKTACOLOR Print Film 4109 (ESTAR Thick Base) in the frame with the emulsion side toward the 35mm slides and the glass of the frame. Expose the film to the light from your enlarger, with or without a colored filter over the enlarger lens. It's very important to keep track of the exposure time and the filter number so you can duplicate your results.

After the film has developed for 5 minutes, re-expose it to the light from the enlarger, with or without a filter over the lens. Again, keep track of the exposure time and the filter used. Finish the process and then judge the film over an illuminator. Remember to judge the density of this film just as you would a print—if the film is too dark, it needs less exposure; if it's too light, it needs more exposure.

You'll save yourself a lot of time if you make a test strip on your first film. Make the test strip in the usual way during the original exposure, and then during the re-exposure, expose half the film for thirty seconds and the other half for one minute with the enlarger just high enough to cover an area 8 by 10 inches. This type of test strip should enable you to produce well-exposed slides on your second film. Keep track of the filter combination and exposure you use for each film so you can duplicate your results in the future. One easy way to code the film is to cut off one or more corners before exposing the film.

Using white light for both exposures or using a 40Y yellow filter for the original exposure and a 40C cyan filter for the re-exposure produces good results. For other color combinations, refer to the color examples on pages 212 and 213.

(1)

(1) This is the original slide and (2), (3), and (4) are samples of the derivations you can create with the Sabattier Effect on KODAK EKTACOLOR Print Film 4109 (ESTAR Thick Base). (2) Was contact-printed from (1); original exposure through a purple filter and re-exposure through a dark red filter. (3) Was contact-printed from (1); original exposure through a 5Y yellow filter and re-exposure through a 5C cyan filter; then a piece of yellow filter was sandwiched with the resulting slide. (4) A high-contrast film was made by contact-printing from (1); then the high contrast film was contact-printed onto EKTACOLOR Print Film 4109. Original exposure was through a yellow filter and re-exposure through a 5C cyan filter.

(2)

(3)

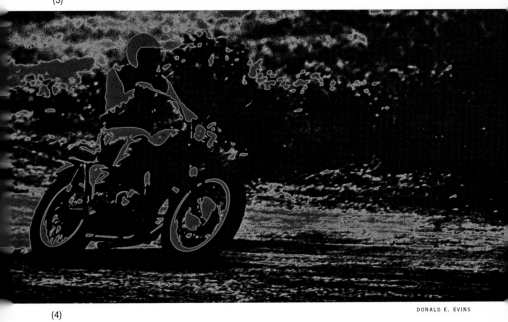

(4)

DONALD E. EVINS

(1)

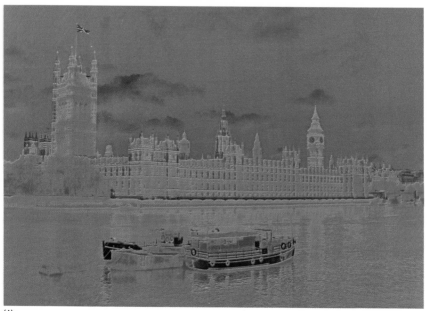

BARBARA KUZNIAR

Three variations are from the same underexposed original slide. All were printed on KODAK EKTACOLOR Print Film 4109 (ESTAR Thick Base) and re-exposed five minutes into the development. (1) Original exposure through a 40 C cyan filter; re-exposure through a 40Y yellow filter. (2) Original exposure through a 61 green filter; re-exposure through a 40M magenta filter. (3) Original exposure through a 40M magenta filter; re-exposure through a 40M magenta filter.

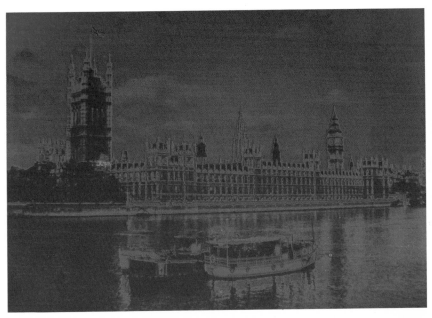

(2)

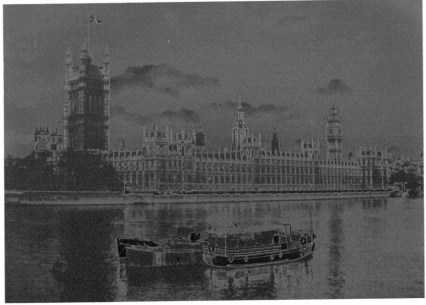

(3)

For ease in handling in total darkness (required for the first part of this process), tape the edges of your original slides to a sheet of glass or the glass of your printing frame. Masking tape works well because it's easy to remove.

In total darkness, contact-print the slides onto a sheet of KODAK EKTACOLOR Print Film 4109 (ESTAR Thick Base). You can actually do this process without an enlarger by using any ordinary light source. However, it is easier to control the exposure with an enlarger and timer, and when you use filters they can be just large enough to cover the enlarging lens. This picture was taken in white light to simulate a step that would normally be done in total darkness.

During the re-exposure, the film should have a black image visible. This picture was taken in white light to simulate a step that would normally be done in total darkness (except for the exposing light).

BOB CLEMENS

Once the film is in the stop bath for two minutes, you can turn on the room lights and watch the image continue to develop.

In the bleach, some of the color begins to emerge. Don't try to judge your success at this point—continue the process to the end because the color and density will change.

During the final step, the fixing, the finished colors are visible.

BOB CLEMENS

Here's the film produced during this process beside the original slides.
Original exposure for the KODAK EKTACOLOR Print Film 4109 (ESTAR Thick
Base) was one minute at f/4.5 through a 40Y yellow filter; re-exposure was
30 seconds at f/4.5 through a 40C cyan filter. Some of the Sabattier slides
from this film are reproduced on the next page.

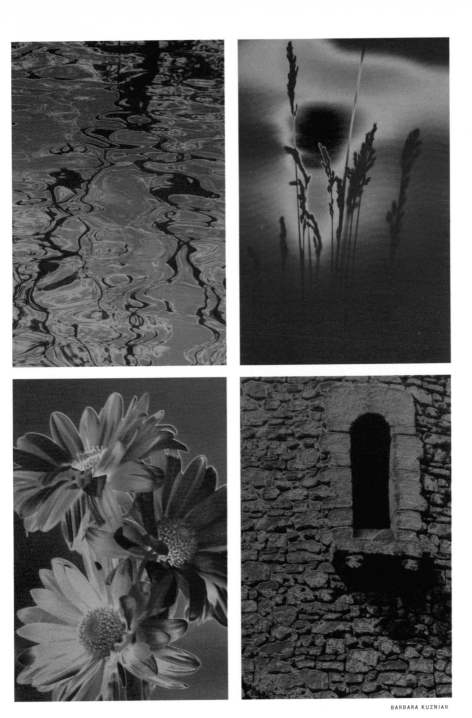

BARBARA KUZNIAR

These slides are the results of the process described on pages 224 and 225. Original exposure on EKTACOLOR Print Film was one minute at $f/4.5$ through a 40Y yellow filter; re-exposure was 30 seconds at $f/4.5$ through a 40C cyan filter.

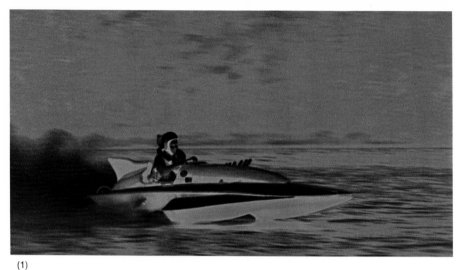

(1)

Subjects with a full range of tones and good contrast produce the best results with the Sabattier Effect. This original slide (1) was printed directly onto KODAK EKTACOLOR Print Film 4109 (ESTAR Thick Base) to produce the two derivations. (2) Original exposure through a purple filter and re-exposure through a blue filter. (3) Original exposure through an orange filter and re-exposure through a 5C cyan filter.

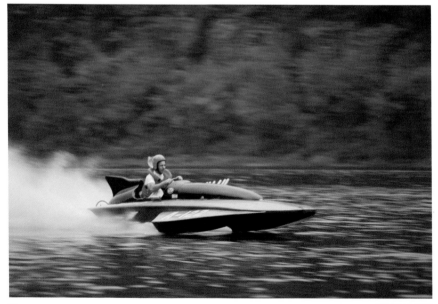

(2)

DONALD E. EVINS

(3)

THE SABATTIER EFFECT WITH
KODAK EKTACOLOR PRINT FILM 4109
(*ESTAR* THICK BASE)

Use continuous agitation throughout the process.

In total darkness:

1. Expose the film to the light of an enlarger, with or without a filter.
2. Develop for a total time of 7 minutes. Develop the film for 4½ minutes with continuous agitation.
3. Move the tray under the enlarger, turn the film emulsion side up, and allow it to settle to the bottom of the tray without agitation. Allow 30 seconds for this step.
4. When the film has been in the developer for 5 minutes, start the re-exposure, with or without a filter over the enlarging lens.
5. After the re-exposure, move the tray back to the sink and continue development with continuous agitation to a total development time of 7 minutes.
6. Stop Bath—5 minutes. After the film is in the stop bath for 2 minutes you may turn on the room lights.

In room light:

7. Hardener—3 minutes.
8. Bleach—8 minutes.
9. Fix—8 minutes.
10. Wash—8 minutes in running water, then put the film through KODAK PHOTO-FLO Solution, and hang to dry.

Posterization

During posterization, the normal tones of a subject are separated into distinct tone ranges with the use of high contrast films. These films are then printed in register and in combination to create a photograph that shows a sharp delineation of tones. Color posterizations often show unreal color combinations.

R. SCOTT PERRY

With the posterization technique you can produce photographs
that are very graphic with a poster-like quality.

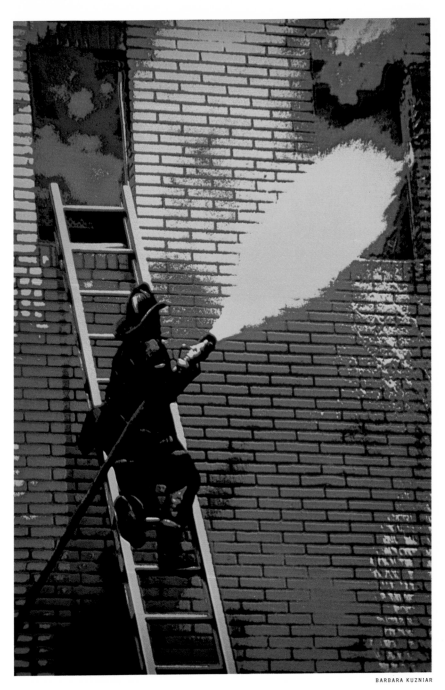

BARBARA KUZNIAR

Posterization lets you turn black-and-white photos into color.
The original for this posterization was taken on KODAK PLUS-X Pan Film.

231

Once you've made the tone separations, you can use different-color filters to produce variations of the same picture. These color-slide posterizations were done in the camera, and the colors visible in the picture are the colors of the filters used over the camera lens. Refer to page 219 for details on this technique.

25 red, 12 yellow, and 47 blue filters.

25 red, 58 green, and 47 blue filters.

47 blue, 58 green, and
12 yellow filters.

25 red and 58 green filters.
The background didn't
receive any exposure so
it remained black.

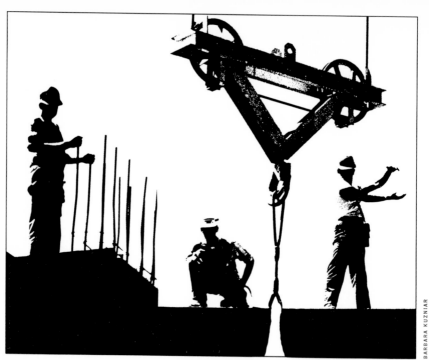

This high-contrast photograph is the simplest form of posterization
because it contains only two tones—black and white.

A three-tone posterization made from a highlight negative and a shadow negative
printed slightly out of register to create a bas-relief (the white outlines).

Artists and designers usually represent their subjects in pure line or in a full range of graduated tone. However, for generations they have realized that they could produce rich, broad effects by replacing full gradation with a limited number of flat tones. The most effective application of this technique is found in poster drawing.

During the days when the exposure latitudes of photosensitive emulsions were still inadequate, various methods of tone separation were practiced. The pictures produced by tone separation had a poster-like quality, and so, the technique of "posterizing" was developed. As films continued to improve in quality, posterizing became less practical and was almost forgotten. However, in the modern world of advertising and salon photography, the posterization technique is enjoying a new popularity.

Posterization lies between photography and graphic arts but is, nevertheless, a purely photographic technique. In posterization, the scale of continuous tone in a photograph is split into a series of distinct, uniform tones that separate against one another and do not merge.

Posterized reproductions can be characterized by the number of tones which they contain. For example, the simplest posterized print consists of two tones—black and white. Black-and-white posterization is easily achieved by limiting the process to a single high-contrast negative and is called a single-tone separation. High-contrast negatives are covered in Chapter 6.

More common are three- and four-tone posterizations. A three-tone black-and-white print consists of black (representing the shadows), gray (representing the middle tones), and white (representing the highlights). A four-tone black-and-white print consists of black, white, light gray, and dark gray. Posterized prints consisting of more than four tones are usually not successful, because the result is much like a continuous-tone image. In color posterizations, tones are represented as different colors.

Although posterizing produces unique and dramatic results from appropriate photographs, not all photographs lend themselves to this process. Pictures with simple patterns and strong designs usually produce the best results. Experiment with some of the many possible variations in the posterization technique and you'll find that the results are limited only by your imagination.

CAROLE G. HONIGSFELD

A four-tone posterization made from three high-contrast negatives.
The negatives were registered by taping a piece of white paper in the easel,
projecting the image on it, and sketching an outline of the image with a felt pen.
This sketch was then used as a guide for registration.

Selecting Materials

Original	High-Contrast Negatives	High-Contrast Positives
Black & White Negative	KODALITH Ortho Film 4556, Type 3 (ESTAR Thick Base) or KODALITH Ortho Film 2556, Type 3 (ESTAR Base)	
Color Negative	KODALITH Ortho Film 4556, Type 3 (ESTAR Thick Base) KODALITH Ortho Film 2556, Type 3 (ESTAR Base)	KODALITH Pan Film 2568 (ESTAR Base)
Color Trans-parency	KODALITH Pan Film 2568 (ESTAR Base)	KODALITH Ortho Film 4556, Type 3 (ESTAR Thick Base) KODALITH Ortho Film 2556, Type 3 (ESTAR Base)
	KODALITH Developer	

POSTERIZING TECHNIQUE

You can make both black-and-white and color posterizations from an original black-and-white print, a black-and-white negative, a color negative, or a color transparency. In working from an original color negative or transparency, use a panchromatic film such as KODALITH Pan Film 2568 (ESTAR Base) for the tone separations; KODALITH Ortho Film 4556, Type 3 (ESTAR Thick Base), is not sensitive to red. Selecting the proper materials is most important.

For the highest-quality posterizations, the KODALITH Films used to produce a posterization should be the same size as the final print. These films must be printed in register, and for critical work you should use a register printing device such as a KODAK Register Printing Frame and a KODAK Register Punch. However, you can make successful posterizations by using 4 by 5-inch film and registering the film visually. One method of registration and a copying technique is described on page 253.

TONE SEPARATION

Exposure causes tone separation. Make a series of exposures onto a high-contrast film, such as KODALITH Ortho Film 4556 or KODALITH Pan Film 2568, to break the tone range of the continuous-tone original into shadow tones, middle tones, and highlights. In working from an original negative, underexposing allows adequate exposure only through the thinnest areas of the negative, thus producing a shadow positive. The shadow areas are blocked up and the middle tones and highlights remain clear. Overexposing allows adequate exposure through all densities of the negative except for specular highlights, thus producing a highlight positive. In other words, both shadow areas and middle tones are blocked up and only the specular highlights remain clear. Obviously, normal exposure produces a middle-tone positive that falls between the shadow positive and the highlight positive. After making the three positives from your negative, contact-print the positive films onto KODALITH Film to produce three negatives. Or, you can make negatives in one step by starting with a slide. Examine the KODALITH Films to be sure they provide definite tone differences.

(1)

(2)

(3)

Three tone-separation positives produced from an original black-and-white negative. (1) overexposure, (2) normal exposure, and (3) underexposure on KODALITH Film produce distinct separations of tone.

TONAL SEPARATION
Negatives and Positives

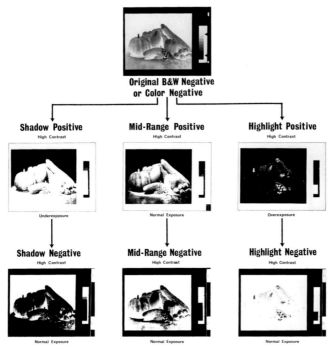

Procedure for producing tone-separation negative and positive masks from an original black-and-white or color negative.

MAKING A TONE SEPARATION

Use a KODAK Safelight Filter, No. 1A (light red) and select the appropriate KODALITH Film from the table on page 237.

1. Make a test strip with a wide range of exposures on KODALITH Film.
2. From the test strip, select three different exposures.
3. Exposure No. 1 should be very light and record only the highlight areas. Print a KODALITH Film using this exposure.
4. Exposure No. 2 should be normal, showing detail through the middle tones. Print a KODALITH Film using this exposure.
5. Exposure No. 3 should be very dark and have detail only in the shadow areas. Print a KODALITH Film using this exposure.

Exposures 1 (highlight), 2 (mid-tone), and 3 (shadow) are tone separations and when printed in combination will produce a posterized print. If your original image was a negative, the tone separations will be positive images. To produce tone-separation negatives, contact-print the three films onto KODALITH Film.

POSTERIZING
BLACK-AND-WHITE PRINTS

When making a black-and-white post-erized print, print one high-contrast negative at a time. If you're not using a pin register system, register the negatives as described on page 253. Starting with the shadow negative (darkest overall), adjust the exposure time to obtain a light gray tone, and make an exposure. Remove the shadow negative from the paper, replace it with the mid-tone negative, and print again, using the same exposure as that used for the shadow negative. Since exposure is cumulative, each area becomes progressively darker with successive exposures. If the print were processed at this point, the shadow areas would be a dark gray; those areas exposed only with the mid-tone negative, during the second exposure, would be a light gray. Now, make a third identical exposure using the highlight negative (thinnest of all), and finally, process the print. The shadow areas, which received all three exposures, will be dark gray; the highlight areas, which received only one exposure, will be light gray; and the specular highlights, which received no exposure, will remain paper-white.

For posterizing in black-and-white printing, use only high-contrast negatives. When working from an original negative, first prepare a black-and-white intermediate film positive. This intermediate positive should be full-scale with contrast somewhat higher than average. In working from an original print or transparency, the intermediate film positive is not necessary, since the positive original yields negative tone separations.

Think of the smooth, continuous range of gray tones or color values in a normal photograph as a ramp that posterization converts to a staircase. Instead of a continuous progression with an infinite number of tones, there are a limited number of distinct steps. Each step represents one level of density on the original photograph.

Print (1) is a continuous-tone black-and-white photograph, and (2) is the negative. The circle on the right is a density wedge or gray scale, and it shows what happens to different tones during the posterization process. The portrait shows these effects on a particular subject.

Prints (3) through (7) show how a high-contrast film breaks up the tonal range into distinct steps. Looking at the density circle as a clock face, there are sharp breaks between the tones in the areas of 11:00, 9:00, 7:00, 5:00, and 3:00. These *five* divisions break up the gray scale into *six* distinct steps. Instead of the wide variety of tones in (1), there are only six. Since each step is a different sheet of film, you can manipulate the image in a wide variety of ways by using different combinations of the tone-separation films.

The simplest posterization contains two tones, usually black and white, so (3) through (7) are all two-tone posterizations. Prints (8) through (12) are the negative images of (3) through (7) respectively.

Print (13) is a three-tone posterization. All the light tones have become white, the whole range of middle tones is now one uniform gray tone, and all the darker areas are solid black. So the original continuous tonal scale has been divided into three sharply defined steps—three levels of density.

You can use any number of negatives to produce a posterization, but in black-and-white the more shades of gray you print in a posterization the more the result begins to look like a continuous-tone photograph. In color, however, the situation is different because each tone separation can produce a different color in posterization. Refer to pages 258 and 259.

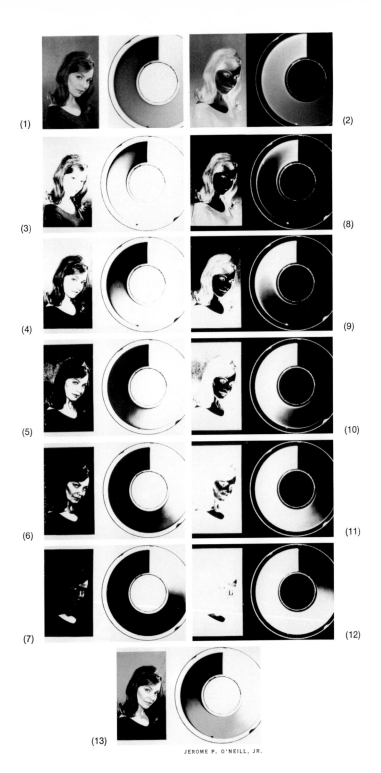

(1)

(2)

(3)

(8)

(4)

(9)

(5)

(10)

(6)

(11)

(7)

(12)

(13)

JEROME P. O'NEILL, JR.

MAKING A BLACK-AND-WHITE POSTERIZATION

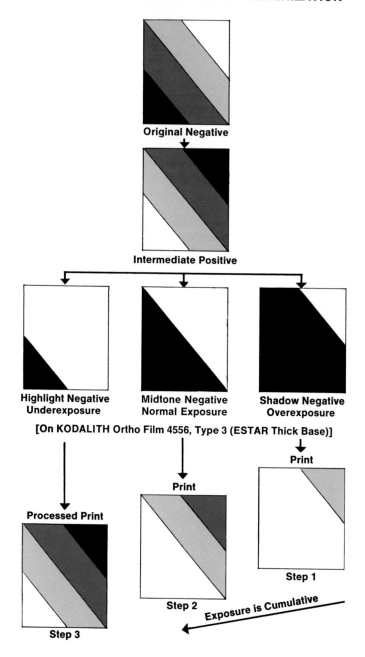

Procedure for producing a black-and-white posterized print
from an original black-and-white negative.

POSTERIZING BLACK-AND-WHITE PRINTS

Use the appropriate safelight for the paper.

1. Make tone-separation negatives as described on page 239.
2. Register the negatives. If you do not have a pin register system, you can tape the edge of the negatives to the baseboard so that you can flip them over the paper one at a time. This is the same registering method described on page 253.
3. Starting with the shadow negative (darkest overall), adjust the exposure time to obtain a light gray tone, and make an exposure.
4. Remove the shadow negative and replace it with the mid-tone negative. *Do not move the paper.* Print again using the same exposure.
5. Remove the mid-tone negative and replace it with the highlight negative. *Do not move the paper.* Print again using the same exposure.
6. Process the print normally.

A posterization printed in the darkroom through 25 red, 58 green, and 47 blue filters.

POSTERIZING COLOR PRINTS

For posterizing in color printing, you need both high-contrast negatives and high-contrast positives. You can use KODALITH Ortho Film 4556, Type 3 (ESTAR Thick Base), to make both the negatives and positives. From an original negative, the tone separations are positives. Reverse them to obtain negatives by contact-printing them onto additional film. From an original slide, the tone separations are negatives. Reverse them to obtain positives by contact-printing onto KODALITH Ortho Film 4556.

Register the positives and the negatives. The positives are used for masking during the color-printing operation. For example, if the first exposure is made with the shadow negative, then the second exposure is made with both the shadow positive and the mid-tone negative in register. The shadow positive masks the areas of the color paper that were exposed through the shadow negative, so that these areas are not affected during the second exposure with the mid-tone negative. When you make the third exposure with the highlight negative, use the mid-tone positive mask to cover the areas of the color paper that were exposed during the first exposure with the shadow negative and during the second exposure with the mid-tone negative.

The added dimension of color complicates posterizing. Deciding which color to reproduce in each tonal area is simply a matter of personal taste. You can save time and materials by trying to visualize the image in advance and planning the end result.

PRINTING A COLOR POSTERIZATION

Printing Posterizations on KODAK EKTACOLOR 37 RC Paper with KODAK WRATTEN Filters. To print posterizations in color, you'll need a standard enlarger setup including a 2B filter in the enlarger, and the following KODAK WRATTEN Filters:

KODAK WRATTEN Filter No.	Color of Filter	Color Produced in Print
25 or 29	Deep Red	Cyan
58 or 61	Deep Green	Magenta
47 or 47B	Deep Blue	Yellow
44	Light Blue-Green (Cyan)	Green Red
32	Magenta	
12	Deep Yellow	Blue

Since they are sharp-cutting, these six filters allow a great control over the color in the reproduction. They are preferable to KODAK Color Compensating Filters (CC) or KODAK Color Printing Filters (CP).

For best results, balance the KODAK EKTACOLOR Paper emulsion to produce a neutral color, using standard CC or CP Filters in the enlarger with an unexposed, developed KODACOLOR or EKTACOLOR Negative placed in the negative carrier. Once the emulsion is "balanced-in," make a test to determine the exposure time for printing through one of the six filters. For example, select the green filter and make a series of test exposures, using the mid-tone KODALITH Negative. Evaluate the color rendition of the print by using each of the six filters to make separate prints at the same exposure time se-

lected from the first exposure series. Simply change exposure to make the color lighter or darker.

Since this is a negative color system, the desired color is produced by printing through the complementary filter. For example, printing through a KODAK WRATTEN Filter, No. 25 (red) exposes the red-sensitive layer of the color paper. As a result, cyan dye is formed during processing, and the final print is cyan. Similarly, printing through a KODAK WRATTEN Filter, No. 58 (green) exposes the green-sensitive layer of the paper, producing a magenta image. Printing through a blue filter produces a yellow image. Cyan produces red, magenta produces green, and yellow produces blue. For a more complete discussion of color negative-positive theory, see the KODAK Data Book No. E-66, *Printing Color Negatives,* available from photo dealers.

Use the filters listed in the table on page 244, and follow the procedure described on page 249 to produce a posterized color print.

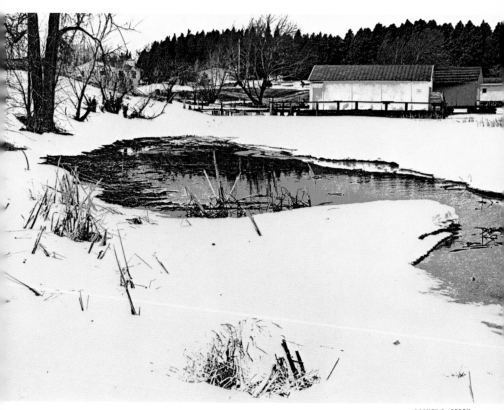

RODNEY S. PERRY

A darkroom posterization. Deciding what color to reproduce in each tonal area is simply a matter of personal taste, and you can save time and materials by trying to visualize the image in advance.

245

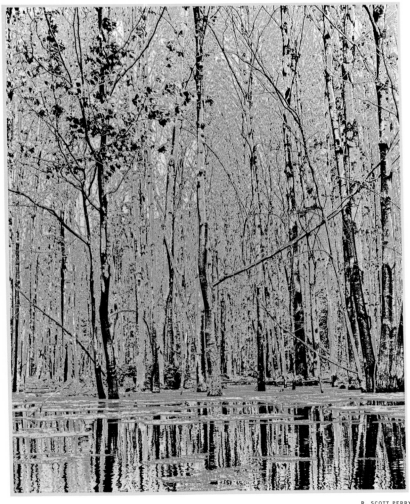

Here are just two of the many color combinations possible with
posterization. These darkroom posterizations each have a completely
different "feeling" due to the colors used.

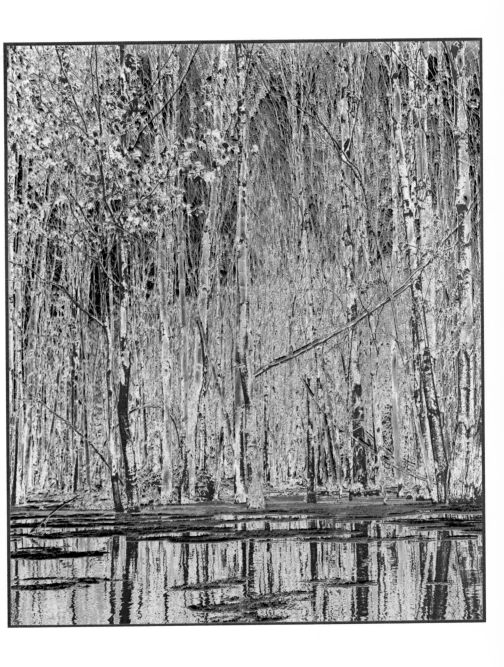

247

MASKING & PRINTING COLOR POSTERIZATIONS

Tone Separation	Positives	Negatives	Masking	Filtration	Printing
Shadow				None	1
Low Mid-Tone	Combination →			Magenta	2
High Mid-Tone	Combination →			Red	3
Highlight				Blue	4

Procedure for combining tone-separation negative and positive masks and filters for printing.

POSTERIZING COLOR PRINTS

Use a KODAK Safelight Filter, No. 10 (dark amber) with
EKTACOLOR Paper.

1. Make tone separation negatives and positives as described on
 page 239, and register them (refer to page 253 for a registering system).
2. Place a sheet of unexposed, developed KODACOLOR or EKTACOLOR
 Film in the filter drawer of the enlarger. This is not necessary if the
 filters you're printing from are incorporated in negatives. Refer to
 page 250. Balance the paper to produce a neutral color as described
 on page 244.
3. Make separate test strips from each of the three negatives (highlight,
 mid-tone, and shadow negatives), using the filter you've selected to
 use with each negative. After processing the test strips, select and
 record the best exposure time for each negative.
4. Print the shadow negative using the exposure determined above.
5. Remove the shadow negative and replace it with the shadow positive
 and the mid-tone negative in register. *Do not move the paper.* Print
 this combination, using the exposure determined above for the
 mid-tone negative.
6. Remove the mid-tone negative and shadow positive and replace them
 with the mid-tone positive and the highlight negative in register.
 Do not move the paper. Print this combination, using the exposure
 determined above for the highlight negative.
7. Process the paper in the normal way.

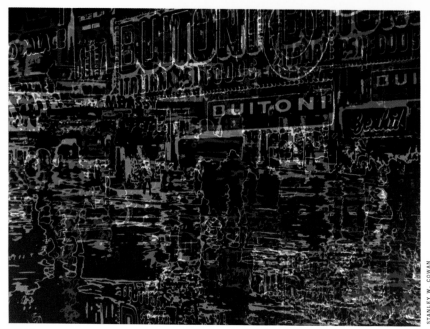

STANLEY W. COWAN

These separation negatives, which were originally made for a posterization, were deliberately printed out of register to produce a creative variation of the posterization technique.

Printing Posterizations with Homemade Color Negatives

One of the most predictable methods for producing a posterized print is with negatives of colors and textures. You can prepare these color negatives by photographing various colored art papers on KODACOLOR or EKTACOLOR Film. You'll find ready-made texture patterns in woven fabrics, stucco walls, wood grain, reticulated film, and pressed glass. When copying these textures onto film, be sure to keep the lighting uniform and the exposure constant.

To print a posterization with the texture negative, first make a straight print of the texture negative and balance the color using CC or CP filters in your enlarger. When you have the correct color balance for the texture negative, you can print the posterization following the procedure described on page 249.

Each color texture negative you use in the posterization process will have to be color balanced as described above. If you plan to use many color texture negatives, you may want to make a gang proof or contact print of a group of negatives and determine the color balance for the whole group at one time.

You can produce light and dark shades of one color with a single texture negative by changing the exposure.

T. H. GROVE

A darkroom posterization made from a black-and-white original on KODAK PANATOMIC-X Film. Highlight, shadow, and mid-tone negatives were made from an intermediate positive. Then highlight and shadow positives were made from their respective negatives. The films were registered and printed in combination by exposing through a 25 red filter to produce the cyan image, through a 44 cyan filter to produce the reddish-black image, and through a 47 blue filter to produce the yellow image.

DONALD J. MAGGIO AND APRIL PETRONE

Creativity with photography often extends beyond the darkroom.
Here are two color combinations of the same posterization. One was mounted
on a board in the traditional manner. The other was mounted on a
thick piece of wood, and the zebra was cut out with a jigsaw.

POSTERIZING COLOR SLIDES

It's possible to create posterized slides if you have a 35mm camera and an electronic flash unit. Make 4 by 5-inch KODALITH Negatives and positives, just as you would to posterize a color print. Register the films on a sheet of opal glass or plastic so that they will flip in and out of the camera's range as illustrated below. Place the electronic flash unit at least one foot below the glass and aim directly at the glass. Mount the camera on a firm support, such as a tripod, and aim it down at the film on the glass. If you plan to do a lot of copying work using your electronic flash unit as the light source, you may want to build a copying box like the one illustrated below.

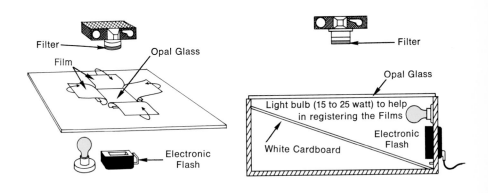

Select the combination of negatives and positives you'll need to produce a color posterization. Visually register the films over the picture-taking area on the opal glass. Tape the films along one edge so that you can flip them in and out of the picture-taking area. Make an exposure through a colored filter; then flip the film out of the picture-taking area; make a second exposure through a different colored filter; then flip the films out of the picture-taking area. Continue exposing the films in this manner until all the stages of the posterization have been exposed.

If you plan to copy films or create many posterizations, you might want to build a copy box like this one. It has a sheet of opal glass or plastic on the top. The white cardboard set at an angle reflects the light from the flash up through the opal glass. The light bulb provides the light necessary for focusing the camera and registering films, but it should be turned off during the exposure. You can fire the electronic flash manually or attach it to the camera with a long cord.

Use the sharp-cutting filters recommended on page 244 for color printing. Remember that the filter will reproduce its own color in the slide, so with this method of posterizing it is really easier to determine the color than with color printing.

Review the procedure described on page 244 for printing with KODALITH Negatives and positives. You use the same method of combining the films, but instead of printing onto paper, you'll copy them onto a single frame of film. Use a different colored filter over the camera lens during each exposure. You'll find that an exposure of *f*/22 or *f*/16 will produce good results with KODAK EKTACHROME-X Film, but of course this depends on the output of your flash unit and the distance from the flash to the opal glass. Use the same exposure for each film and filter combination.

If your camera will not make multiple exposures, work in a darkened room. (You can have a very dim light in the far corner from the camera.) Set your camera on "T" or hold the shutter open on "B," and manually flash the electronic flash for each exposure. If you leave the filter over the lens or put the lens cap on while you're arranging the films between flashes, you should be able to produce the registered multiple exposures needed with this method.

You can produce 35mm negatives with this system by using a color negative film, such as KODACOLOR Film. Print these color negatives as you would print any color negative, and you eliminate registering at the easel. However, prints made in this manner usually are not as sharp as prints made directly from KODALITH Films enlarged the same size as the paper.

The photo-posterization techniques described here are basic. By combining them with other photographic controls such as the tone-line process, bas-relief, and Sabattier Effect, or by using more than one negative, you can achieve many different and fascinating effects.

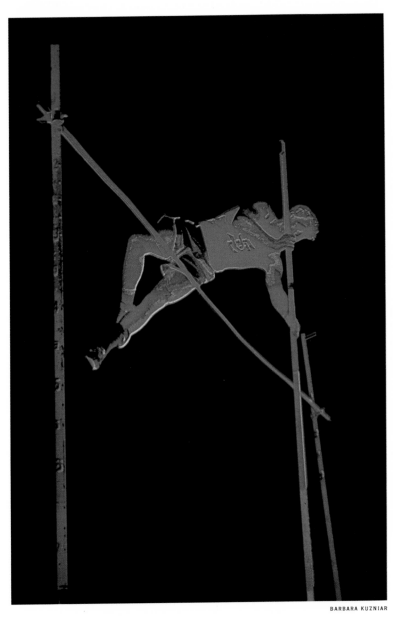

An in-camera posterization on KODAK EKTACHROME-X Film
exposed through 25 red, 58 green, and 47 blue filters.

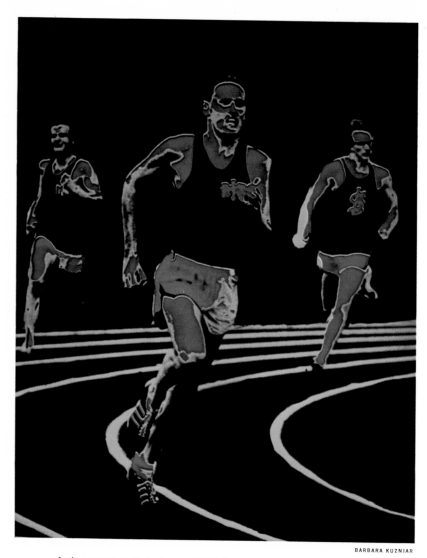

An in-camera posterization on KODAK EKTACHROME-X Film exposed through 47 blue and 12 yellow filters. The posterization eliminated a very busy background which was distracting in the original straight print.

An in-camera posterization on KODAK EKTACHROME-X Film exposed through 47 blue, 58 green, and 12 yellow filters. The original picture was taken on KODAK TRI-X Film with existing light, and the separation positives were made from a very small portion of the original negative to produce an accentuated grain pattern.

(1)

(2)

(3)

(4)

(5)

(6)

(7)

(8)

JEROME P. O'NEILL, JR.

(1) through (4) show four tone-separation positives photographed through different color filters. Slides (5) through (8) show the results when the positives and their corresponding mask negatives are photographed in combination to produce a color posterization. (5) Blue shadow positive and red highlight positive with black (unexposed) mid-tones. (6) Blue shadow positive plus green mid-tone positive. Note the cyan areas formed where the two colors overlap. (7) Blue shadow positive, green mid-tone positive, and red highlight positive for a three-exposure five-color posterization. Slide (8) is the same combination as for (7), but with the blue highlight positive added, which combined with the red exposure from the highlight positive to produce the magenta color.

Here are some of the color combinations that are possible by using the same set
of four separation positives and exposing with different color filters.

With posterization, you can turn a black-and-white photo into many different color images. These posterizations were all made in the camera using the technique described on page 253.

JEROME P. O'NEILL, JR.

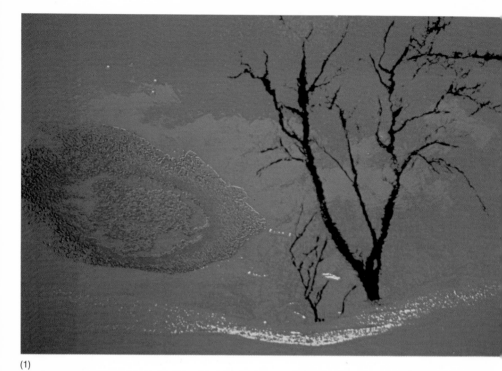

(1)

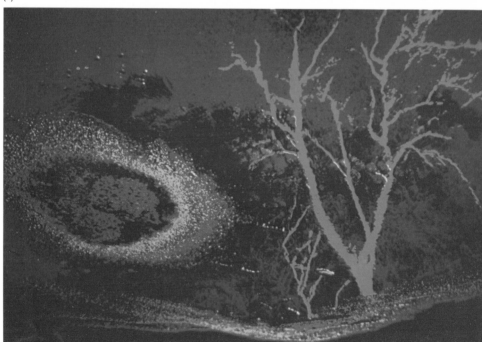

(2)

FREDERICK C. ENRICH

POSTERIZING COLOR SLIDES

Work in a dimly lighted room.

1. Make tone-separation negatives and positives as described on page 239 and register them.
2. Use a slide copier or the copying method described on page 253. Determine the exposure for your equipment by making a series of test posterizations at various lens openings. Keep good records and have the film processed, then select the best exposure. If you use the filters listed on page 244, you will not have to vary the exposure to compensate for different filter factors, so the exposure will be the same for the whole posterization. Once you have determined which lens opening produces a well-exposed slide, you can make all your slide posterizations at that exposure.
3. Copy the shadow positive with the appropriate filter over the camera lens.
4. Remove the shadow positive and replace it with the shadow negative and the mid-tone positive in register. *Do not move the camera.* Copy this combination onto the same frame of film with a different color filter over the camera lens.
5. Remove the mid-tone positive and the shadow negative and replace them with the mid-tone negative and the highlight positive in register. *Do not move the camera.* Copy this combination onto the same frame of film through a different color filter.
6. Have the film processed or process it yourself in the normal way.

Posterization is an exciting technique that challenges a photographer's creativity, but some photographers are always trying to extend the creative possibilities. Picture (1) is an in-camera posterization. Picture (2) is a double exposure of two posterized slides to create a new color combination.

Gum Bichromate Printing

With gum bichromate printing, you make your own photographic paper by mixing a light-sensitive emulsion and coating it on paper. The paper is exposed by contact printing with continuous-tone or high-contrast negatives, and developed in water.

Gum bichromate print made with four films and four emulsion layers.

Gum bichromate print made with a continuous-tone negative and one emulsion layer. Cyan pigment was added to the emulsion to produce the color.

The process of gum bichromate printing has been around for many years and was quite popular around the turn of the century. The process is not as involved as it may seem at first glance. With a little time and experimentation, you can master the technique and adapt it to your own needs. The variety of materials that you can use all introduce variables that must be worked out according to your own individual method.

Basically, the process consists of contact-printing negatives on a good grade of paper coated with a light-sensitive bichromate solution. This is composed of a water-soluble pigment and potassium or ammonium bichromate suspended in a vehicle of gum arabic.

The gum arabic and potassium or ammonium bichromate are available from any chemical-supply company. The ammonium bichromate, being more sensitive to light, requires about half the exposure of the potassium bichromate. The pigment can be anything from tube watercolors to tempera paint, just as long as it will dissolve in water. The paper should be strong enough to withstand a good deal of soaking. You can choose from any number of good-quality watercolor papers in a variety of grades and surface textures.

These single-emulsion gum bichromate prints were made from
continuous-tone negatives. The color was added to the surface of the print
with watercolor paints after the prints dried.

PREPARING THE CHEMICALS AND PAPER

Some preparation is necessary before you actually make a print. First, mix separate stock solutions of gum arabic and bichromate in the following amounts: Mix one ounce of gum arabic (dry weight) in two ounces of warm water. For the bichromate, mix one-half ounce (dry weight) in five ounces of warm water. This will give you enough of each stock mixture for several prints. It is not a good practice to mix too much gum arabic at one time, because it is an organic compound and should be kept refrigerated after it has been mixed.

The paper also requires some preparation before it is ready for coating. First, soak it in hot water (approximately 150 F) for fifteen minutes and dry. This preshrinking will avoid distortion after final development. These preliminary steps must be completed before you can start any printing.

When you are ready to start coating, first tack the paper down at the corners to a stiff support. Then, to avoid having the pigment soak into the paper, add sizing by spraying the paper with any household spray starch. Use the sizing sparingly. Too much will cause difficulty in later coating the paper with the light-sensitive emulsion.

MIXING THE EMULSION

The next step is to mix an emulsion made up of equal parts of the stock solutions of gum arabic and bichromate. Start with a quarter of an ounce of each stock solution. Then mix three parts of this emulsion to one part of the pigment. A little variation is acceptable and recommended until you determine the best mixture for your working conditions.

After the emulsion is mixed, you must coat it on the dry, sized paper. A good method of coating is to use a good-quality, flat brush about two and one-half inches wide. In laying down the emulsion, use crisscross strokes to get as smooth a surface as possible. This can be carried out in room light because the emulsion is not sensitive to light until it is almost dry. When you have completed the coating, put the paper in a warm, dimly lit place to dry.

PRINTING ON GUM BICHROMATE PAPER

When the sensitized paper is dry, you are ready to make contact prints from negatives. You can use both normal and high-contrast negatives, such as negatives made on KODALITH Film. Refer to page 152 for information on making negatives on KODALITH Film.

Use a printing frame or heavy piece of glass to hold the negative and paper together during the exposure. Remember, this is a contact-printing process, so your print will only be as large as your negative.

A good starting point for the exposure time is fifteen minutes if you have an ammonium bichromate emulsion, and one-half hour for the slower-acting potassium bichromate emulsion. One 500-watt photolamp makes a good light source for the exposure, but anything from sunlight to carbon-arc light will work. The density of the final print depends on the density of the emulsion and intensity of the exposing source.

Gum bichromate print made with a yellow emulsion layer and a red emulsion layer, and printed from KODALITH Film negatives. The print was left in a tray overnight and the dye in the emulsion floated toward the center, causing a concentration of color in the middle of the picture.

DEVELOPING THE PRINT

Develop the exposed print by placing it face down in a tray of water at 70-80 F. It should be left face down for a few minutes to soften the unexposed emulsion. To help develop certain highlight areas locally, use a small soft brush. Complete development takes anywhere from fifteen minutes to several hours, depending upon the exposure and the amount of density you desire in the print. It's up to you to decide when to stop development. When it is complete, the last step is to hang the print to dry.

USING MULTIPLE COLORS AND NEGATIVES

It's possible to work with several colors and many negatives on the same print by repeating the emulsion-coating, printing, and developing steps for each successive color. The gum bichromate process offers many possibilities for the creative photographer to explore.

Some of the prints in this chapter have been taken a step further than the simple gum print. Colors were added by pen and ink and transparent water colors after the prints dried. This is just one of the many things you can add to the basic process for a more expressive print.

STANLEY W. COWAN

Gum bichromate print on green art paper made from a KODALITH Film negative.
A water-based ceramic stain was used to dye the emulsion gold.

Gum bichromate print made with four layers of emulsion ranging in color from light blue to black, and printed from four KODALITH Film negatives.

Three separation negatives were made on KODALITH Film from a slide.
To produce this gum bichromate print, one negative was printed on a
yellow emulsion layer, the second negative printed on a magenta emulsion layer,
and the third negative printed on a cyan emulsion layer.

THE GUM BICHROMATE PROCESS

All steps can be done in white light.

1. Mix 1 ounce of gum arabic with 2 ounces of water.
2. Mix ½ ounce bichromate with 5 ounces of water.
3. Soak the paper in hot water (approximately 150 F) for about 15 minutes and then allow it to dry.
4. Size the paper by spraying it with any household spray starch. Use the starch sparingly.
5. Mix equal parts (start with ¼ ounce of each solution) of the previously mixed solutions of gum arabic and bichromate. This mixture is the emulsion.
6. Mix 1 part pigment with 3 parts emulsion to give the emulsion color.
7. Coat the emulsion on the paper using a flat 2½-inch brush and making crisscross strokes to get as smooth a surface as possible.
8. Put the paper in a dimly lit place to dry.
9. Contact-print your negative onto the paper using a printing frame (emulsion to emulsion).
10. Expose the paper to any light source for 15 minutes for the trial exposure. The depth of the final print depends upon the density of the emulsion and the intensity of the exposure.
11. Develop the exposed print by placing it face down in a tray of water at 70-80 F. Development takes anywhere from 15 minutes to several hours depending on the depth of exposure and the amount of density you desire. When the print looks good to you, stop development.
12. Hang the print to dry.

Photo Silk-Screen Printing

In silk-screen printing, an image on high-contrast film is transferred to a special silk-screen film which adheres to the silk screen and serves as a mask during printing. The silk-screen image is printed onto paper by forcing inks through the screen with a rubber squeegee while the screen is in contact with a sheet of art paper. Silk-screen prints look like they've been painted with poster paints.

Photo silk-screen printing is a combination of photography and graphic arts. The original image is a negative or slide, and in the darkroom this image is enlarged onto a high-contrast film, such as KODALITH Ortho Film. The image is then transferred from the high-contrast film onto the silk screen. There are a number of methods used for making the mask on the silk screen. We're going to cover one method, the use of Hi-Fi Green Presensitized Photo Film. (For information on other methods of silk screening, refer to the list of reference books on page 287.)

Once the photographic image has been transferred to the silk screen the photographic process ends and the graphic-arts process begins. Print the silk-screen image onto the paper by forcing inks through the screen with a hard rubber squeegee while the screen is in contact with the paper.

You can apply as many silk-screen images as you want to create a multi-colored image, but you must allow each color to dry thoroughly before applying the next image. It's necessary to make a separate silk-screen mask for each color or image you want to print.

Photo silk-screen printing provides an excellent creative outlet for the photographer who has tried all the other photographic processes available. It is a time-consuming process, and to produce good multiple color silk screens you'll need to plan each image and color carefully in advance. You'll need to experiment and perhaps deviate from the recommendations given here to achieve the best results with your equipment, inks, and paper.

It's a challenge to a photographer who enjoys making new pictures out of existing images, because several photographs, or parts of photographs, can be combined in one silk-screen print. This motivates some photographers to seek special subjects to photograph with the idea that they will end up as silk-screen prints. Photo silk-screen printing is rewarding too, and it's becoming increasingly popular as a means of expression. Some exhibitions accept photo silk screens as both a graphic-art form and a photographic method. The process is also adaptable for making greeting cards, wedding and birth announcements, and personalized note paper.

A photo silk-screen print.

A photo silk-screen print made with one screen and one color ink.

A photo silk-screen print made with two screens. One screen printed the rose-colored background and the other screen printed the purple areas.

CLEANING THE SCREEN

Use a silk or nylon screen with a 14-17 mesh. You can purchase ready-made screens which are on wooden frames in graphic-arts supply stores or buy the fabric and stretch your own screens.

Good results in silk screening depend on a clean screen, so wash the screen with Serascreen SPC Enzyme or Foto-Film Remover. Rinse well and apply DeGreaser with a soft scrub brush. Neutralize the screen by rinsing with an acetic acid solution (one capful of 28 percent acetic acid in a gallon of water). Allow the screen to dry. After you have cleaned the screen, NEVER TOUCH THE FABRIC WITH YOUR HANDS. The slightest trace of oil will keep the Hi-Fi Green from adhering properly to the screen.

PREPARING THE PHOTOGRAPHIC IMAGE

You can start with any well-exposed negative or slide as the original image. If you start with a negative image, the final silk screen will be a positive image; a positive original image produces a negative silk-screen image. If you start with a positive image (a slide), you may wish to go through one extra step by contact-printing the KODALITH Film positive to another sheet of KODALITH Film to convert the image to a negative.

The size of the image in your silk-screened print will be the same as the image on the KODALITH Film, so enlarge the image to exactly the size you need. The degree of enlargement is very important when you plan to apply more than one image in a silk-screen print—particularly if the images are to be registered.

After you've transferred the image to one of the KODALITH Films listed below, black out any dust spots with an Eberhard Faber Thinrite Marker 690 black or KODAK Opaque.

High-Contrast Images

For a high-contrast image which will produce concentrated areas of color in the final silk-screened print, print the negative onto KODALITH Ortho Film 6556, Type 3. Refer to page 150 for the details on how to use this film.

Continuous-Tone Images

To produce an image similar to a continuous-tone image, one with varying degrees of color density in a photo silk-screen print, enlarge your original image onto KODALITH AUTOSCREEN Ortho Film 2563 (ESTAR Base). This film has a dot pattern built into it and will allow you to reproduce shades of one color. For information on how to use this film, refer to page 66.

TRANSFERRING THE IMAGE TO HI-FI GREEN

Hi-Fi Green Presensitized Photo Film is easy to use because it can be handled in normal room light. However, avoid exposing it to sunlight or bright fluorescent lights. After exposure to an ultraviolet light source—such as a sun lamp, photolamp, or arc lamp—and development, the exposed areas of the image can be washed away in warm running water (not over 115 F). Then the sticky side of the film will adhere to the silk screen. Hi-Fi Film has a plastic backing which you can easily peel away after the film is dry. After the backing is removed, the Hi-Fi Film acts as a mask on the silk screen; ink will flow through the screen only in those areas where the Hi-Fi Film has been exposed and washed away.

EXPOSURE FOR HI-FI FILM

Lamp-to-copy distance	New No. 2 Photolamp	Photolamp No. 2 (used 3 hrs.)	250-watt Sun Lamp	15-amp Arc Lamp	35-amp Arc Lamp
10 inches	2 min.	3 min.	2 min.		
20 inches	8 min.	12 min.	5 min.	5 min.	1½ min.
40 inches	32 min.	48 min.	20 min.	20 min.	6 min.

BOB CLEMENS

Place the Hi-Fi Film under your film positive with the plastic backing on the Hi-Fi Film toward the film positive and the light source.

Exposure

Place a sheet of Hi-Fi Film and your film positive from the previous step in a printing frame as shown at the left. The plastic backing on the Hi-Fi Film should be toward the film positive and the light source. Always make the exposure through the KODALITH Film positive and through the plastic backing sheet to the emulsion of the Hi-Fi Film. The emulsion side feels tacky when touched with a wet finger. Expose the film using the table above as a guide for your first exposure. You can make a test strip of various exposures, develop the film, and then select the best exposure.

The longer the exposure, the thicker the resulting mask will be. Too long an exposure will close up the fine lines; too short an exposure produces a mask that is thin and lacks strength. A faint image will be visible after exposure.

BOB CLEMENS

A sun lamp is one of several lights that you can use to expose the Hi-Fi Film.

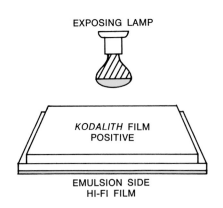

EXPOSING LAMP

KODALITH FILM POSITIVE

EMULSION SIDE HI-FI FILM

Develop the exposed Hi-Fi Film with the plastic side of the film toward the bottom of the tray, and use just enough developer to cover the film.

Development and Wash Out

Develop the exposed Hi-Fi Film in InP #201 Liquid or Ulano A and B powder type developer. Follow the mixing and developing instructions given on the developer package. Protect the developer from strong light by covering the tray when it is not in use. *Never bottle used developer because it forms a gas;* discard the developer at the end of each working session.

Place the plastic side of the Hi-Fi Film toward the bottom of the tray, and use just enough developer to cover the film. DO NOT TOUCH THE STICKY SIDE OF THE FILM AFTER IT'S IN THE DEVELOPER BECAUSE THE EMULSION WILL COME OFF.

Immediately after development, transfer the Hi-Fi Film to a clean tray or the bathtub. Using a mild spray of warm water (not over 115 F), wash the film until the design is clear and the water running off the film is clear. If you're using a tray, tip the tray so that the stream of water is washing over the film and running out over the bottom edge of the tray. Finish the wash by rinsing the film with cold water for 30 seconds.

Immediately after development, place the Hi-Fi Film in a clean darkroom tray or the bathtub and rinse it with a mild spray of warm water. Keep rinsing the film with water until the design is clearly visible and the water running off the film is clear.

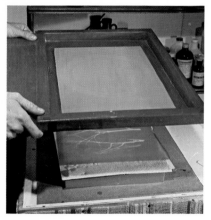

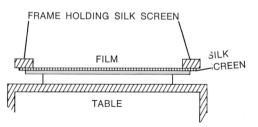

FRAME HOLDING SILK SCREEN

FILM

SILK SCREEN

TABLE

Place the Hi-Fi Film, emulsion side up, on a platform of boxes the same size as the opening in the screen frame, and gently lower the screen down over the film with one slow and even movement.

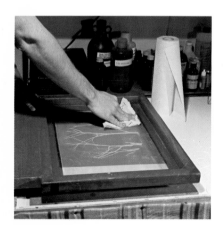

Use paper towels to absorb the excess water, and pat the surface of the screen with a wad of paper towels to force the adhesion of the Hi-Fi Film to the screen. DON'T TOUCH THE SCREEN WITH YOUR HANDS!

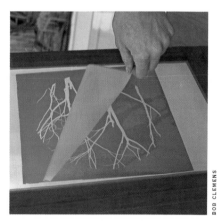

Let the screen dry thoroughly, and then gently peel off the plastic backing.

BOB CLEMENS

Adhering the Film to the Screen

To provide good contact all over the surface of the screen, use several photographic-paper boxes to build up a platform that is just slightly smaller in surface area than the screen which you'll lower over it. Refer to the drawing and photography at the left. Place the wet Hi-Fi Film on the platform with the emulsion side up. (Note: It's important to keep the film wet if there's any delay between the washout step and adhering the film to the screen.) Hold the screen in position over the film and platform and gently lower the screen down over the film with one slow and even movement. Any side-to-side movement after the screen is in contact with the film will blur the image. Place paper towels over the screen and pat them down to absorb the excess water, then pat the surface of the screen with a wad of paper towels to force the adhesion of the Hi-Fi Film to the screen. DON'T TOUCH THE SCREEN WITH YOUR HANDS!

Let the screen dry thoroughly and then gently peel off the plastic backing. Clean the screen with turpentine to remove the adhesive.

PRINTING

To help register the image in printing, attach the silk-screen frame to a table top or large sheet of wood with loose-pin hinges. (These hinges will come apart when the center pin is pulled out.)

Take a sheet of paper that you intend to print on and place it in position under the screen. Fold strips of heavy paper or light cardboard into a Z shape and tape the Z's to the table with masking tape. Place two Z's on one edge of the paper and two Z's on an adjacent edge. The Z's will hold the paper in place while you're printing and help you register the image in successive prints. Refer to the drawing on page 282.

Tape strips of tissue paper around the edges of the screen in any area where the Hi-Fi Film does not completely cover the screen, or use a blackout that will not be affected by the ink.

Tape 1½-inch squares of cardboard to each corner of the screen frame. These cardboard squares lift the screen off the paper and will help prevent speckles of ink from getting on the paper.

CAUTION: PRINTING WITH SILK-SCREEN INKS MUST BE DONE IN A WELL-VENTILATED ROOM. Inhaling the fumes from silk-screen ink may cause you to become light-headed and giddy; then they produce a severe headache. If you plan to do a lot of silk-screening, you might want to invest in a gas mask.

There are many silk-screen inks available from graphic-arts suppliers and they come in a great variety of colors. Some inks are transparent and others are opaque, and you can mix colors of the same type ink to produce your own shades.

With the paper in place under the silk screen, pour the ink along the edge at one end of the screen and squeegee the ink over the surface of the screen once. Be careful as you lift the squeegee so that the ink does not drip onto the screen. Lift the screen and remove the paper to dry. If you're using a quick-drying ink, it's best to have a helper to remove the prints for you, then you can begin printing the next sheet. Work fast so that you can get as many sheets as possible printed before the ink begins to dry in the screen and block it up.

If the screen begins to block up or when you're finished, scrape off the excess ink and save it in a tightly covered jar. Clean the screen carefully with paper towels or rags soaked with turpentine. To make sure the screen is completely clean, hold it in a vertical position and rub both sides of it at the same time with paper towels.

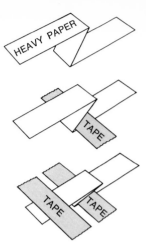

You can make Z's for holding and registering your paper by cutting 1 by 10-inch strips from heavy paper. Fold the paper into thirds in a zigzag fashion. This folded paper is the Z. Place your printing paper in place under the silk-screen frame and place two Z's on one edge of the paper and two more Z's on an adjacent edge. Tape the Z's to the table. You should be able to slide your printing paper into the Z's and have it precisely in place for printing.

When you're ready to print the second color, remove the Z's, register the sheet with the first color printed (make sure the color is dry) under the silk screen in the position where you want the second color to print; then place the Z's on the edges of the paper as described above. You must register and reorient the Z's for each additional color and image you want to add to a silk-screen print.

Tape strips of tissue paper around the edges of the screen in any area where the Hi-Fi Film does not completely cover the screen. This tissue will prevent excess ink from getting on your printing paper.

The printing paper is held in position with four Z's made from folded heavy paper. The silk screen is ready for printing, with tissue around the edges and squares of cardboard taped to each corner of the frame.

With the paper in place under the silk screen, pour the ink along the edge at one end of the screen and squeegee the ink over the surface of the screen once. Immediately lift the screen and remove the paper to dry.

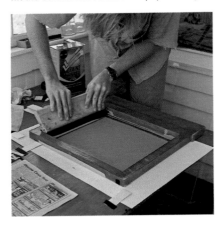

When you're finished, or if the screen begins to block up, scrape off the excess ink and clean the screen carefully with paper towels or rags soaked with turpentine.

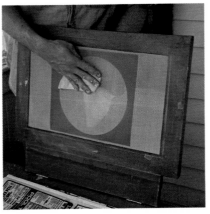

APPLYING SEVERAL COLORS

To produce multiple-color silk screens, you must allow each color to dry thoroughly before applying the next color. For each color or image, you'll need to make a separate screen, and this is where the hinge and Z system of registering comes in handy. Fit each screen with the same size hinges in exactly the same position on the frame so that each screen will fit onto the baseboard or table.

After printing the first color, remove the Z's. Select a dry print made in the first step and place it on the table. Attach the second screen to the table, then lower the screen and move the paper under it until the second image is in its proper position over the first image. Tape the Z's in place on two edges of the paper. As you slip each sheet of paper into the Z's, it will automatically be registered so that the second image will go just where you'd planned. Register any additional colors and images in this same way.

Print the second image, and any additional images, in the same way as the first. Always print the background image first and work from the background toward the foreground with each image.

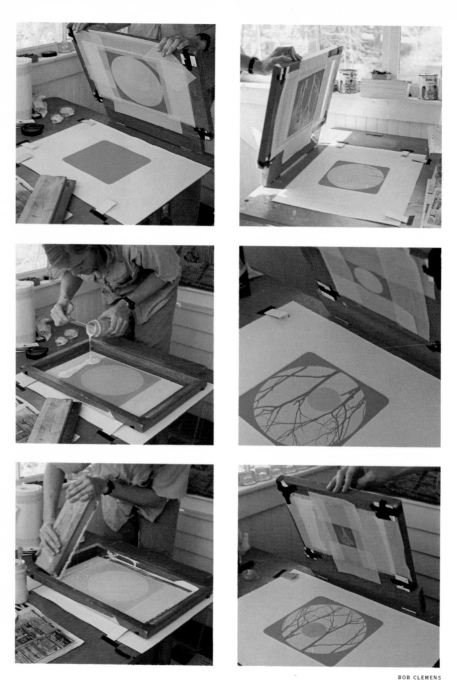

To produce multiple-colored silk-screen prints, you must print each color separately using a different silk screen for each color. Each color layer must dry thoroughly on the paper before another color can be printed over it.

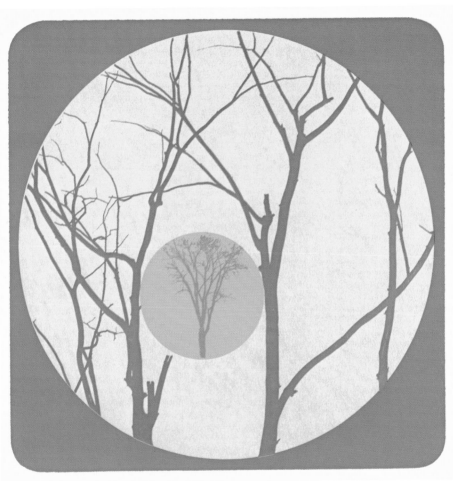

RICHARD V. STOECKER

285

A photo silk-screen print made from three different screens.

THE PHOTO SILK-SCREEN PROCESS

All steps, except the handling of KODALITH Ortho Film, can be done in room light.

1. Clean the silk screen with Serascreen SPC enzyme or Foto-Film Remover. Rinse well and apply DeGreaser with a soft scrub brush. Rinse with a solution of one capful acetic acid in a gallon of water. *Do not touch the screen after cleaning.*

2. Enlarge the original image onto KODALITH Ortho Film 6556, Type 3, or KODALITH AUTOSCREEN Ortho Film 2563 (ESTAR Base). Refer to page 152 for the details on processing these films.

3. Place the KODALITH Film positive in a printing frame with a sheet of Hi-Fi Green Presensitized Photo Film. The plastic backing on the Hi-Fi Film should be toward the film positive and the light source. Expose the Hi-Fi Film to an ultraviolet light source: a sun lamp, photolamp, or arc lamp. Refer to the exposure table on page 278.

4. Develop the Hi-Fi Film in Inko #201 Liquid or Ulano A and B powder-type developer, following the developer instructions.

5. Wash out the developed image on the Hi-Fi Film with warm running water (not over 115 F).

6. Adhere the wet Hi-Fi Film to the silk screen by pressing the screen evenly over the wet emulsion of the film. Use paper towels to pat the emulsion into the screen and to soak up excess water.

7. Allow the screen to dry thoroughly and gently peel off the plastic backing.

8. Clean the screen with turpentine.

9. Tape strips of tissue paper around the edges of the screen in any area where the Hi-Fi Film doesn't completely cover the screen.

10. Tape squares of cardboard to each corner of the screen frame to prevent speckles of paint from getting on the paper during printing.

THE FOLLOWING STEPS MUST BE DONE IN A WELL-VENTILATED ROOM

11. With the paper in place under the silk screen, pour the ink along one end of the screen and squeegee the ink over the surface of the screen once.

12. Remove the paper to dry.

13. Immediately after you finish printing, clean the screen thoroughly with paper towels or rags soaked with turpentine.

MORE INFORMATION

The following books are good references for more information on silk-screen printing.

Inko Silk Screen Printing Techniques in Photography, Fossett

Photographic Screen Process Printing, Kosloff

Silk-screen supplies are available from art and graphic-arts suppliers. If you have difficulty finding silk-screening supplies locally, one supplier is Screen Process Supplies Manufacturing Company, 1199 East 12th Street, Oakland, California 94600.

More Information

ANY QUESTIONS?

If you have any questions about the darkroom techniques described in this book, write to Eastman Kodak Company, Photo Information, Department 841, Rochester, New York 14650.

KODAK BOOKS

There are many other Kodak books like this one. They're written in an interesting and understandable style by experts who know their subjects firsthand. These books will help you get the kinds of pictures you want by giving you ideas for pictures and exposing you to a wealth of picture-taking techniques and photographic information. There's a Kodak book to help you no matter what your photographic interest. Here's a partial listing of the books that might appeal to an advanced photographer. For a free index of the other Kodak books and publications available, write to the address given above, and ask for *Index to Kodak Information* (L-5).

To Help You in the Darkroom

KODAK Professional Black-and-White Films (F-5)—64 pages, $1.50
Many of the sheet films mentioned in this book are the films you'll be using for advanced darkroom work and roll films are also covered. The book tells how to handle, expose, and process professional films.

KODAK B/W Photographic Papers (G-1)—28 pages, $1.50
Contains the many KODAK Photographic Papers available to the darkroom enthusiast and tells how to expose and process the papers for high-quality prints.

Printing Color Negatives (E-66)—52 pages, $2.00
Thoroughly explains the techniques for making color prints and transparencies from color negatives.

KODAK Master Darkroom DATAGUIDE (R-20)—28 pages, $5.50
This is a darkroom guide for black-and-white processing, printing, and copying. Contains paper samples and exposure and processing computer dials to help you in the darkroom.

KODAK Color DATAGUIDE (R-19)—44 pages, $5.95
A darkroom guide to help you expose, process, and print color pictures. Includes viewing filters and a reference chart for color printing.

Processing Chemicals and Formulas (J-1)—64 pages, $1.00
Discusses processing principles, preparing solutions, and processing techniques for black-and-white photography, and includes many photographic chemical formulas.

How to Get Kodak Books

A large selection of Kodak books, including those described in this publication, are usually stocked and sold by photo dealers. See your dealer first; if he can't supply the ones you want, order by title and code number directly from Eastman Kodak Company, Department 454, Rochester, New York 14650. Please send your money order or check with the order, including your state and local sales taxes. The list prices given in this book are suggested prices only and are subject to change without notice.

To Help You Take Better Pictures

Advanced Camera Techniques
(AC-56)—52 pages, 95¢
Provides the know-how to help you
make better pictures by taking full ad-
vantage of the versatility of your ad-
vanced 126 or 35mm camera. Gives
information on lenses, close-up tech-
niques, filters, and flash pictures.

*Adventures in Existing-Light
Photography* (AC-44)—64 pages, 95¢
Thoroughly covers the techniques for
taking black-and-white and color pic-
tures under existing-lighting condi-
tions. Exposure tables provide cam-
era settings for many picture subjects.

*Filters for Black-and-White and Color
Pictures* (AB-1)—44 pages, 95¢
A book about filters—what they are,
what they do, how they work, and how
you can use them to improve your pic-
tures or to obtain unusual and crea-
tive effects.

The "Here's How" Series—AE-81, AE-
83, AE-84, AE-85, AE-87, AE-88, and
AE-90—Most are 64 pages each, 95¢
each. *The Eighth Here's How* (AE-94)
is $1.25.

The eight *Here's How* books are com-
prised of articles written by expert
photographers about their specialties.
The articles range from pictorial light-
ing and composition to movies and
push-processing of films. Each book
contains six to eight articles—a valu-
able reference set.

The Here's How Book of Photography
(AE-100)—410 pages, $10.95
This hard-cover edition is a compila-
tion of the first six books of the *Here's
How* series. Contains 39 articles on
widely varied photographic topics and
has more than 400 color illustrations.

KODAK Master Photoguide
(AR-21)—36 pages, $2.50
Pocket-size reference book on expo-
sure, filters, lenses, and other photo
essentials. Contains tables, dial com-
puters, do-it-yourself flash stickers, a
gray test card, and viewing filters.

KODAK Films for the Amateur
(AF-1)—96 pages, $1.25
Covers both black-and-white and col-
or films. Tells how to choose the right
film and how to use it for the best re-
sults. A data sheet section gives the
details for each film, including expo-
sure and processing information.

REMOVING FIXER STAINS FROM CLOTHING

Even the most careful darkroom workers occasionally find brownish-yellow fixer and developer stains on their clothing, and these stains often appear after the garment has been laundered. These stains are stubborn, but there is a way to remove them. A ready-made fixer and developer stain remover, called Photo-Stain Remover K-14, is available in a ready-to-use plastic squeeze bottle from Anchor Chemical Company, P.O. Box 2983, Cleveland, Ohio 44116.

Or, if you prefer to mix your own stain remover, a solution made from the following formula should remove fixer stains. Although this formula is not harmful to most yarns, it's always wise to test the stain remover by applying the solution to an unimportant part of the garment first. Try it on an inside seam to see if it will bleach or otherwise damage the material.

KODAK SILVER STAIN REMOVER S-10

(For Removal of Fixer Stains from Clothing)

Water 96 fluid ounces
KODAK Thiourea 10 ounces
KODAK Citric Acid . . 10 ounces
Water to make 1 gallon

Instructions for Use

Thoroughly wet the stained part with this solution and wait for the stain to disappear. Old stains usually require more than one application of the solution and take a longer time to disappear—several minutes perhaps. When the stain has been removed, wash the garment thoroughly.

Caution

Most preparations for removing fixer stains contain thiourea, a powerful foggant of photographic emulsions. Do not prepare or use stain remover in close proximity to areas where light-sensitive materials or processing chemicals are handled or used.

TEMPERATURE CONVERSION CHART— DEGREES FAHRENHEIT TO DEGREES CENTIGRADE

F	C	F	C	F	C
45	7.0	74	23.5	102	39.0
46	8.0	75	24.0	103	39.5
47	8.5	76	24.5	104	40.0
48	9.0	77	25.0	105	40.5
49	9.5	78	25.5	106	41.0
50	10.0	79	26.0	107	41.5
51	10.5	80	26.5	108	42.0
52	11.0	81	27.0	109	42.5
53	11.5	82	28.0	110	43.5
54	12.0	83	28.5	111	44.0
55	13.0	84	29.0	112	44.5
56	13.5	85	29.5	113	45.0
57	14.0	86	30.0	114	45.5
58	14.5	87	30.5	115	46.0
59	15.0	88	31.0	116	46.5
60	15.5	89	31.5	117	47.0
61	16.0	90	32.0	118	47.5
62	16.5	91	32.5	119	48.5
63	17.0	92	33.5	120	49.0
64	18.0	93	34.0	121	49.5
65	18.5	94	34.5	122	50.0
66	19.0	95	35.0	123	50.5
67	19.5	96	35.5	124	51.0
68	20.0	97	36.0	125	51.5
69	20.5	98	36.5	126	52.0
70	21.0	99	37.0	127	52.5
71	21.5	100	37.5	128	53.5
72	22.0	101	38.5	129	54.0
73	23.0			130	54.5

The degrees centigrade have been rounded off to the nearest ½ degree.

KODAK FILMS
SEE THINGS YOUR WAY!

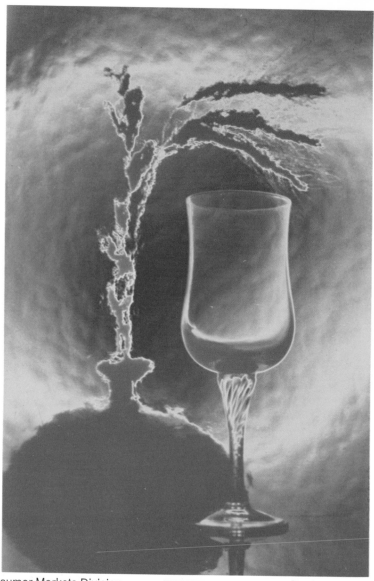

Consumer Markets Division

Creative Darkroom Techniques
KODAK Publication No. AG-18
CAT 142 2211

Rochester, New York

New Publication
10-73-AXX
Printed in U.S.A.